IMAGES
of America

JEWISH
ALBUQUERQUE
1860–1960

IMAGES
of America

JEWISH
ALBUQUERQUE
1860–1960

Naomi Sandweiss
Foreword by Dr. Noel Pugach

ARCADIA
PUBLISHING

Published by Arcadia Publishing
Charleston, South Carolina

Library of Congress Control Number: 2010940825

For all general information, please contact Arcadia Publishing:
Telephone 843-853-2070
Fax 843-853-0044
E-mail sales@arcadiapublishing.com
For customer service and orders:
Toll-Free 1-888-313-2665

Visit us on the Internet at www.arcadiapublishing.com

*To my mother, Rosalia Myers Feinstein (1940–2009), who
would have enjoyed this view of her adopted hometown*

CONTENTS

Acknowledgments 6

Foreword 7

Introduction 9

1. Early Arrivals 11

2. Laying Congregational Cornerstones 41

3. Commerce 73

4. Native American Trade and Tourism 95

5. Civic and Social Life 105

6. Modern Jewish Albuquerque 117

Bibliography 125

Index 126

About the Author 127

ACKNOWLEDGMENTS

My gratitude and appreciation to the following individuals who shared their time and expertise: Judy Weinreb, archivist at Congregation Albert; Martha Liebert of the Sandoval County Historical Society; and Nancy Tucker, New Mexico Postcard Club. Thank you to members of all of the families who contributed photographs and reminiscences, especially Helen Horwitz, Marjorie Ross, Leah Sandman, Leslie Kim, Betsy Messeca, and Frances Katz.

This project would not have been possible without the support of my family, including the best research assistant anyone could have, my father, Stan Feinstein, who loaned me numerous books and resources. My love to my husband of 20 years, Dan, and our kids, Molly and Ethan, who definitely keep me grounded in the present.

Thanks to the researchers who have pursued this topic before, especially Henry Tobias and Noel Pugach.

Images in this volume appear courtesy of numerous sources, including the Albuquerque Museum, University of New Mexico Center for Southwest Research, Museum of New Mexico Photo Archives, and the Israel C. Carmel Archive at Congregation Albert.

FOREWORD

New Mexico has an aura of romance and exoticism. It celebrates, with some justification, its tri-cultural heritage: Anglo, Hispano, and Native American. Spanish is heard in mountain villages and on city streets, Pueblo Revival architecture dominates the skyline, while red and green chile vie for popularity in the daily diet.

The markers along the path of the Santa Fe Trail reveal stories about the adventurous men and women who braved the dangers of the Santa Fe Trail—Indian attacks and kidnappings, sudden snow and violent rain storms, lack of water, and disease. New Mexico's history contains a long chapter on the era of the Wild West—Billy the Kid and the Lincoln County War; the notorious criminal gangs of Black Jack Ketchum and Vincente Silva; the frightening attacks by Victorio and his Apache bands; and the brutal relocation of the Navajo at Bosque Redondo.

The Jewish people shared in this adventure. There is the mystique of the Crypto-Jewry among the early Spanish settlers and the recent attempts of their descendants to recapture their Jewish identity. There is the account of Levi Spiegelberg of the illustrious mercantile house in Santa Fe, who was felled by a raging fever and personally nursed back to health by Archbishop Jean Lamy on the Santa Fe Trail. In Liberty, New Mexico, young Levi Herzstein was gunned down by Black Jack Ketchum, a true psychopathic killer, comparable to the semi-mythical Billy the Kid. Charles Solomon, later a prominent banker, stuttered for the rest of his life after his father, Isadore, hid him from marauding Apache in a packing case off the road to Las Cruces.

Though less dramatic, the history of the men and women who built New Mexico's economy, forged its political institutions, fashioned its religious and cultural bodies, and established its society is far more noteworthy and equally fascinating. They included Native Americans, Hispanos, and those subsumed by the term "Anglos," a diverse group of Anglo-Americans who migrated from other parts of the United States as well as those recently arrived from Germany, France, Italy, Greece, Russia and Eastern Europe, and Syria. In developing the territory and the state, and then integrating it into the modern American economy and polity, these people faced enormous difficulties such as distance and isolation, Indian hostility, a beautiful yet harsh environment, poverty, and technological backwardness. It took hard work, boldness, determination, imagination, creativity, and confidence to prevail. While some failed and moved on, many succeeded and planted themselves permanently. A few achieved great wealth and prominence.

Among the newcomers were Jews, first from German-speaking lands and, after the 1880s, from the Russian Empire. The first known Jew to settle in New Mexico was Solomon Spiegelberg, who made his way over the Santa Fe Trail and became a merchant in Santa Fe. Thanks to his quick success and the American conquest of New Mexico during the Mexican-American War, Solomon called his younger brothers and a number of his German Jewish relatives to New Mexico. Some of them established a number of important commercial enterprises that rivaled the House of Spiegelberg; their presence was felt in a widening area north and south of Santa Fe, as several of them opened outlets and branch stores.

Within a decade (but especially after the Civil War, which dislocated business), a significant number of Jews, some members of other German Jewish families, settled in almost every part of the territory as opportunities opened up for commerce, from retail trade to wholesaling, banking, sheep and cattle raising, and mining. The coming of the railroad shifted the center of economic activity from Santa Fe (which was bypassed by the Atchison, Topeka, and Santa Fe) to Las Vegas and then Albuquerque. As time went on, the construction of other railroads, the Homestead Act, the development of silver and copper mining, and the completion of large irrigation projects spurred the growth of such towns as Clayton, Tucumcari, Las Cruces, and Silver City.

The Jewish people were not the only ones to take advantage of the new possibilities. However, thanks to former experiences elsewhere, family ties and support in New Mexico and the East Coast, a habit of taking risks, and appreciation for the larger currents in the American economy, they were particularly successful in seizing upon the emerging opportunities in New Mexico. First they planted full-fledged, sedentary commercial enterprises where they settled, and then, led by Charles Ilfeld and his company, they advanced into mercantile capitalism, balancing imports and exports, and finally, specialized retailing. They also learned Spanish quickly and forged close ties with Hispanos and Native Americans.

Not all Jews engaged in business. This was particularly true after World War II and the emergence of New Mexico as a center for science and technology. Jews formed a significant part of the growing professional class and the scientific and educational communities.

Meanwhile, Jews took part in New Mexico's general life. They were active in politics, serving as mayors, governors, and in other state positions; they acted as delegates to constitutional conventions and as party officials. They participated in cultural and civic affairs. Because of their isolation and small numbers, they were somewhat slower to create Jewish religious, philanthropic, and fraternal organizations, but these did emerge in Las Vegas and Albuquerque before the 20th century and afterwards in other New Mexico communities. Concurrently, these ordinary citizens married and raised families, worried about educating their children, sought time for recreation and socializing, and built neighborhoods.

By World War I, Albuquerque was fast becoming the commercial, financial, educational, transportation, and population center of New Mexico. Albuquerque's growth accelerated as a result of World War II and the Cold War, which made it a key site for nuclear research. These trends also brought a large number of first- and second-generation Jews, and they played a significant role in developing the state's only metropolis and expanding its Jewish activities.

In her revealing, admirable, and delightful photographic history, Naomi Sandweiss documents the details of Jewish Albuquerque from last third of the 19th century to the 1960s and beyond. Sandweiss captures these ordinary people, their daily lives, their workplaces, their residences, and their special moments. Her text and images provide insight into the small yet growing and diverse Jewish community, some of its notable figures, and new institutions. Furthermore, she gives the reader a glimpse of the culture's place in the larger community and its changing landscape, for Albuquerque became home to at first hundreds and then thousands of Jews.

—Noel Pugach, professor emeritus
University of New Mexico

INTRODUCTION

Albuquerque's transformation from isolated agricultural village to New Mexico's largest city was a remarkable one. In the 100 years between 1860 and 1960, the town's population increased from fewer than 2,000 to over 200,000 residents. While not the capital, the city along the Rio Grande became New Mexico's center for business, higher education, science, aviation, and the armed forces.

Initially, the biggest factor in this growth was the arrival of the railroad in 1880. Jewish immigrants were among those who seized upon the business opportunities presented by the railroad's arrival and established organizations that benefitted both the Jewish and the greater Albuquerque community.

Before the Mexican-American War began in 1846, Jewish immigrants rarely ventured into Mexican territory. Although a few Jewish residents made Albuquerque their home in the 1860s and 1870s, it was not until the 1880s that a significant number of German Jewish immigrants came to town.

The immigration pattern among Albuquerque's Jews mirrored that of the rest of the United States. German-born merchants settled in the Southwest starting in the 1850s and 1860s, following business opportunities from the Santa Fe Trail to military forts to stores in Santa Fe, Las Vegas, and other parts of the territory. Along the way, relatives (often young single men) arrived from Germany and were dispatched around the region to set up branch operations.

When they set their sights on Albuquerque after the railroad's arrival in 1880, the German Jewish merchants had distinct advantages. Capital and kinship connections were already established, and their enterprises were immediately part of existing business networks. These pioneers generally had no language barriers, as they had already mastered Spanish and English. Their timing was ideal—arriving in Albuquerque just as the town transformed from an agricultural economy to a cash-and-trade-based one.

Such a head start enabled families such as the Ilfelds, Jaffas, and Mandells to assume early leadership positions and quickly build religious and civic organizations. Early Jewish institutions included a chapter of the Jewish fraternal organization B'nai B'rith and a synagogue, Congregation Albert, which adhered to German-style Reform Jewish practices. Under the leadership of the merchants, Congregation Albert erected a building within three years of its establishment.

By virtue of their background and skills, Jewish citizens led city government (Henry Jaffa in 1885, Mike Mandell in 1890), established the Commercial Club, joined the Elks and the Freemasons, and led the chamber of commerce. Jewish families were neighbors, living and socializing with each other and their non-Jewish counterparts. Despite their social connections with non-Jews (curiously, all of the immigrants—whether from Lebanon, Greece, Germany, or Italy—were described as "Anglo," a word referring to anyone who wasn't Hispanic or Native American), by and large, Jewish residents of Albuquerque married within their faith, often selecting partners from other established Jewish families of German descent.

The Jews who arrived after New Mexico statehood in 1912 were part of the immense wave of Jewish immigration at the turn of the 20th century. These immigrants, more likely of Eastern European than of German descent, were more religiously observant than their German counterparts, often struggling to stay kosher. Most had gone first to larger communities such as Denver or Chicago before venturing to Albuquerque, which some selected for the climate and touted health benefits. These newer immigrants typically arrived as married couples or young families; initially, their businesses were more modest than those of their predecessors. However, unlike their East Coast counterparts, early-20th-century Jewish immigrants in Albuquerque were not isolated in particular neighborhoods nor restricted by employment or educational quotas. Resourceful and patient, they built businesses and religious institutions. It took the leaders of Congregation B'nai Israel 20 years to erect a synagogue building and hire a rabbi, all the while providing religious services and education for their children.

While the Depression and Dust Bowl paralyzed other areas of the region, Albuquerque and its Jewish residents remained relatively immune. While businesses did fail and organizations struggled, an influx of Works Progress Administration (WPA) funds and projects led to population growth during the era.

During and after World War II, Albuquerque's population boom enabled many of these businesspeople to achieve financial success, including those citizens who came as refugees in the 1930s and 1940s. The influx of military, federal, and scientific enterprises brought Jewish newcomers to Albuquerque. Over the years, members of Albuquerque's Jewish community have joined forces on behalf of Jewish, national, and international causes in support of soldiers assisting Jewish refugees and defending Israeli statehood.

The vision that the majority of the Jewish immigrants shared was that of a multicultural and multireligious Albuquerque. They worked and lived side-by-side with their non-Jewish neighbors. Once Albuquerque expanded beyond the plaza and downtown, Jewish residents lived in every area of city. To serve their customers, Jewish merchants spoke both Spanish and English, and many Jewish businesspeople championed Native American arts and crafts.

Albuquerque's Jews experienced little anti-Semitism. Jewish individuals have not been barred from social, fraternal, or country clubs. In fact, much to the contrary, Jewish citizens were instrumental in establishing such organizations. Over the years, Jewish leaders have also worked cooperatively with their Christian neighbors to serve the greater community. As early as 1907, Rabbi Jacob Kaplan of Congregation Albert jointly published a newsletter with a minister. In 1918, Rabbi Moise Bergman led the Albuquerque Charities, a predecessor of the United Way. In the intervening years, ecumenical cooperation has dominated.

These factors have lent a special character to Albuquerque's Jewish community, and while there is a sense of uniqueness, the Jewish community is fully engaged with the city at large. Despite their small percentage of the population (approximately 10 percent of the population in 1960), Jewish individuals held significant leadership positions that impacted the civic, business, and social life of Albuquerque.

If one walks in downtown Albuquerque, it is not difficult to find evidence of the Jewish impact upon the Southwestern city. From the Rosenwald Building on Central Avenue to the plaque commemorating the Congregation Albert's first site of on Gold Avenue to buildings and businesses still run by descendants of Jewish families, a significant part of Albuquerque's story is a Jewish one.

One

EARLY ARRIVALS

The area surrounding the agricultural hamlet of La Villa de San Francisco Xavier de Albuquerque was inhabited by Native Americans long before the Spanish founded the settlement in 1706. Some of New Mexico's Spanish residents may have been crypto-Jews attempting to escape the long arm of the Inquisition (which did operate in Nuevo Mexico).

After the Americans took control of the territory in 1848 as a result of the Mexican-American War, commercial operations expanded in Albuquerque's plaza. Among the proprietors was Simon Rosenstein, who established himself in the 1850s. However, it wasn't until the Atchison, Topeka, and Santa Fe Railroad purchased a parcel of land for its railroad stop and yard in 1880 that many Jewish businesspeople flocked to Albuquerque. The arrival of the railroad led to the development of "New Town" Albuquerque, 1.5 miles east of the original plaza, built in large part by Jewish citizens, along with newcomers from many other regions such as Greece, Lebanon, and Italy. In the three short years between 1880 and 1883, Albuquerque went from a sleepy agricultural village to a frontier town with gas, water, and electric companies; a fire department; trolley cars; and plenty of saloons. The town was incorporated in 1885.

The first Jewish businesspeople to seize upon the opportunities prompted by the railroad's arrival had been operating businesses in other parts of New Mexico Territory for decades; thus, they were quickly able to establish operations in Albuquerque, often dispatching relatives to staff the outposts. Some of these families, like the Spiegelbergs of Santa Fe and Ilfelds of Las Vegas, were already wealthy, with wide influence and many contacts.

These early arrivals wasted no time in establishing and building governmental, social, and religious institutions to meet their needs. Merchants Henry Jaffa and Mike Mandell served as Albuquerque's first and second mayors. One of the first orders of business for a group of Jewish citizens was to found New Mexico's first chapter of B'nai B'rith, a Jewish fraternal organization, in 1883. Twenty-five members signed the registration book, all of them merchants or clerks.

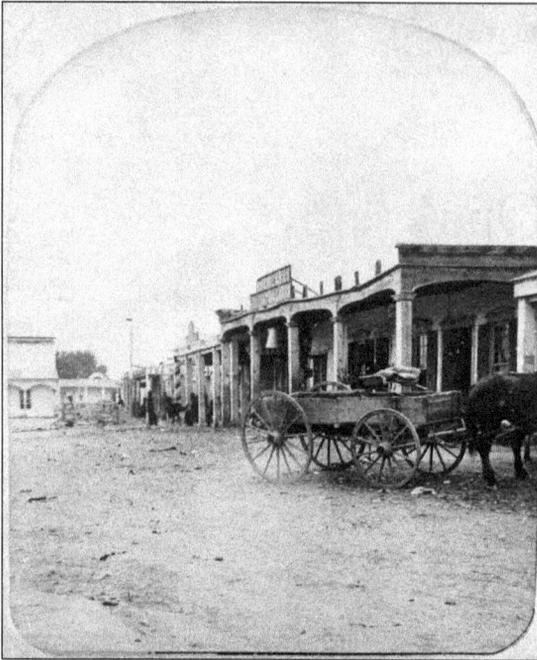

This early view of Albuquerque's plaza is from 1879. The earliest known Jewish resident of Albuquerque was Simon Rosenstein, a colorful merchant from Hanover, Germany. Rosenstein was certainly in the territory before 1850, as he complained of the poor treatment he received from U.S. military personnel in 1849. Rosenstein had a store on the Albuquerque plaza and gave Franz Huning, an Albuquerque pioneer, his first job in New Mexico. Germans (of both Jewish and non-Jewish descent) made up the greatest percentage of Albuquerque's immigrants in the mid-19th century. (Courtesy of the Museum of New Mexico Photo Archives.)

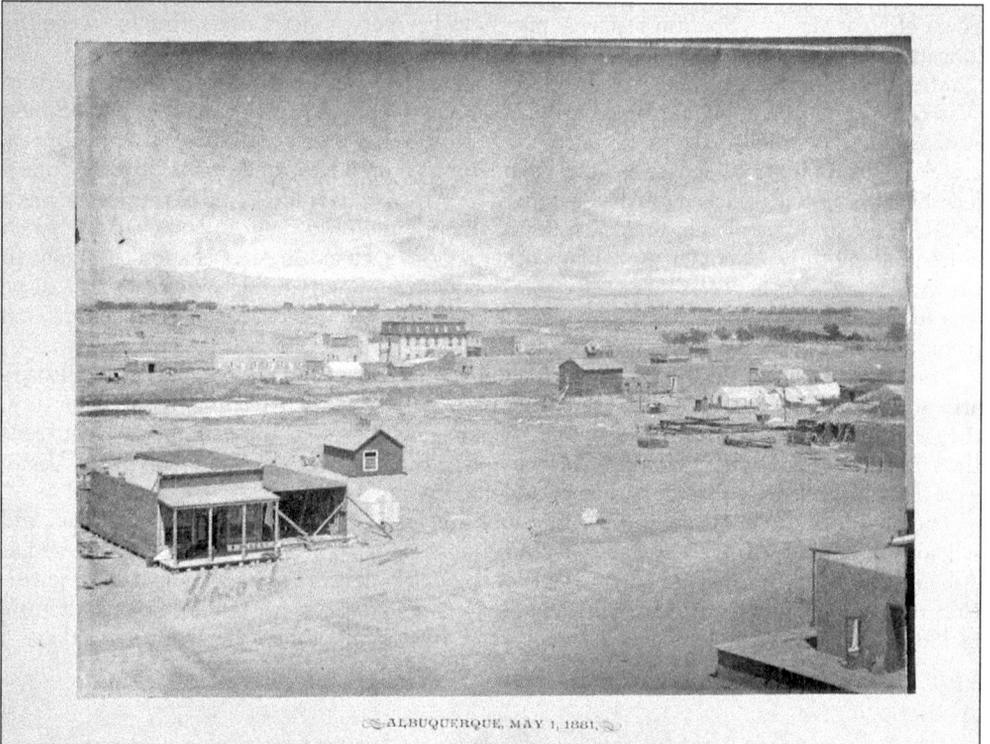

This photograph was taken in 1881, one year after the arrival of the railroad in Albuquerque. Jewish merchants who owned stores in the plaza moved operations to New Town Albuquerque. For many years, a trolley ran between the plaza and the new commercial district. (Courtesy of the University of New Mexico Center for Southwest Research.)

12

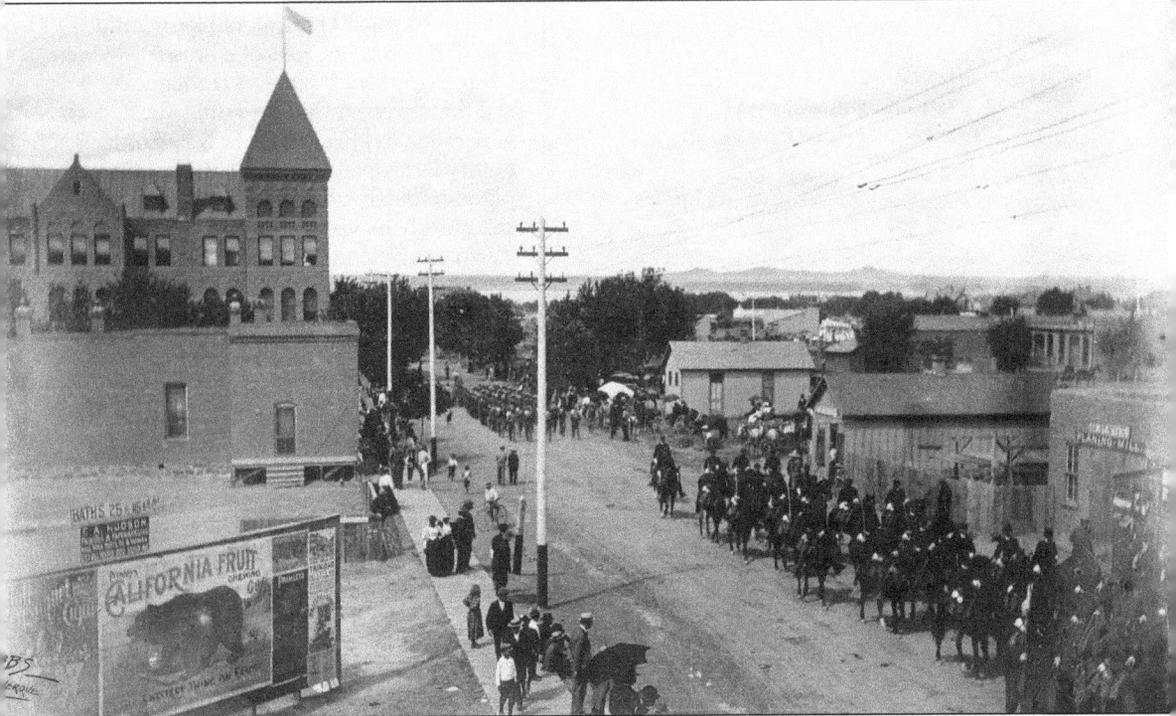

Albuquerque's urban transformation is apparent. One-story adobes, traditional New Mexican dwellings, can be viewed on the right, while power lines and framed brick buildings appear on the left. An early visitor, C. M. Chase of Vermont, made the following observation in 1882: "The town is hungry for labor and capital. Opportunities are everywhere open for the employment of capital and sure and high paying profits." (Courtesy of the University of New Mexico Center for Southwest Research.)

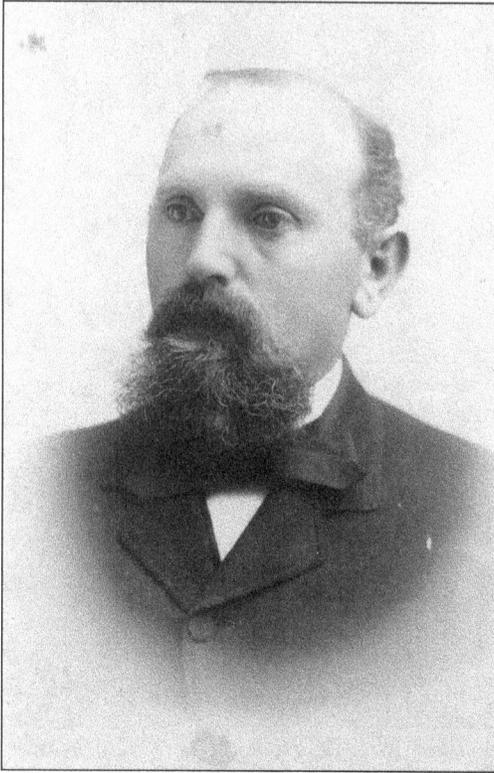

At left is an 1880 portrait of Henry Jaffa. The Jaffa brothers, sons of a Prussian cantor, operated businesses throughout the Southwest, including Trinidad, Colorado, and Roswell, New Mexico. Henry Jaffa opened a Jaffa outpost on the plaza in Old Town Albuquerque in 1880 but quickly moved operations to New Town after the railroad's arrival. Jaffa also served as the president of Albuquerque's Board of Trade and as the first president of Albuquerque's Congregation Albert. Jaffa married Sophia Moise, daughter of a Jewish Santa Rosa businessman. (Courtesy of the University of New Mexico Center for Southwest Research.)

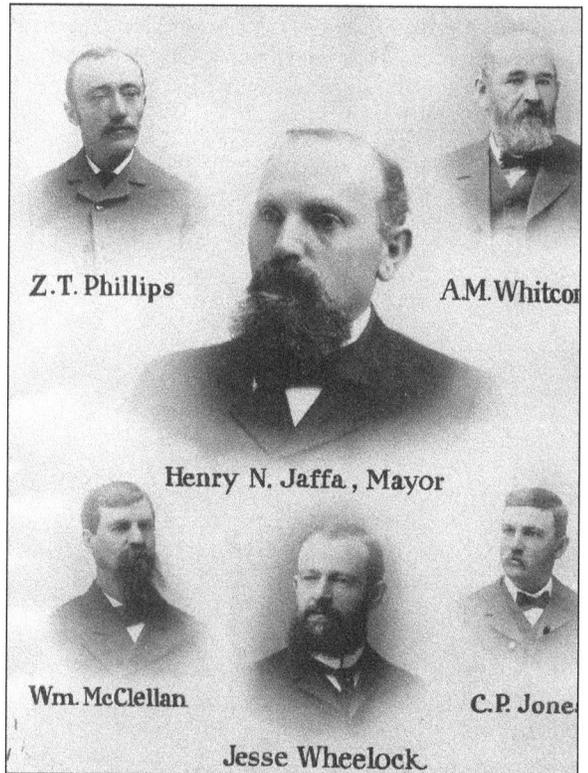

Z.T. Phillips

A.M. Whitcor

Henry N. Jaffa., Mayor

Wm. McClellan

C.P. Jone

Jesse Wheelock

Henry Jaffa, who was elected Albuquerque's first mayor in 1885, is pictured here along with his cabinet. (Courtesy of the Israel C. Carmel Archive at Congregation Albert.)

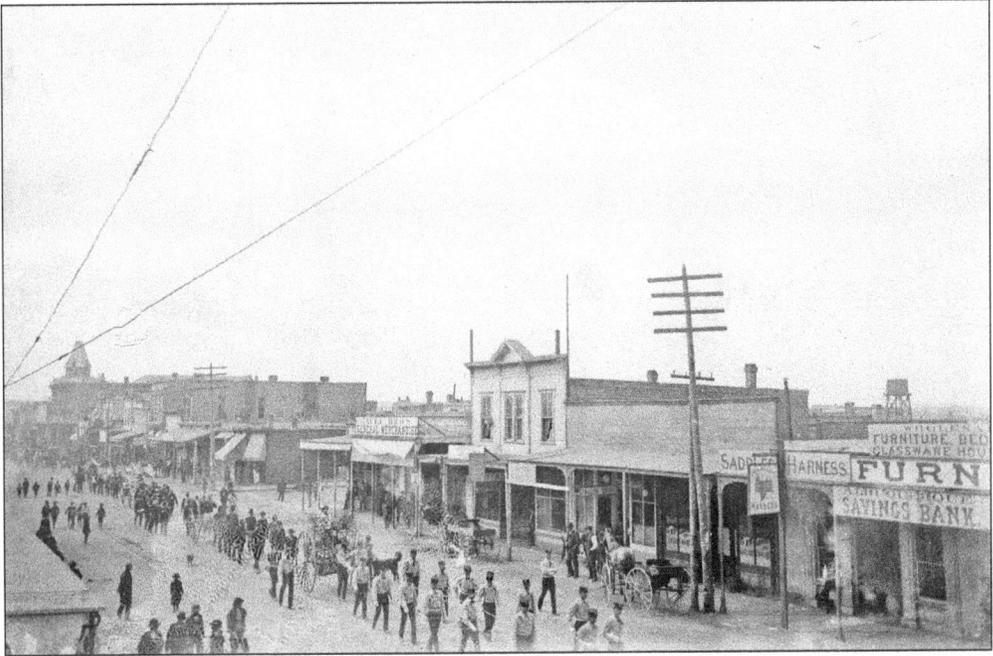

A parade commences in front of Jaffa Brothers General Merchandise store on Albuquerque's Railroad Avenue, later named Central Avenue. (Courtesy of the University of New Mexico Center for Southwest Research.)

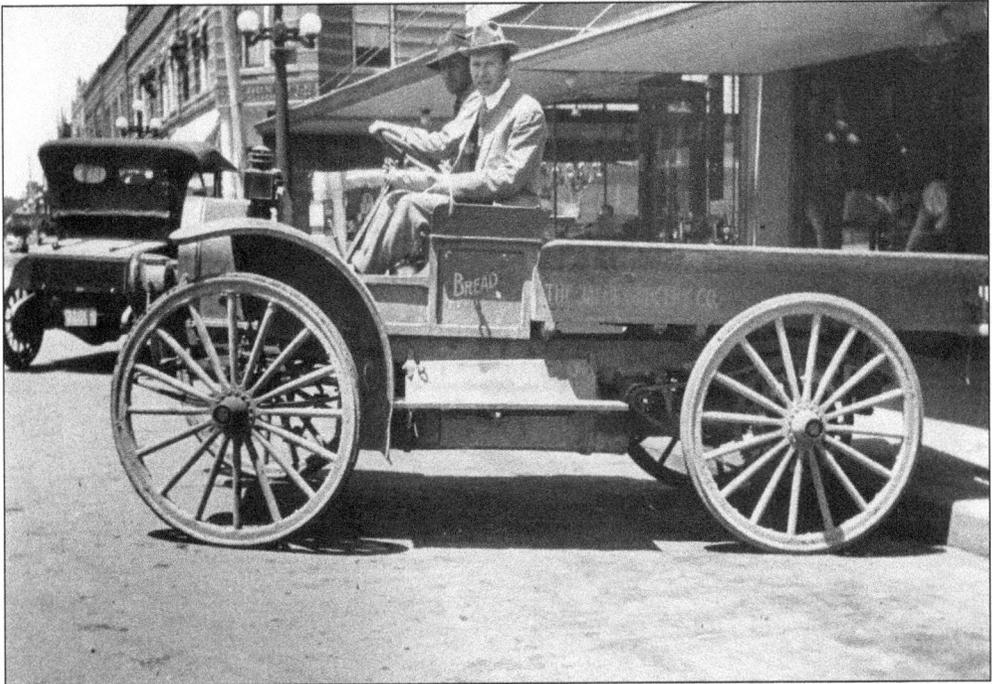

Pictured above is the Jaffa Brothers delivery truck. Jaffa later transformed his grocery into a dry goods store and devoted some of his attention to his political career. (Courtesy of the Albuquerque Museum.)

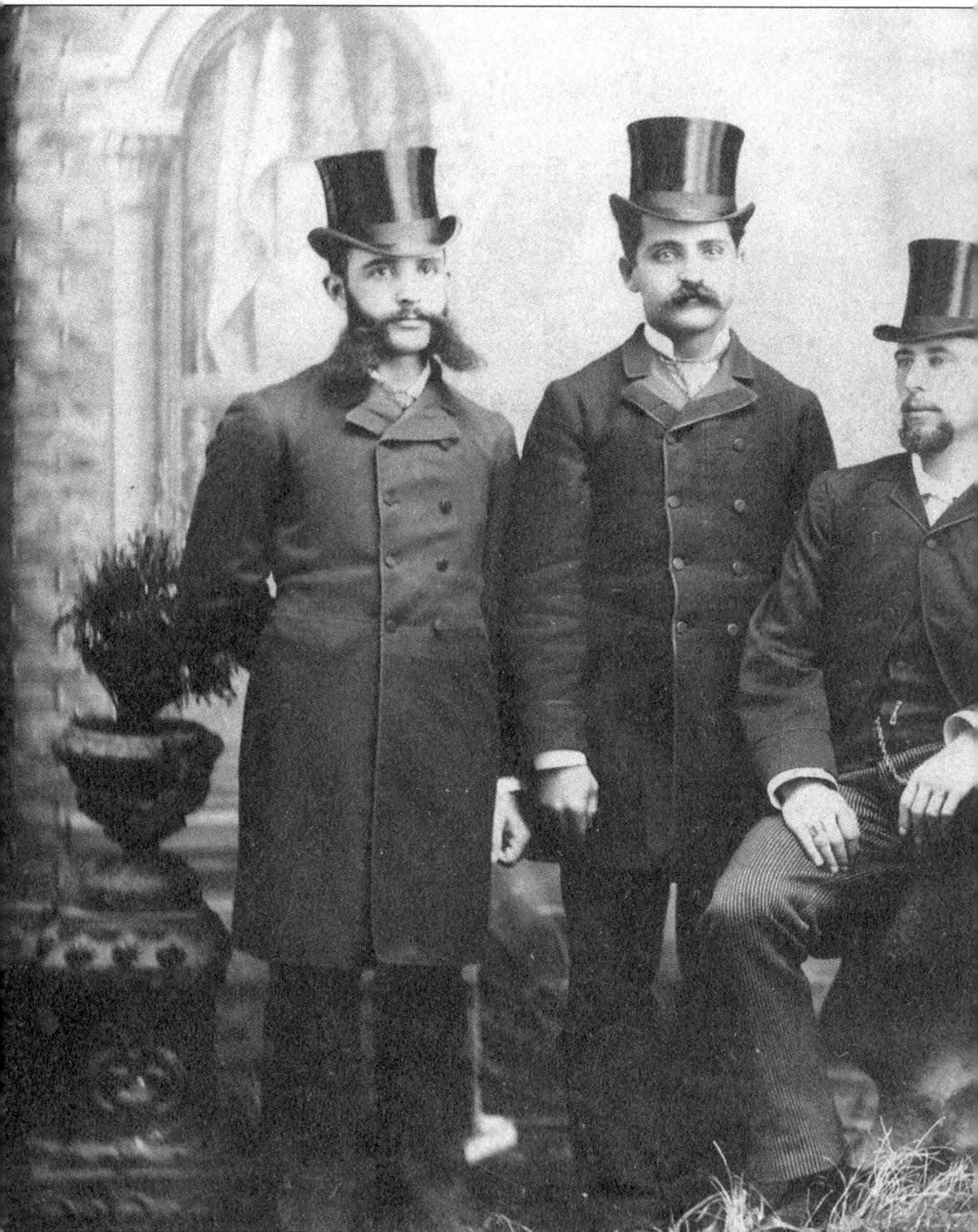

This is an 1883 portrait of the following five Jewish Albuquerque businessmen, from left to right: Louis Kornberg, Mike Mandell, Louis Neustadt, Dr. Z. B. Sawyer, and David Weinman. Mandell

later became mayor of Albuquerque. (Courtesy of the University of New Mexico Center for Southwest Research.)

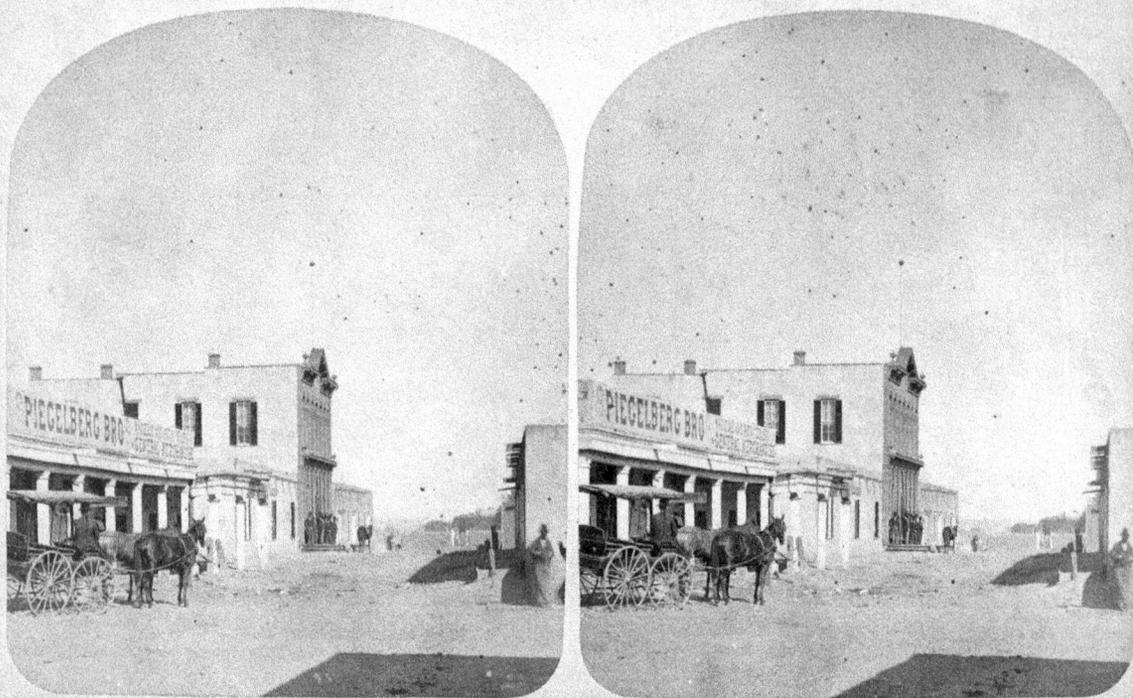

This stereoscope card displays the Spiegelberg Brothers store in Albuquerque prior to 1876. Members of the Spiegelberg family arrived in New Mexico Territory around 1850, settling in Santa Fe. The family founded the Second National Bank of New Mexico in Santa Fe in 1872. In the 1870s, the Spiegelbergs opened a branch store on the Albuquerque plaza ran by the Grunsfelds, who were relatives of the family, before moving to New Town after the railroad arrived. (Courtesy of the University of New Mexico Center for Southwest Research.)

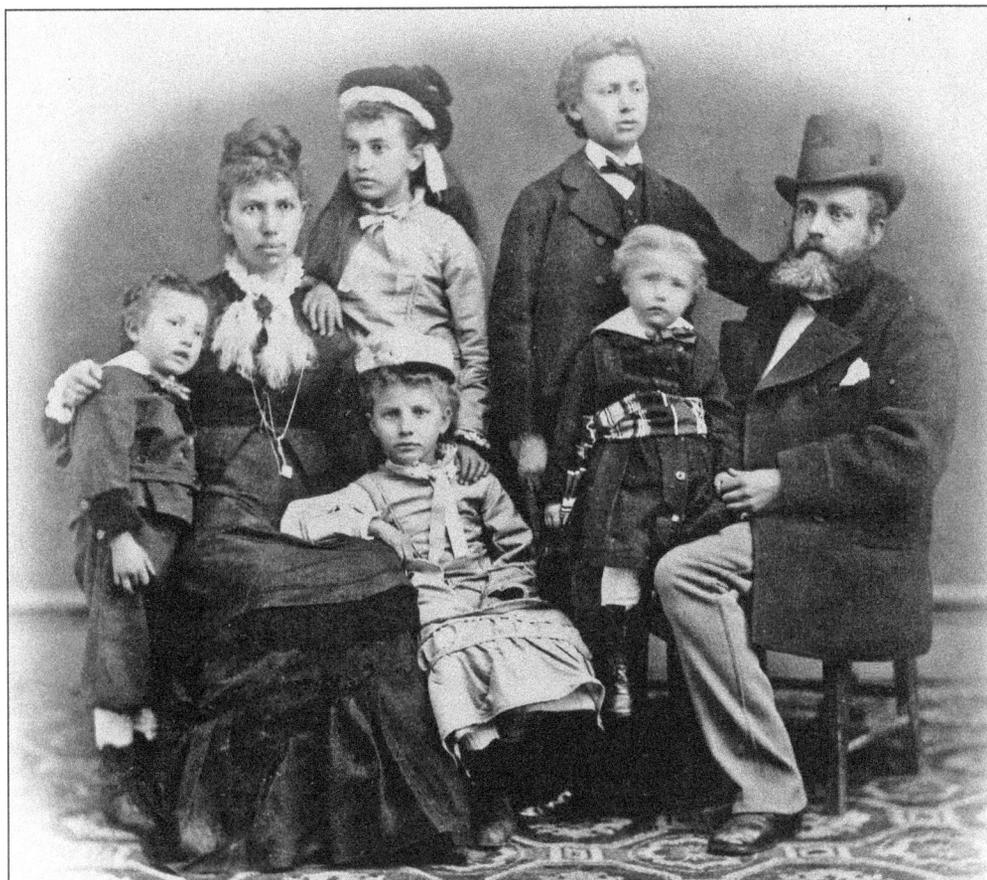

In this photograph of the Grunsfeld family are, from left to right, James, Hildegarde, Sally, Helen, Alfred, Ivan, and Albert Grunsfeld. (Courtesy of the Israel C. Carmel Archive at Congregation Albert.)

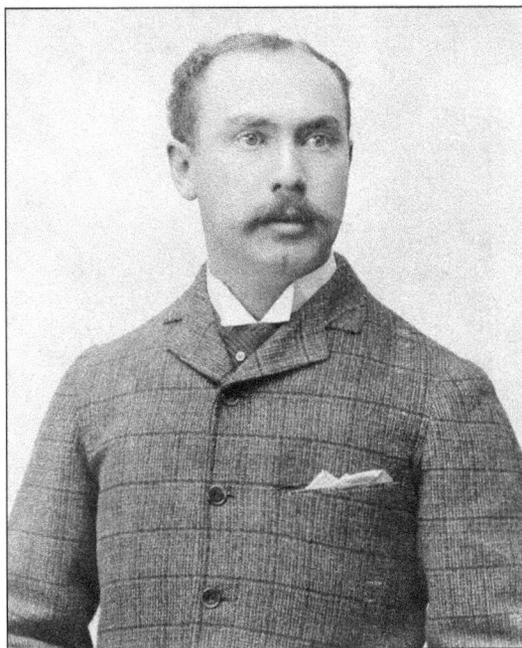

This portrait of Alfred Grunsfeld was taken around 1890. In 1876, Alfred was the first boy known to celebrate his bar mitzvah in New Mexico. Grunsfeld helped run the Spiegelberg store in Albuquerque and was a founder of Albuquerque's Commercial Club. Grunsfeld later served as a colonel during World War I. (Courtesy of the University of New Mexico Center for Southwest Research.)

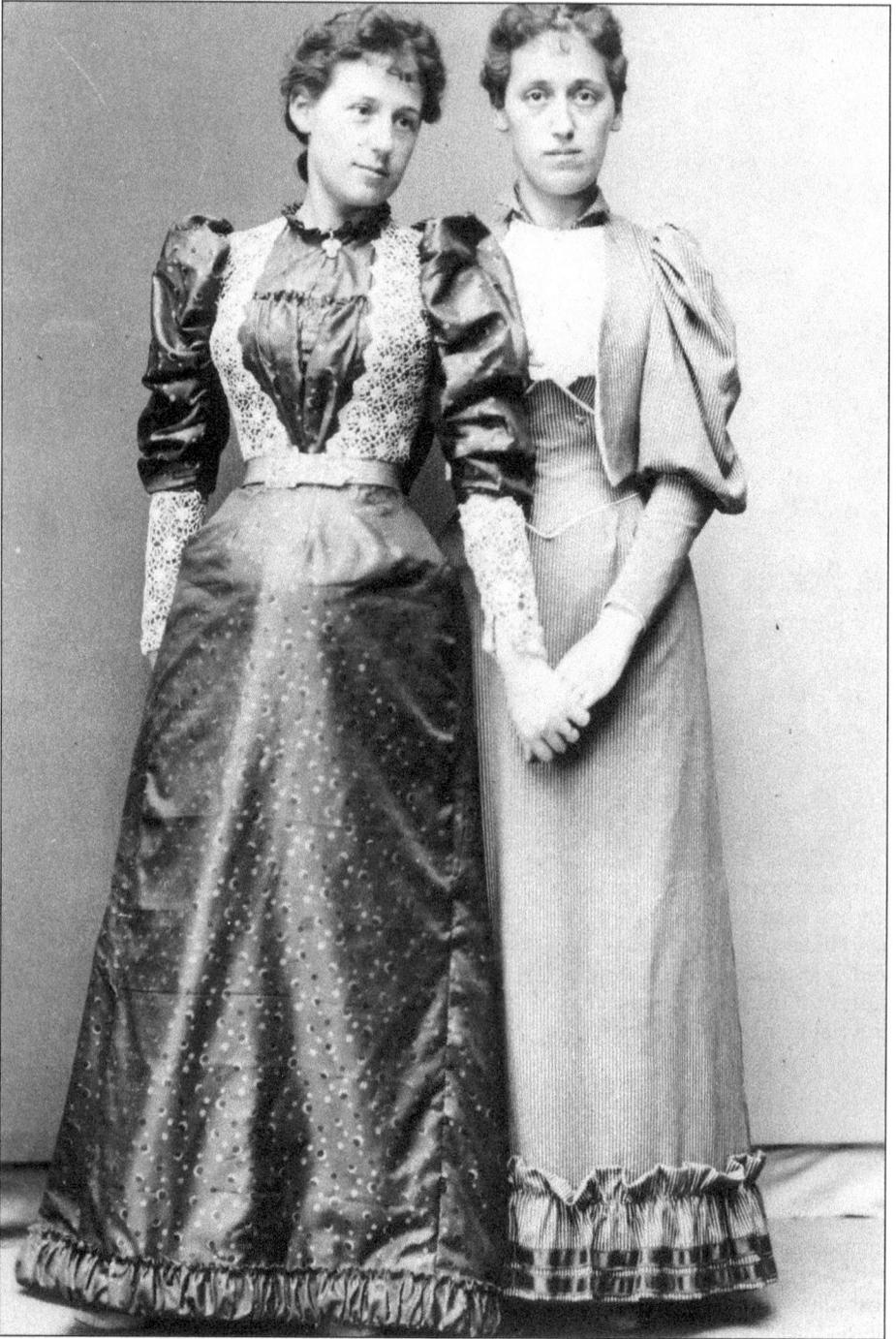

Seen here are Hannah N. Grunsfeld and Miriam Grunsfeld (right), wives of New Mexico businessmen, posing for a photograph about 1900. Miriam Grunsfeld served as president of Ladies Hebrew Benevolent Aid Society, a predecessor of the Congregation Albert Sisterhood. Hannah, Ivan Grunsfeld's wife, was German-born, a relative to Julius Rosenwald, a founder of Sears, Roebuck and Company. The families traveled a great deal back and forth to Europe before World War I. (Courtesy of the University of New Mexico Center for Southwest Research.)

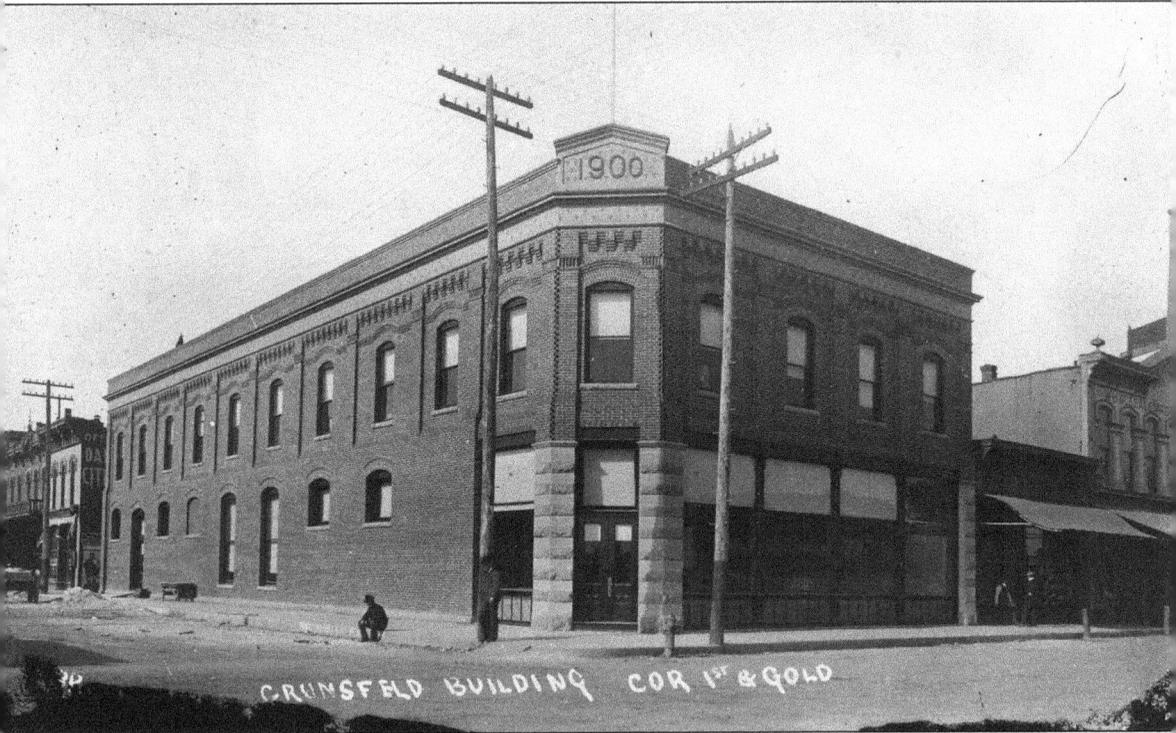

The Grunsfeld brothers advertised their business as "importers and jobbers." In 1900, the Grunsfelds built this modern building at the corner of First Street and Gold Avenue. (Courtesy of the Albuquerque Museum.)

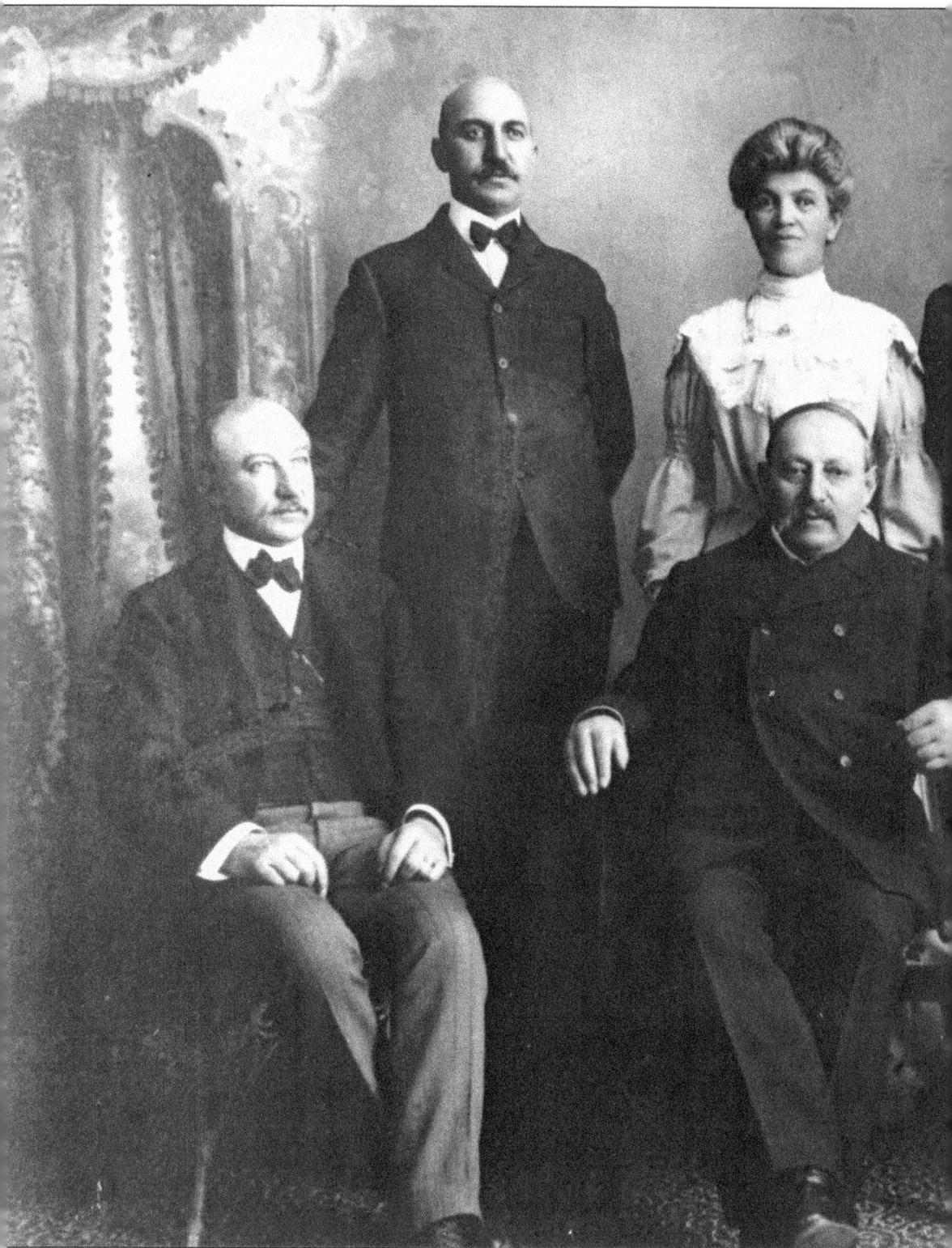

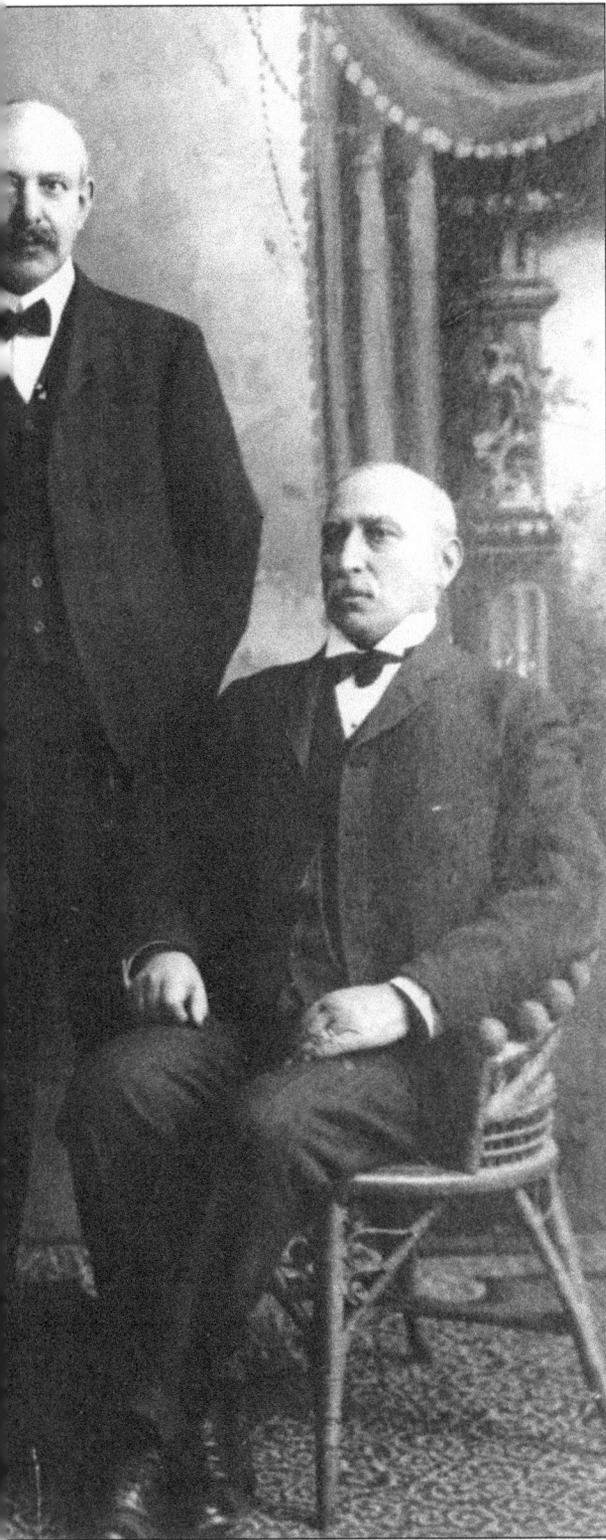

The Ilfeld family is, from left to right, (first row) Noah, Wilhelm, and Charles; (second row) Louis, Johanna, and Herman. Charles, known to locals as Tio Carlos (Uncle Charlie), was the founder of the most successful enterprise in New Mexico, headquartered in Las Vegas, New Mexico. Ilfeld, along with his brother-in-law Max Nordhaus, operated retail and wholesale operations in addition to their work in the sheep and wool business. The Charles Ilfeld Company moved its headquarters to Albuquerque, replicating its Las Vegas building and motto "wholesalers of everything." (Courtesy of the University of New Mexico Center for Southwest Research.)

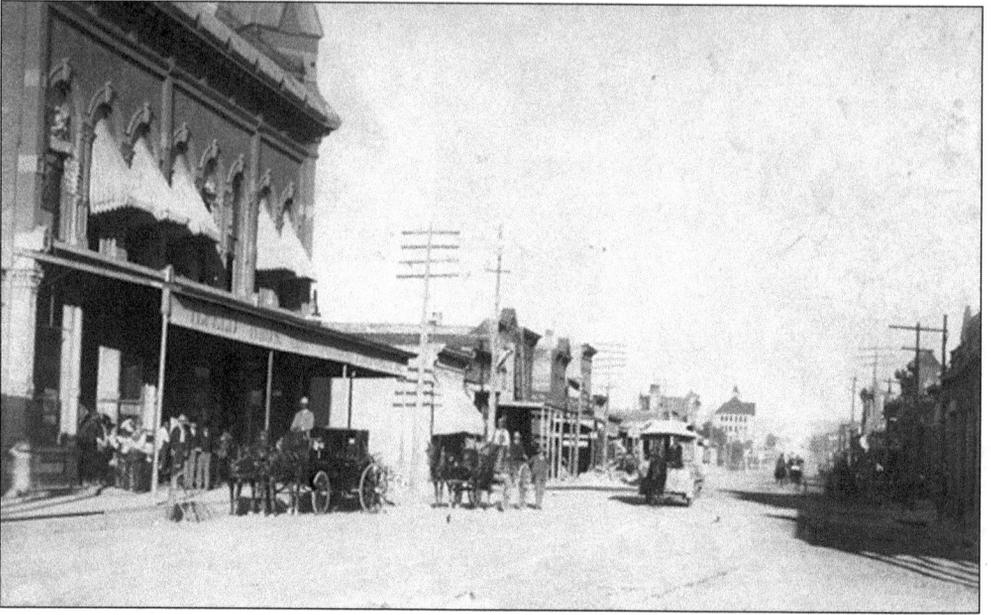

Above is the Ilfeld Brothers dry goods store in Albuquerque (on the left) at Third Street and Railroad Avenue (later named Central Avenue) in 1896. Louis and Noah Ilfeld ran the enterprise. A horse-drawn trolley is seen in the background. (Courtesy of the Albuquerque Museum.)

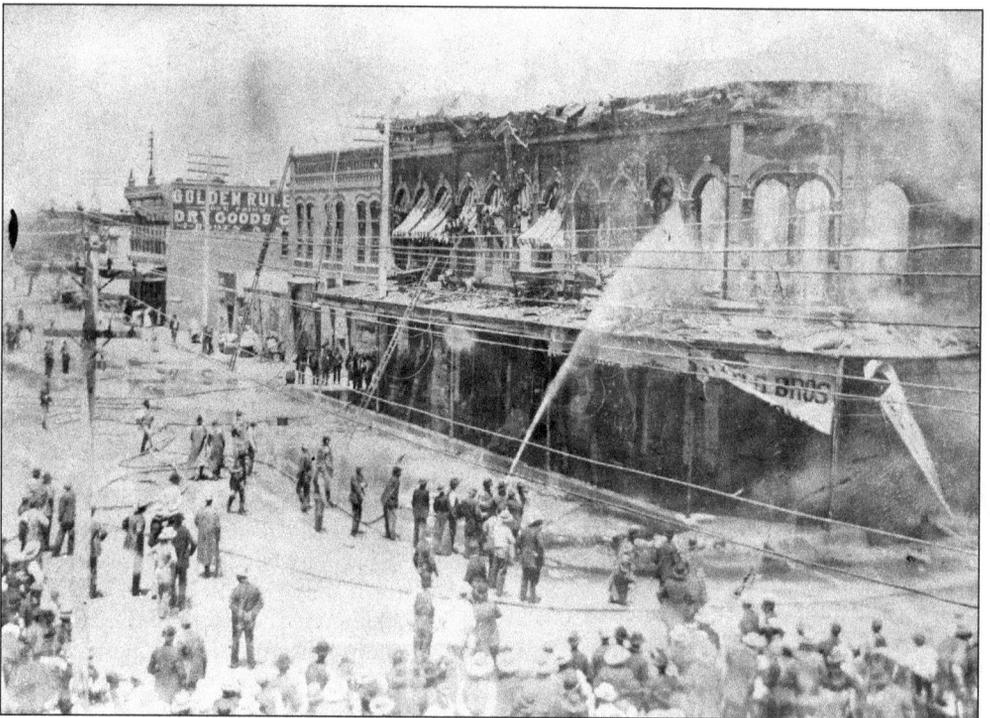

Fire was an enemy of the early Albuquerque merchants. This 1898 view shows a fire engulfing the building housing the Ilfeld Company at Third Street and Railroad Avenue. Another Jewish-owned business, the Golden Rule, is visible in the background. (Courtesy of the University of New Mexico Center for Southwest Research.)

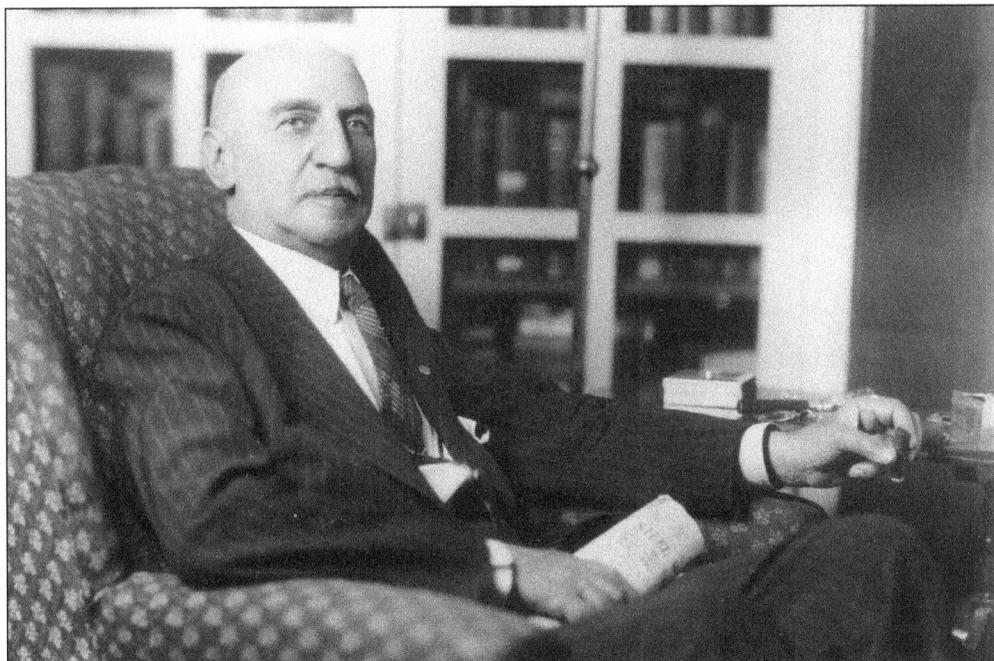

Above is Louis Ilfeld, a brother of pioneer merchant Charles Ilfeld. Ilfeld was civic minded, helping found the Jewish War Relief in Albuquerque in 1917 and serving as president of Albuquerque's Congregation Albert in 1921. (Courtesy of the University of New Mexico Center for Southwest Research.)

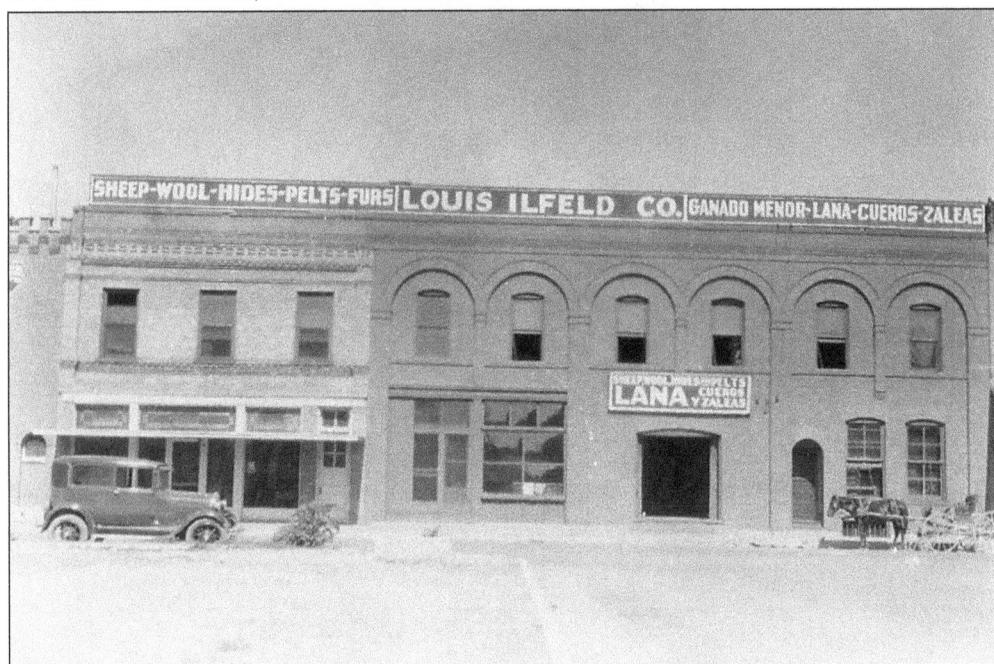

Louis Ilfeld's warehouse, as seen above, displayed signs in English and in Spanish. Most of the early immigrant families spoke not only German and English but Spanish and a smattering of native dialects as well. (Courtesy of the Albuquerque Museum.)

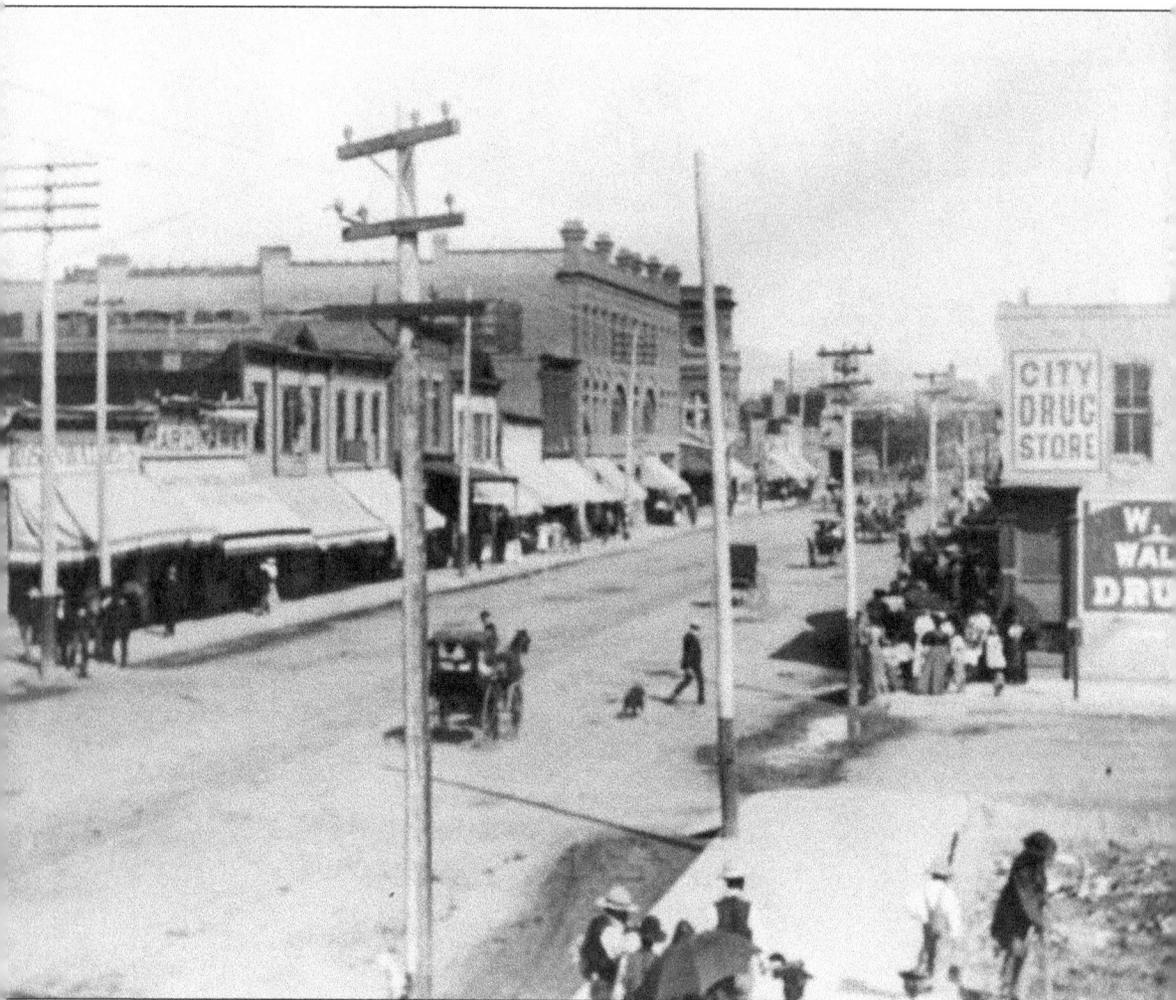

This street scene at Third and Railroad Avenues shows the Rosenwald store on the left in 1897. (Courtesy of the University of New Mexico Center for Southwest Research.)

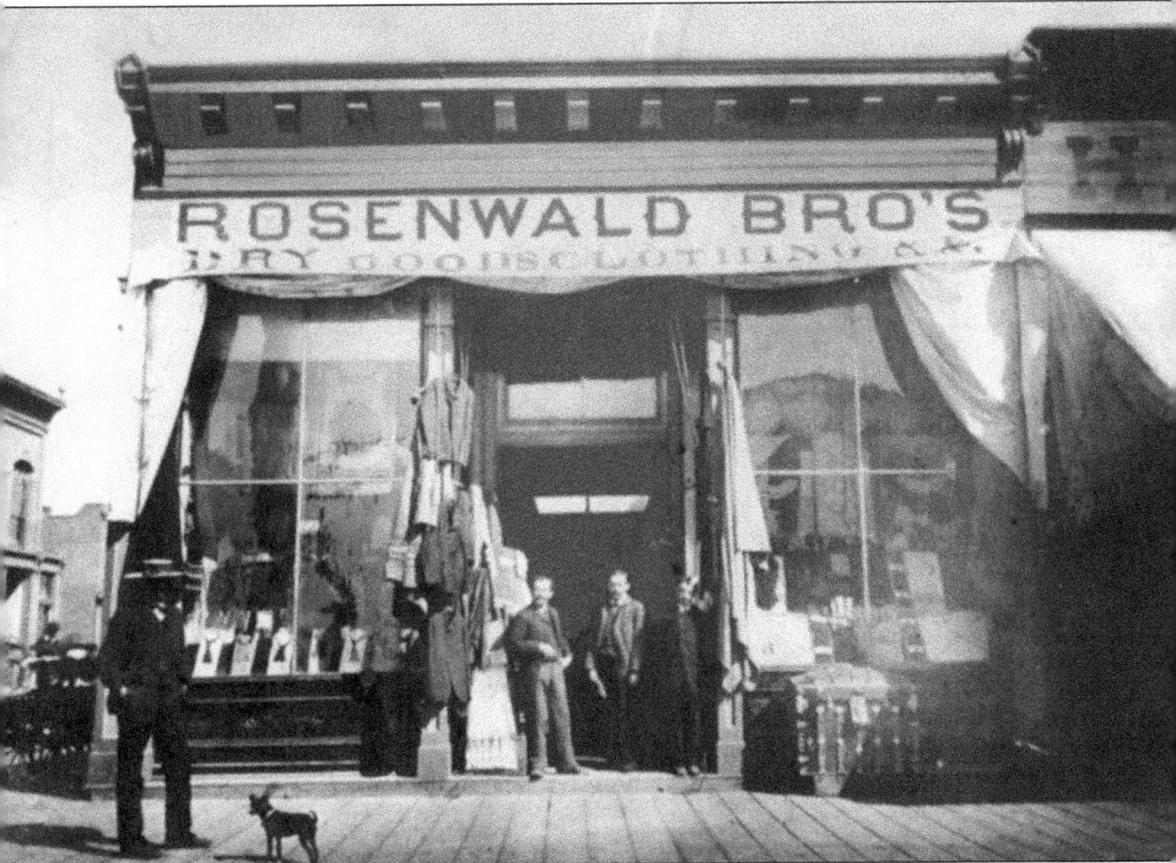

The Rosenwald brothers, Aaron and Edward, came to New Mexico from Bavaria. They operated Rosenwald Brothers Dry Goods and Clothing on Central Avenue, shown here in 1905. Two other brothers, Emanuel and Joseph, ran a separate business in Las Vegas, New Mexico. (Courtesy of the Albuquerque Museum.)

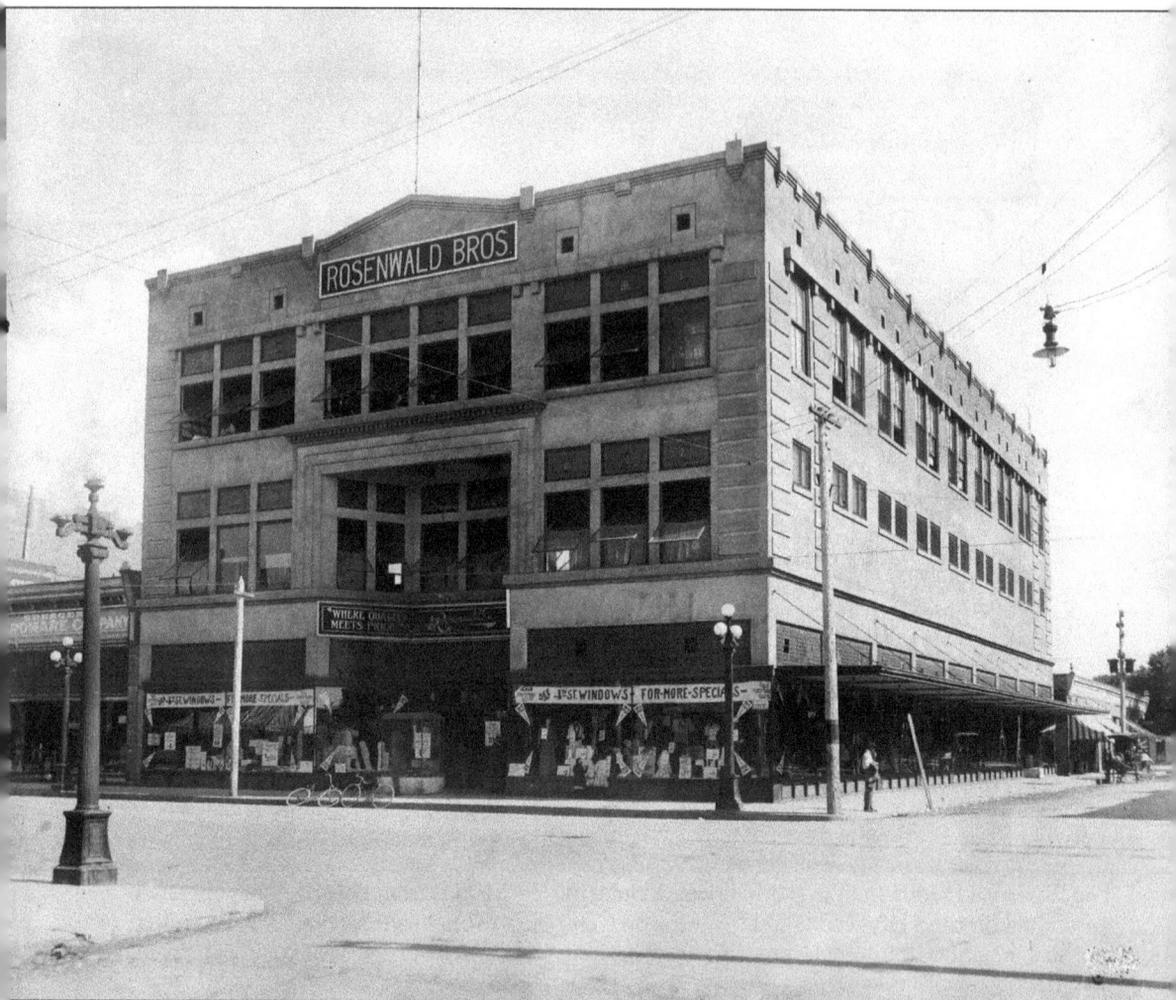

The Rosenwald brothers expanded their shop and erected Albuquerque's first department store in 1910. According to reporters at the *Albuquerque Morning Journal* of that year, "With the opening of the Rosenwald Brothers' store, at the corner of Fourth Street and Central Avenue yesterday afternoon, Albuquerque gained the distinction of having within its boundaries the handsomest, most up-to-date, and most complete department store in the southwest." The building, located at 320 West Central Avenue, still stands and has served as a bank and office building. (Courtesy of the Albuquerque Museum.)

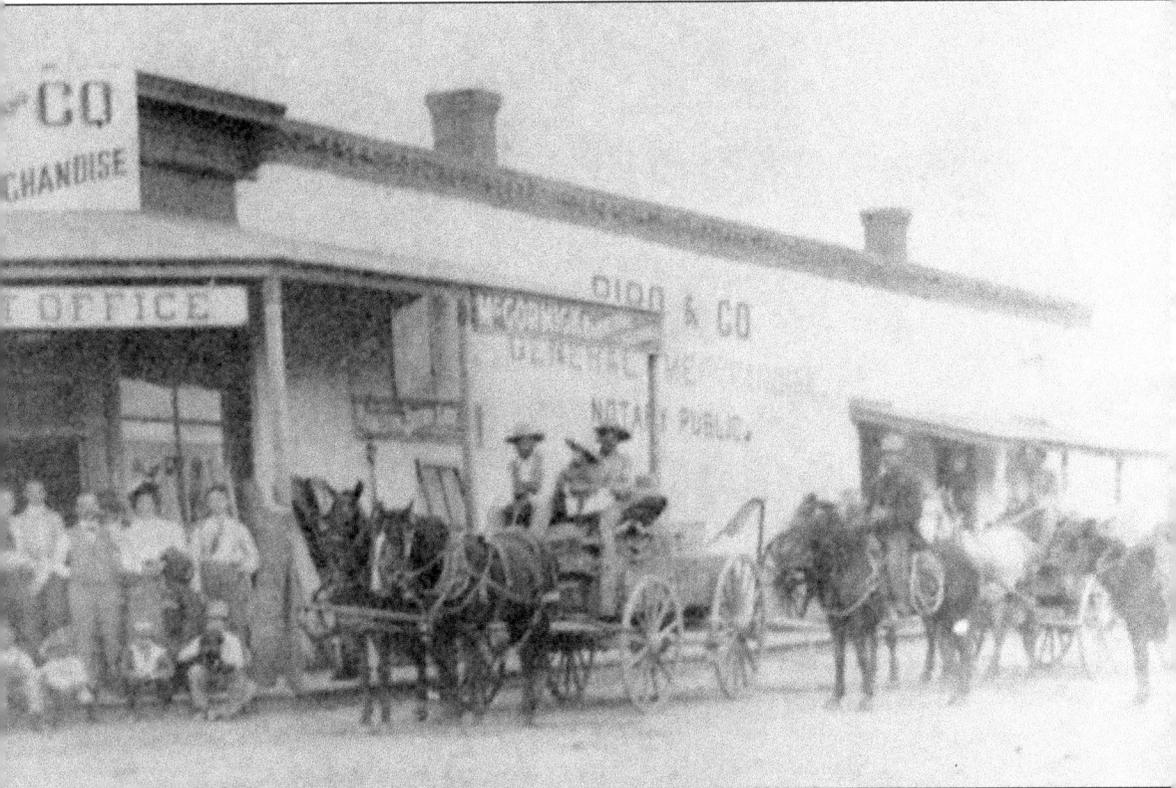

Above is Nathan Bibo's store in Bernalillo, 15 miles north of Albuquerque, in 1903. Nathan Bibo (1844–1927) came to the territory to work for the Spiegelberg brothers in Santa Fe, followed by his nine siblings. According to the Sandoval County Historical Society, in 1873, Bibo opened Bibo Mercantile at the urging of his friend Fransisco Perea. Anticipating the arrival of the railway in Bernalillo, a disappointed Bibo left the business after railway executives chose Albuquerque as their hub. He later returned to Bernalillo after the San Fransisco earthquake of 1906. Brother Joseph Bibo appears in the bow tie, with his wife by his side. (Courtesy of the Sandoval County Historical Society.)

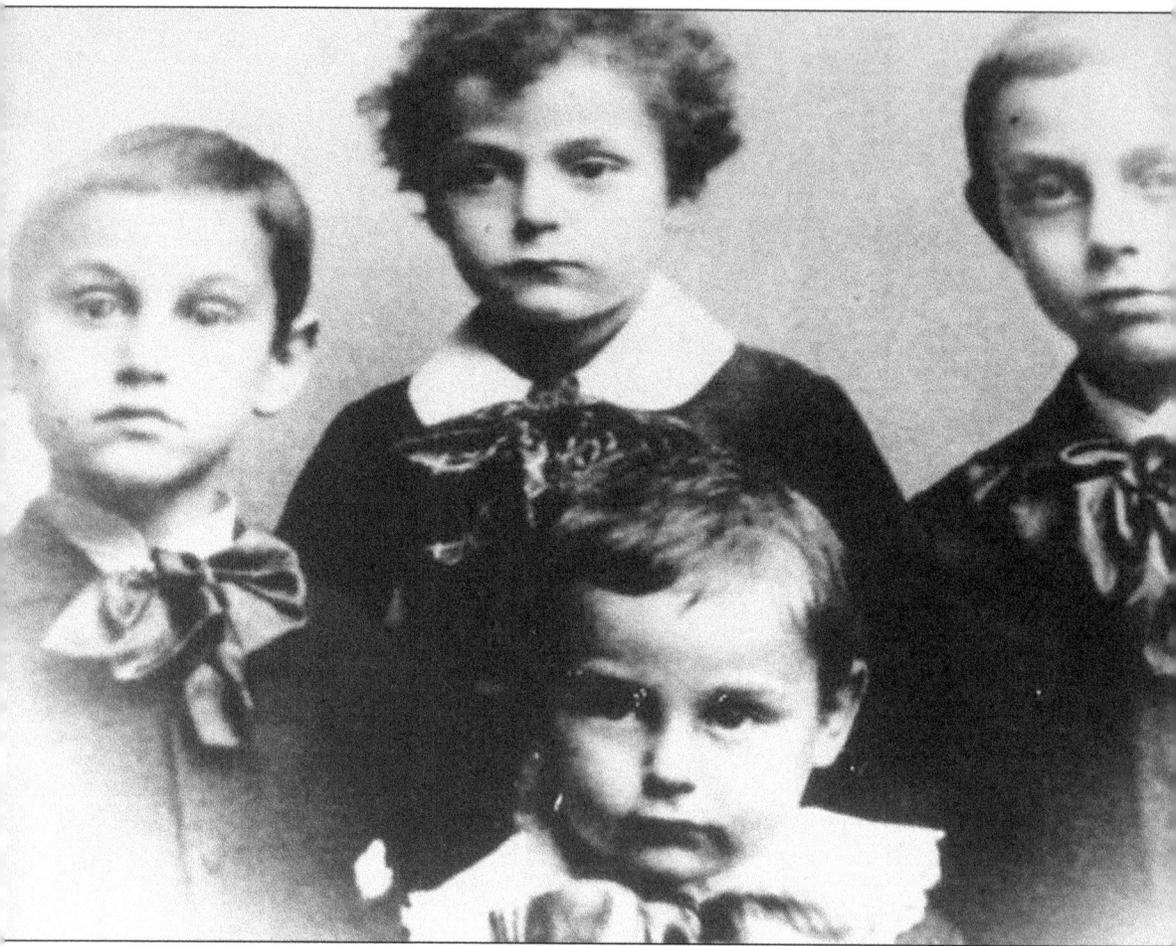

Five Seligman siblings, relatives of the Bibos, came to Bernalillo from Germany. Four are pictured here. They worked in the Bibo Mercantile, later buying it out and renaming it Bernalillo Mercantile Company, locally referred as the "Merc," in 1903. While they lived outside of Albuquerque, the Seligmans were extremely involved in Albuquerque's Jewish life, particularly Congregation Albert. From left to right are Leopold, Julius, and Siegfried Seligman; Ernest is in front. Carl Seligman is not pictured. Three Seligman siblings married three Block sisters, daughters of Henry Block. (Courtesy of the Sandoval County Historic Society.)

Above is the business office of the Bernalillo Mercantile Company, with Milton (left) and Siegfried Seligman (right). The business has been in the same location since 1919, employing hundreds of locals. Siegfried Seligman ran the mercantile business, while Julius was in charge of the jewelry business. The Seligmans spoke Spanish fluently. (Courtesy of the Sandoval County Historical Society.)

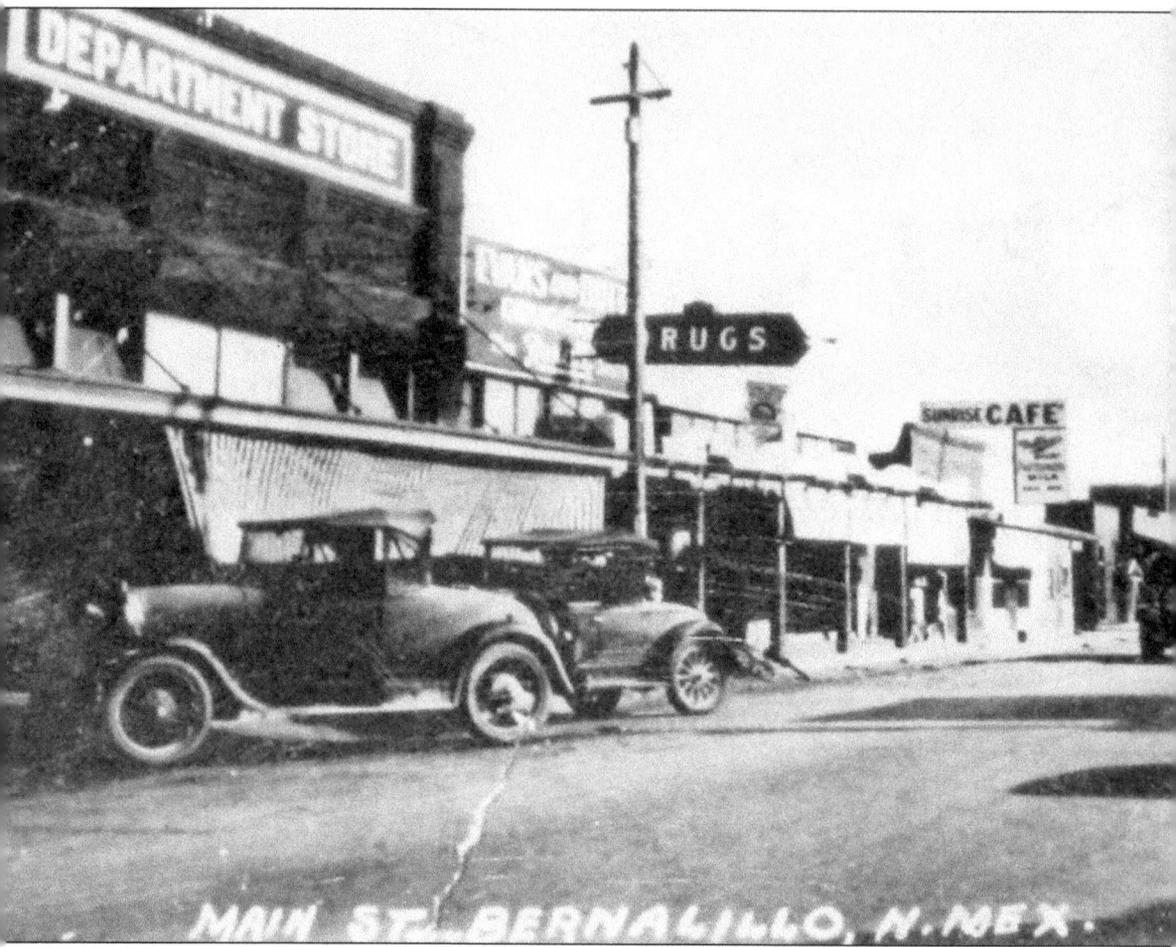

The Bernalillo Mercantile, or "Merc," served the residents of the region's pueblo communities, in addition to purchasing Native American goods and selling them to eastern markets. (Courtesy of the Sandoval County Historical Society.)

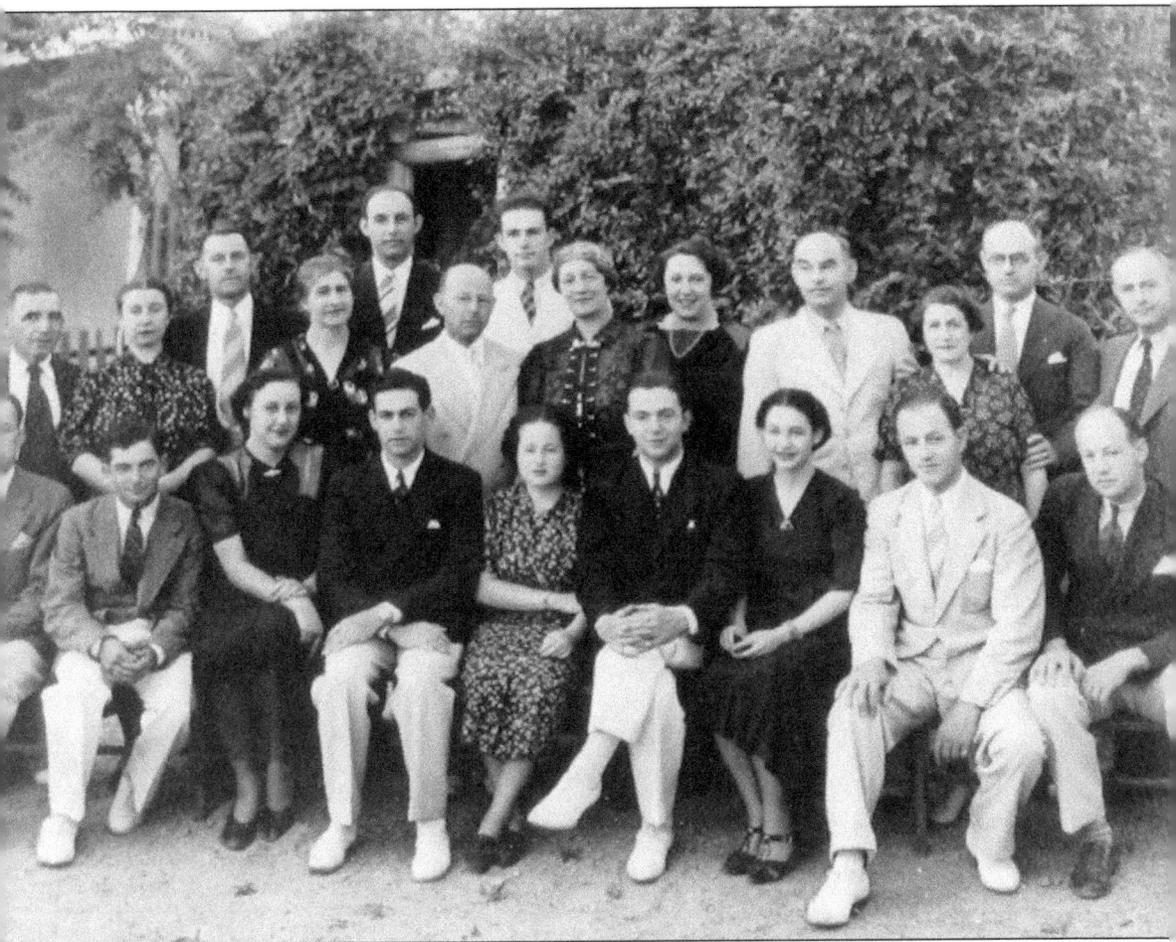

This Seligman family portrait was taken around 1937. Pictured are, from left to right, (first row) Irving Seligman, Larry Rhee, Ruth Seligman, Milton Seligman, Wanda Seligman, Henry Rhee, Anita Rhee, Thornton Seligman, and Randolph Seligman; (second row) Morris Rhee, Elsa Seligman Rhee, Siegfried Seligman, Meta Seligman, Harold Seligman, Julius Seligman, Jack Seligman, Blanche Seligman, Hanni Seligman, Leopold Seligman, Lucille Seligman, Carl Seligman, and Ernest Seligman. (Courtesy of the Sandoval County Historical Society.)

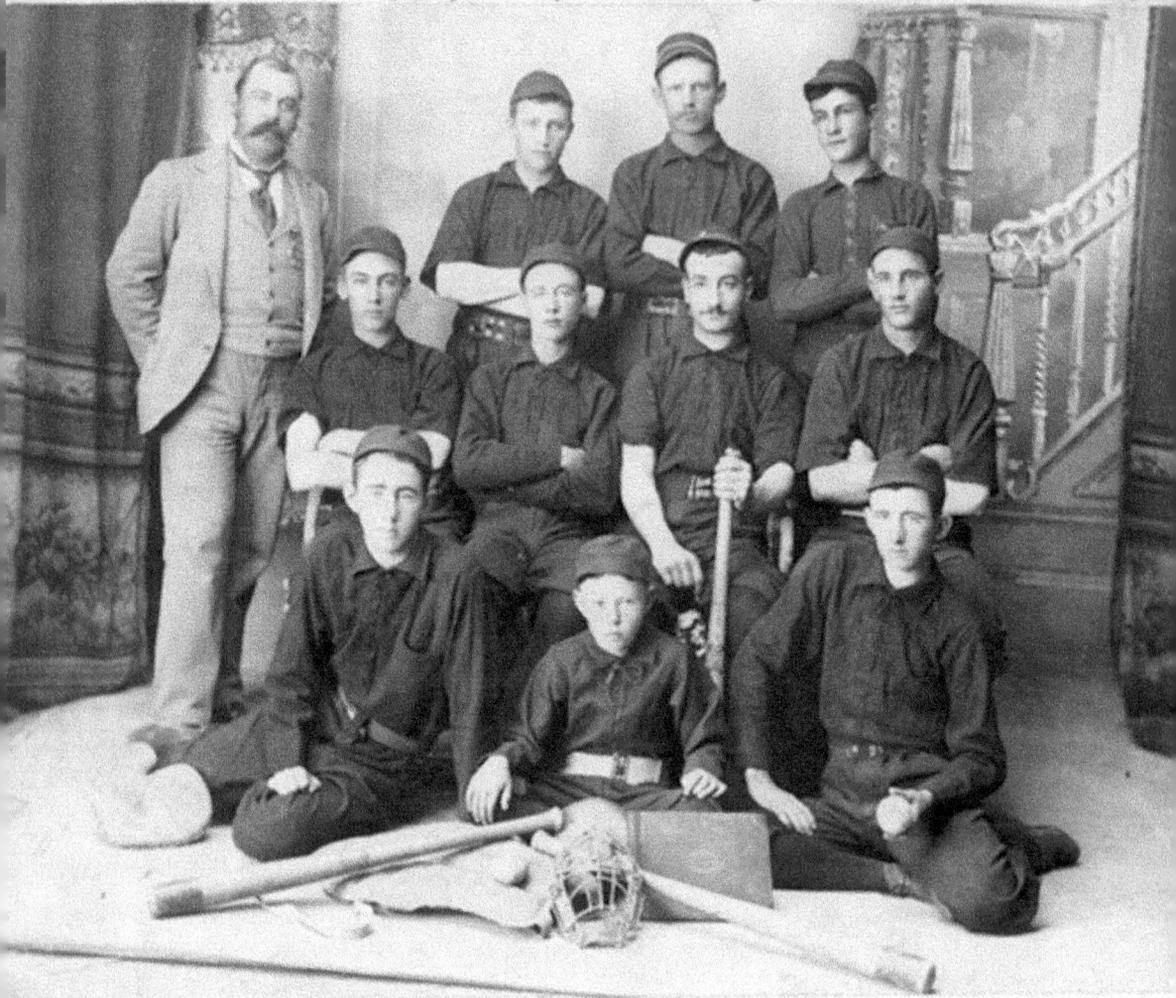

Albuquerque Browns Base Ball Club.

Champions, 1894—Winners of Tournament.

W. T. McCREIGHT, Manager. CHAS. QUIER, Left Field. W. K. WOODMANSEE, Capt. & C. F. ANTONIO ORTIZ, Right Field.
HARRY McCUE, First Base. BERT. VORHES, Second Base. L. D. MANDELL, Third Base. FRED. RAYMER, Short Stop.
ROY McDONALD, Catcher. JOHN JACOBY, Mascot. CHAS. McDONALD, Pitcher.

The extended Mandell family consisted of cousins from Alsace-Lorraine who settled in the southwest. L. D. Mandell was a third baseman with the league champion Albuquerque Browns baseball team in 1894. (Courtesy of the University of New Mexico Center for Southwest Research.)

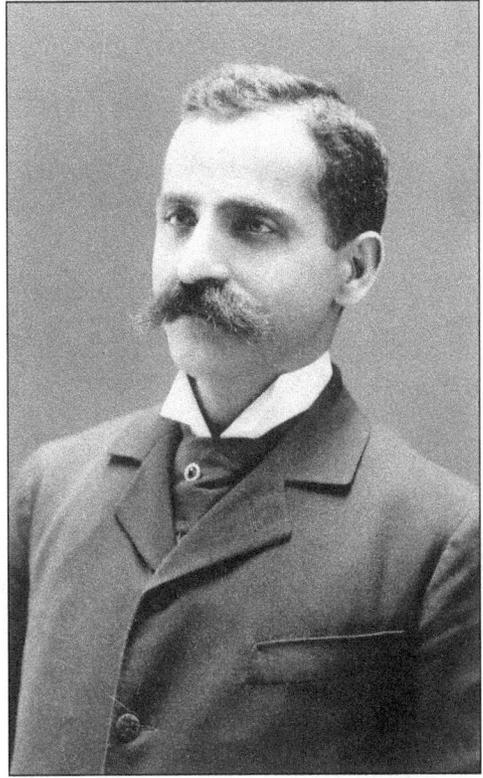

Mike Mandell, photographed at right in 1890, was a merchant and the second mayor of Albuquerque. Mandell and his wife, Marie, a second cousin, came to Albuquerque by train two weeks after their marriage in New York City in 1887. Mandell immigrated to the United States from Alsace-Lorraine with his wife's parents at age 15. Mandell later served as the treasurer for Bernalillo County. Below is an image of his wife, Marie Mandell. (Both, courtesy of the University of New Mexico Center for Southwest Research.)

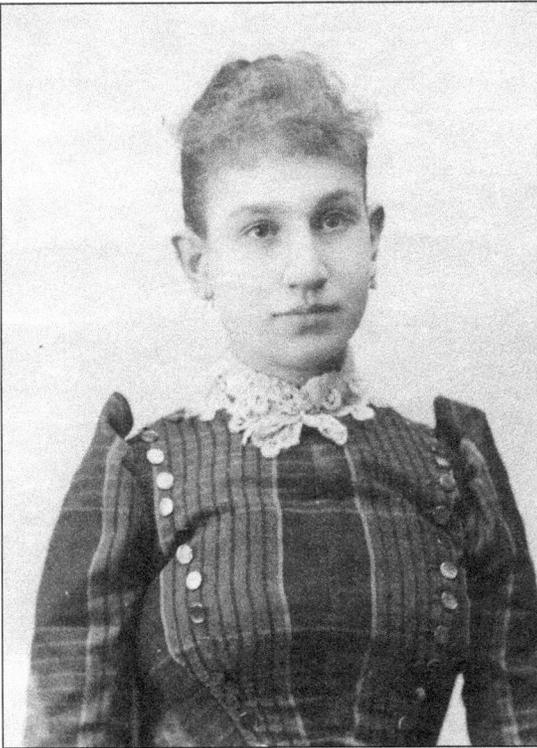

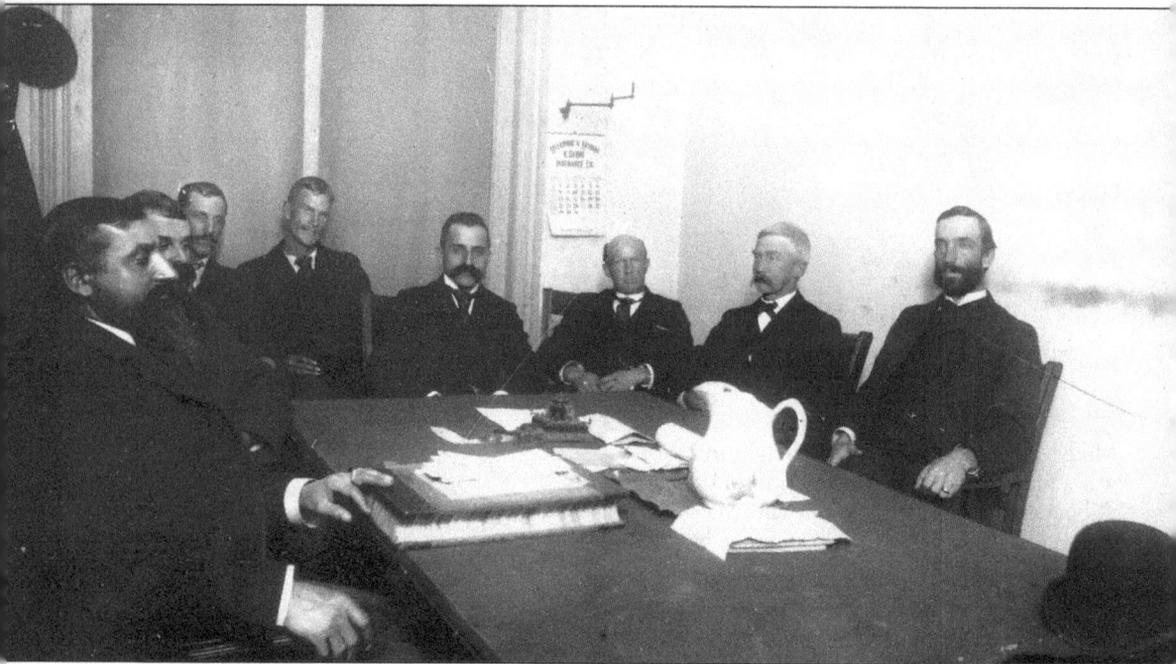

During his tenure as mayor in 1890, Mike Mandell meets with a group of Albuquerque business leaders. (Courtesy of the University of New Mexico Center for Southwest Research.)

Above is Gladys Mandell, a daughter of Mike and Marie Mandell, at about age 15 in 1908 or 1909. Gladys was born and raised in Albuquerque, frequently socializing with the children of other Jewish families including the Grunsfelds, Jaffas, Staabs, and Rosenwalds. Unlike some of the other daughters of New Mexico Jewish families such as the Staabs and Grunsfelds, Gladys Mandell was not sent away to be educated; she attended Albuquerque schools. Mandell married Harold Epstein and helped run the Children's Shoppe in Albuquerque for eight years. The family moved to San Francisco in 1932 when the shop went out of business. (Courtesy of the University of New Mexico Center for Southwest Research.)

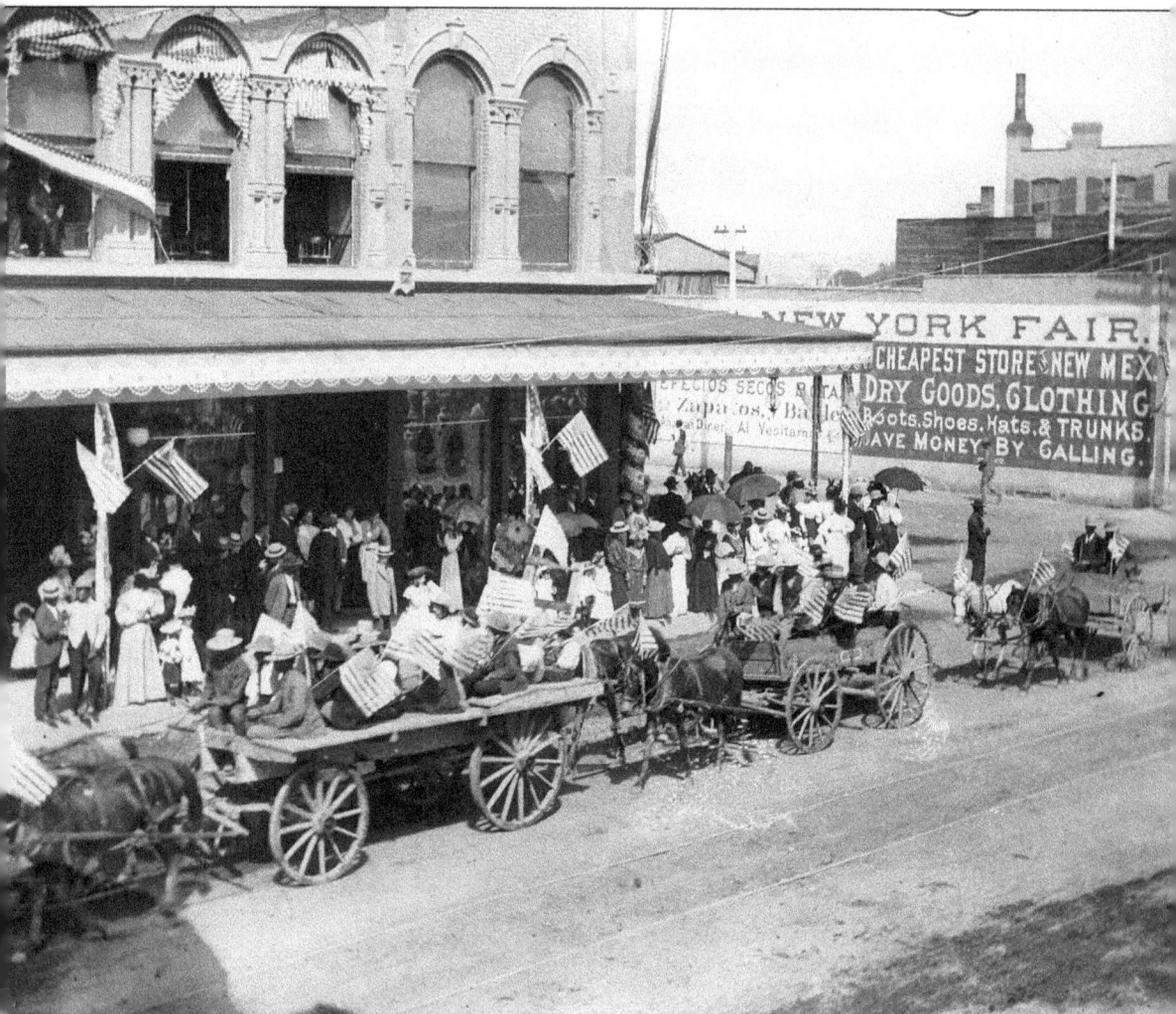

The Territorial Fair Parade in Albuquerque passes by the New York Fair store in the Rosenwald Building in 1890. Many of the Jewish Albuquerque merchants (Ernest Meyers, David Weiller, the Mandells, and Lowenthal relatives) opposed New Mexico statehood, going so far as to write a formal protest to the U.S. Senate and House of Representatives in 1889. Noah Ilfeld held the opposing view. (Courtesy of the University of New Mexico Center for Southwest Research.)

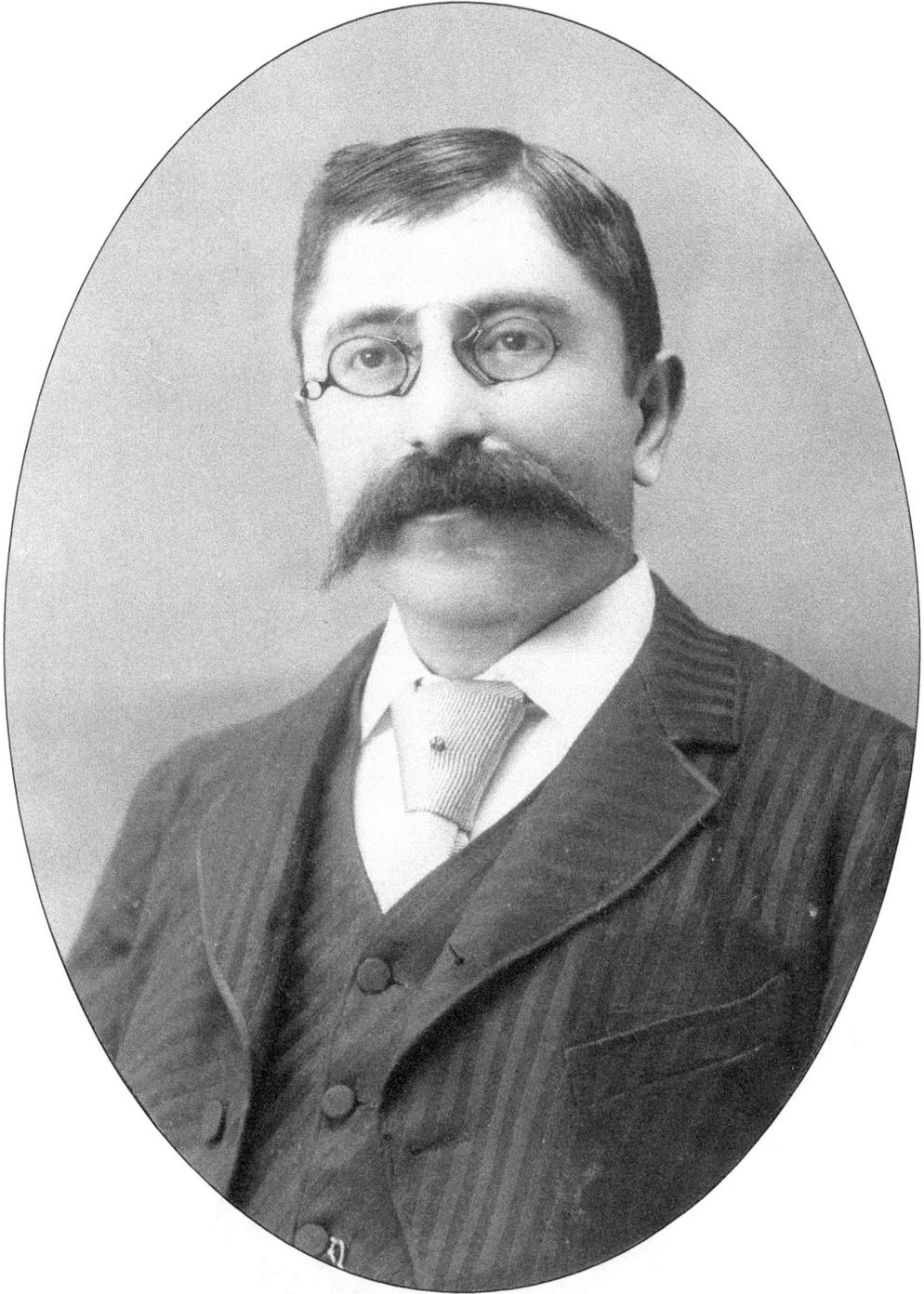

Joseph Goldstein was a salesman at the Golden Rule Bazaar, a dry goods store owned by his brother-in-law Jacob Weinman. (Courtesy of the University of New Mexico Center for Southwest Research.)

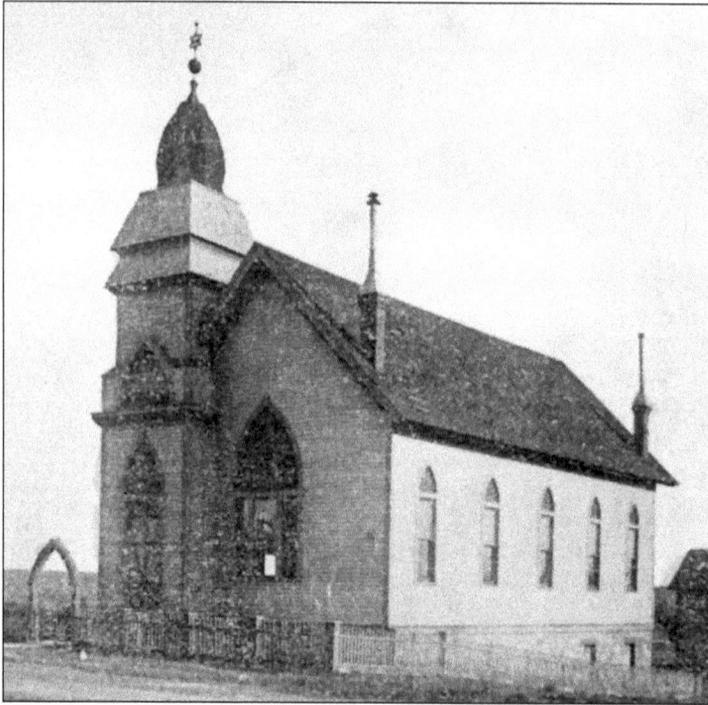

The only New Mexico congregation chartered prior to Congregation Albert was Las Vegas's Congregation Montefiore, established in 1884. Albuquerque weddings were arranged according to the date a visiting rabbi was available; in the 1890s, Rabbi Joseph Glueck of Las Vegas officiated. (Courtesy of the Museum of New Mexico.)

The Albuquerque B'nai B'rith chapter began the process of establishing a burial ground in 1883 but did not formalize the cemetery until nearly a decade later. At right, early mourners, possibly members of the Mandell family, arrive at the B'nai B'rith Jewish Cemetery in Albuquerque. (Courtesy of the Albuquerque Museum.)

Two

LAYING CONGREGATIONAL CORNERSTONES

In 1897, Albuquerque's first Jewish congregation, Congregation Albert, was founded. While B'nai B'rith had met some community needs, including founding a Jewish cemetery (later owned by Congregation Albert), the growing community required a religious institution that focused on worship and life cycle events. The congregation received its distinctive name at auction; for $250, Alfred Grunsfeld named the congregation after his father, Albert.

In 1898, a rabbi, William H. Greenburg of London, was secured. A Moorish-style building was erected on the northeast corner of Seventh Street and Gold Avenue in 1900. The laying of the cornerstone in 1899 was a community event attended by the governor, mayor, and members of the Masonic Grand Lodge of New Mexico. As noted earlier, most of Albuquerque's earliest Jewish residents were German and preferred Reform over a more traditional Jewish religious practice. Early Congregation Albert rabbis wore clerical collars, conducted services in English, and were referred to as ministers of the congregation.

For some of the Jewish newcomers, especially those of Eastern European backgrounds, Congregation Albert did not meet their needs. In 1920, a group of men chartered Congregation B'nai Israel as a traditional/Orthodox house of worship. Initially, the new congregation met in living rooms and shops. In 1937, after a series of fund-raising events, the Ladies Auxiliary secured enough money to buy a parcel of land on the corner of Coal and Cedar Avenues. In 1941, a house of worship was erected.

In the early years, Congregation Albert seemed to have a revolving door of rabbis. Some of the rabbis were more progressive than their congregants, clearly out of sync with the merchant members who paid the bills. In 1948, Rabbi David D. Shor was called to the pulpit at Congregation Albert, where he remained for 30 years, bringing stability and leadership to both the congregation and the community. In 1960, Congregation Albert had about 250 member families and 200 students enrolled in religious school; B'nai Israel had approximately 200 families with 100 religious school students. Family membership dues for each synagogue were $75 annually.

For many years, a rivalry of sorts existed between the congregations, with "intermarriage" jokingly referred to as one between a member of the temple (Congregation Albert) and the shul (B'nai Israel). There were many matters on which the congregations did agree, of course. Both institutions offered religious education for Jewish youth, sustained a chapter of the Jewish student group Hillel at the University of New Mexico, and worked to support Israel.

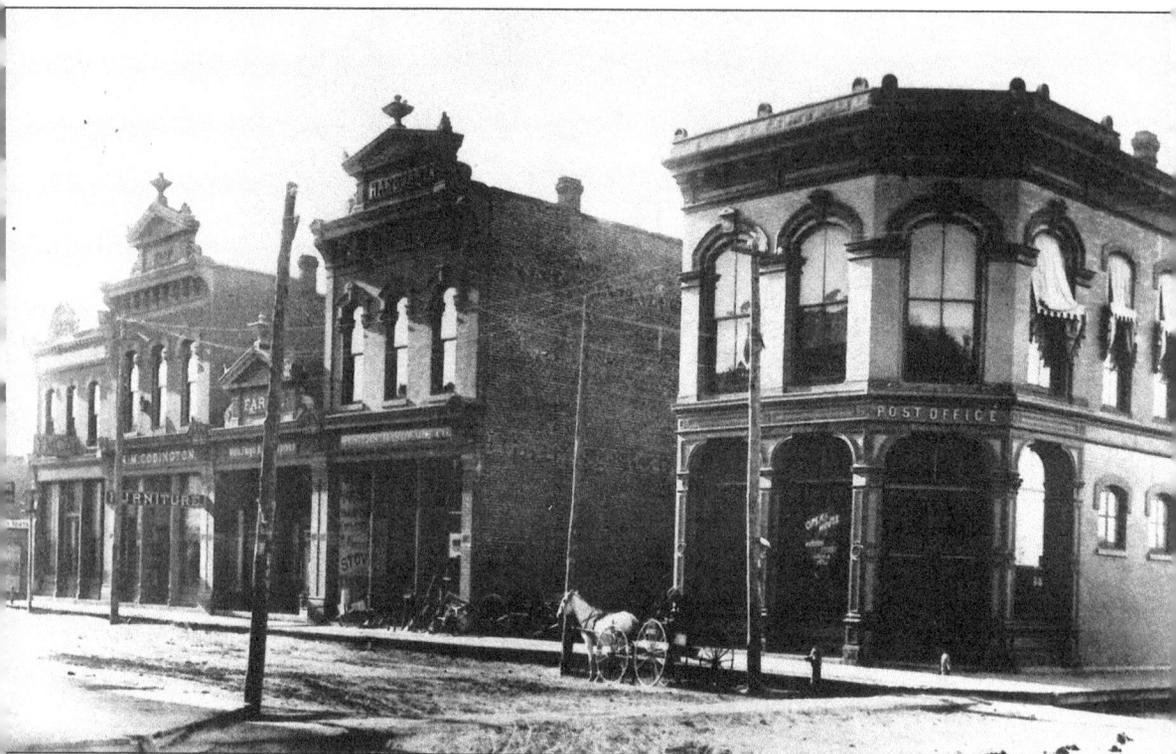

Knights of Pythias Hall, in the 100 block of West Gold Avenue, is where Congregation Albert was chartered and the congregation's first services were held in 1897. Before the organization of the congregation, Henry Jaffa, Albert Grunsfeld, and Berthold Spitz alternately conducted services in their homes. (Courtesy of the Israel C. Carmel Archive at Congregation Albert.)

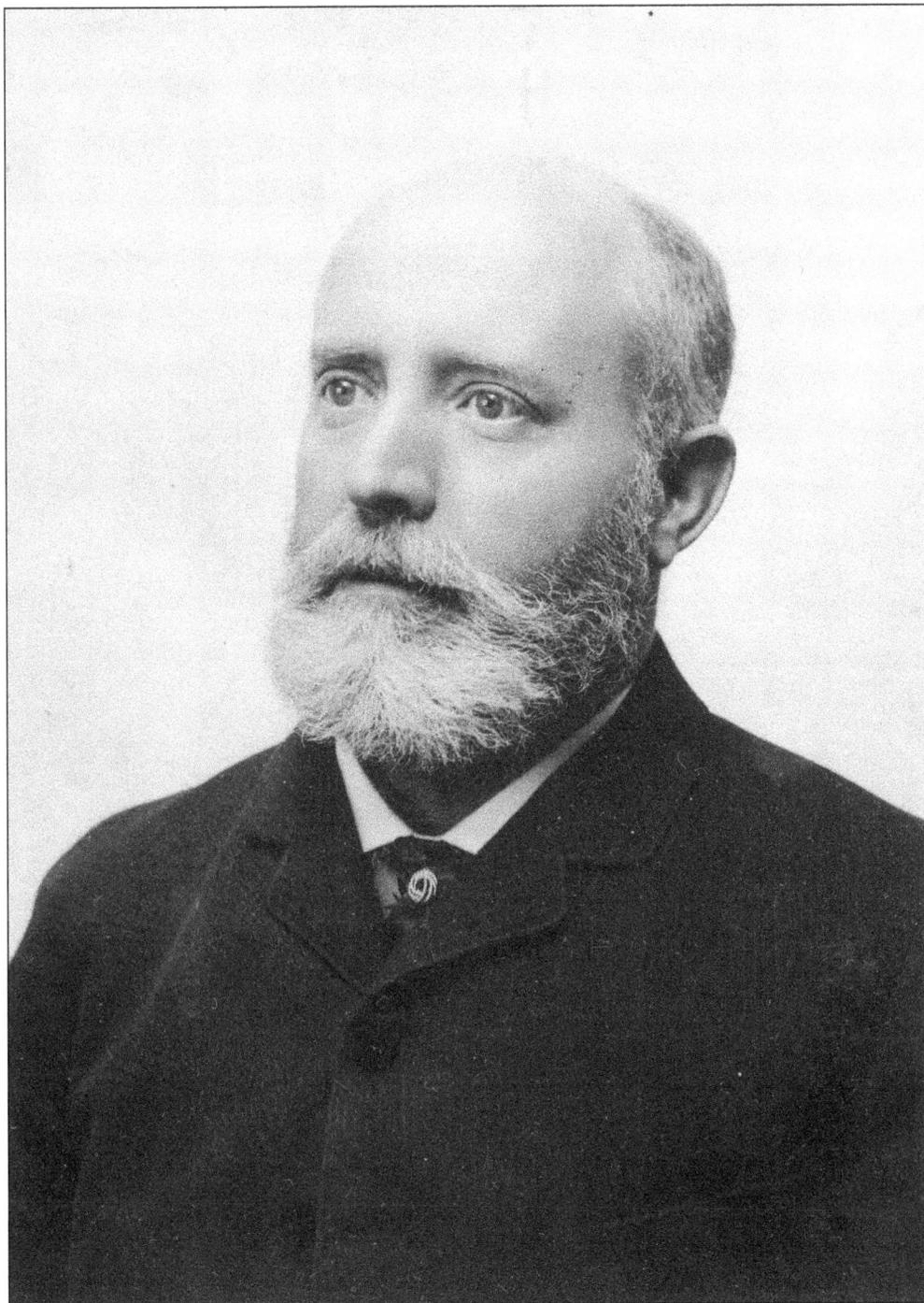

At right in 1890 is merchant Albert Grunsfeld, for whom Congregation Albert was named. Alfred Grunsfeld paid $250 to name the Congregation after his father. (Courtesy of the University of New Mexico Center for Southwest Research.)

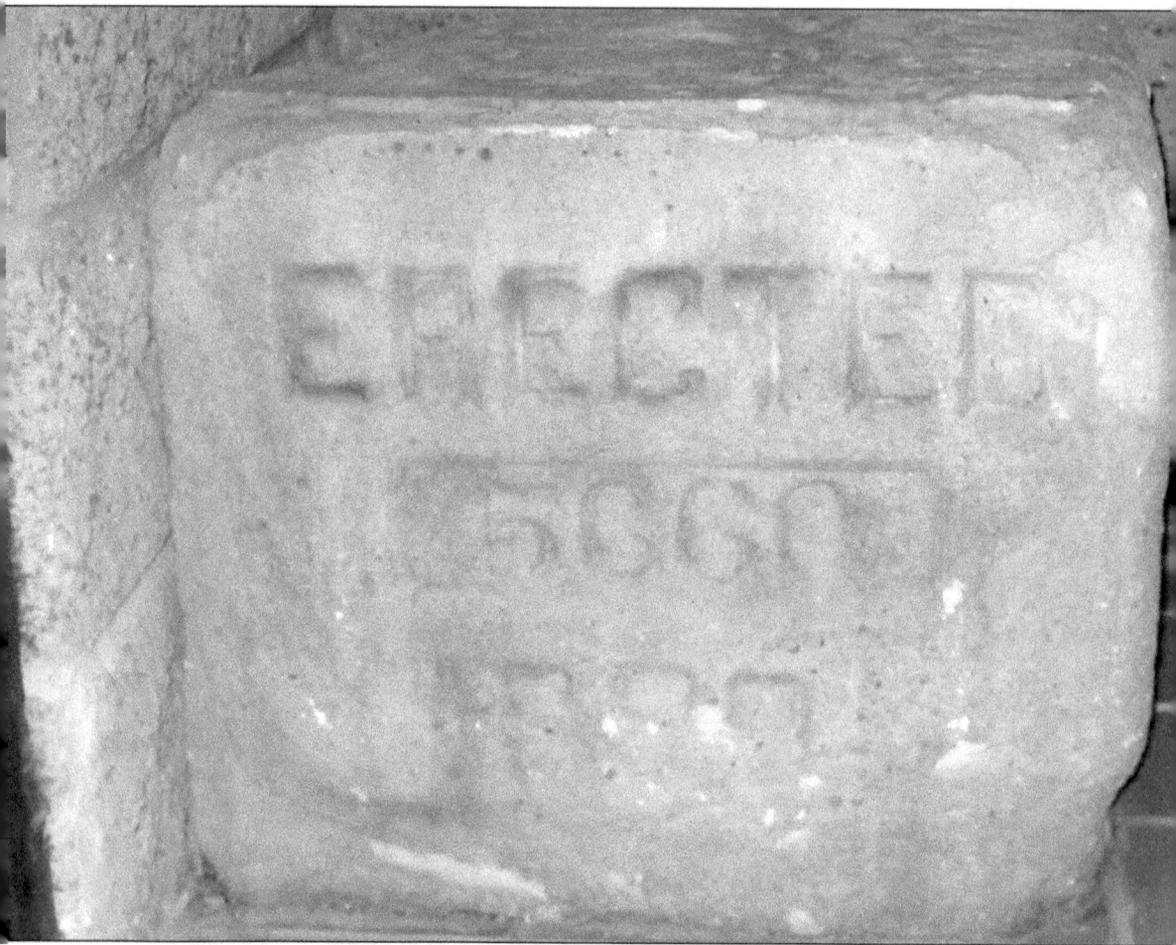

Above is the cornerstone of Congregation Albert. The congregation was the second synagogue established in New Mexico and remains in operation. (Author's Collection.)

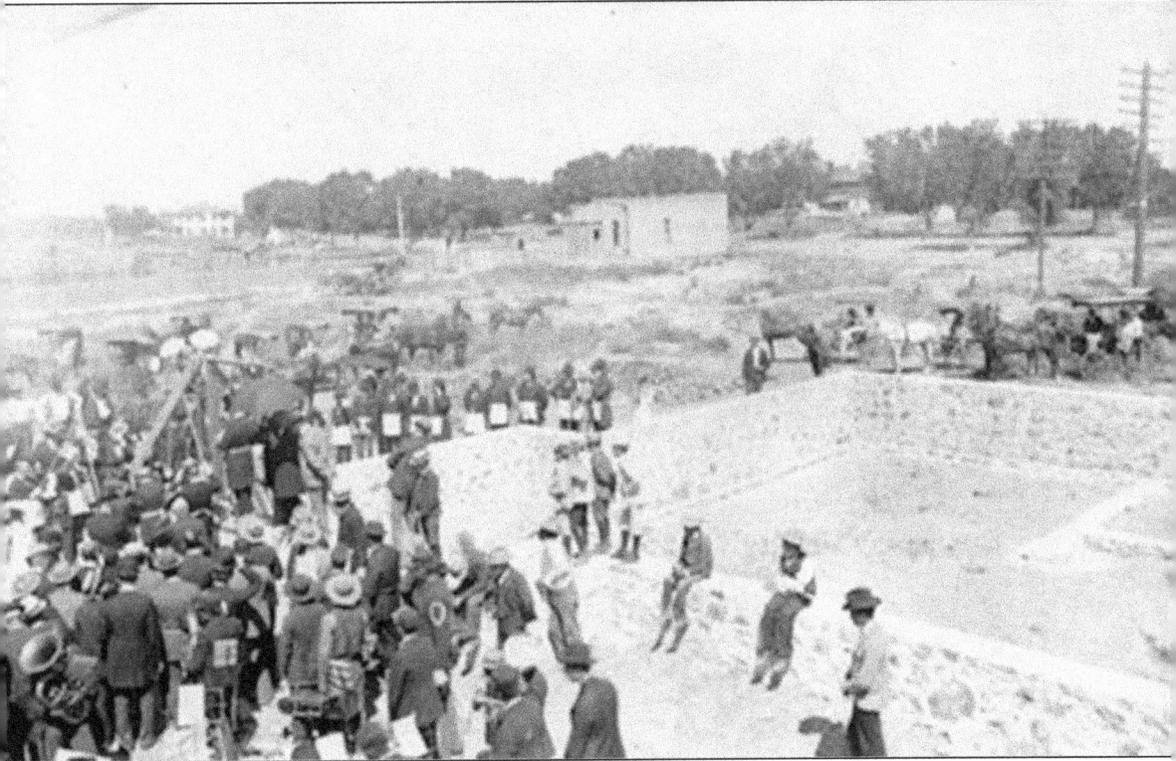

Many people participated in the laying of the cornerstone of Congregation Albert in 1899. It was considered a community event, with the governor, mayor, and other dignitaries in attendance. By 1915, the building was paid off. (Courtesy of the University of New Mexico Center for Southwest Research.)

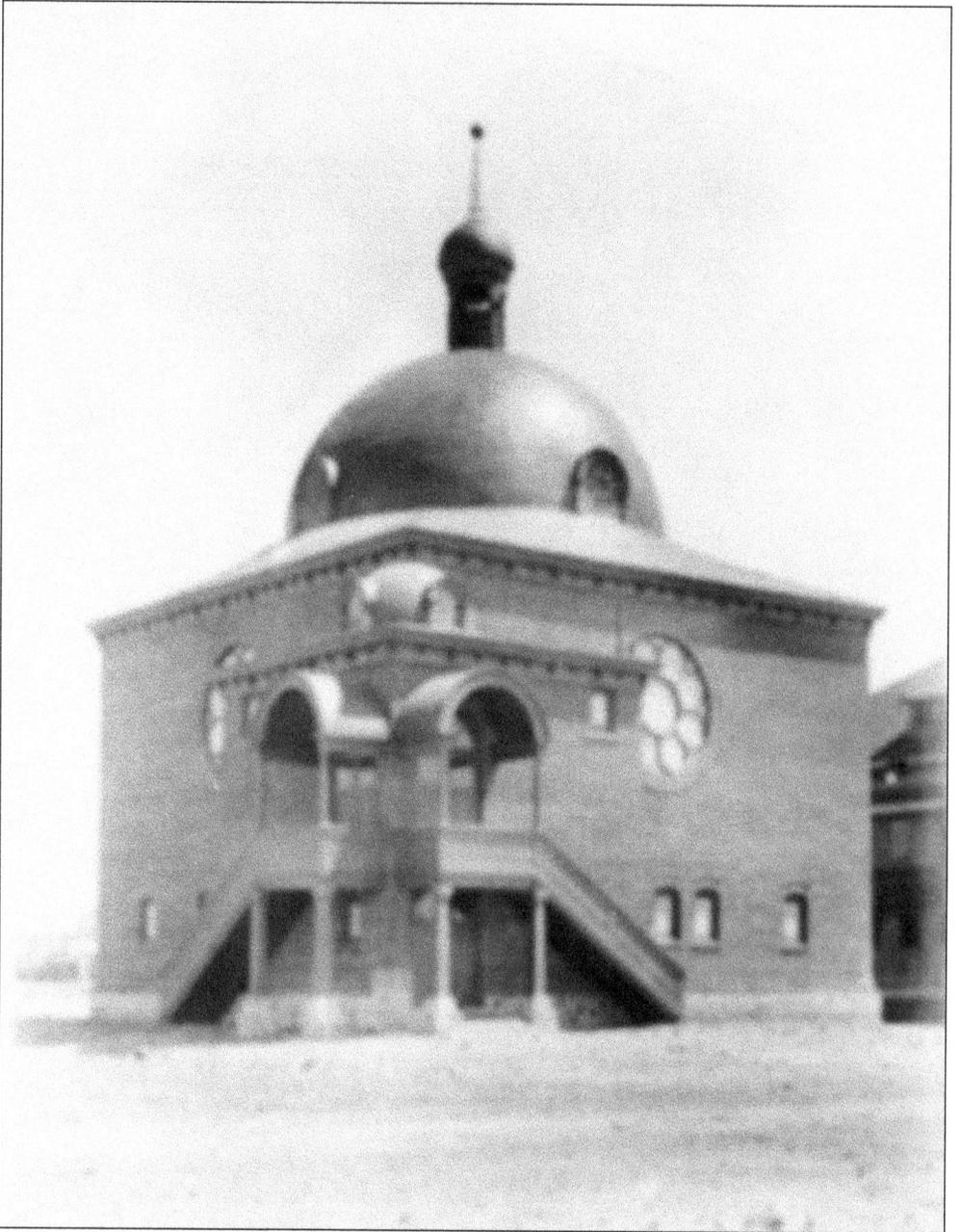

Albuquerque's original Congregation Albert building was at Seventh Street and Gold Avenue. While the Reform congregation was founded in 1897, Albuquerque's Jewish community had already established a B'nai B'rith chapter in 1883. (Courtesy of the University of New Mexico Center for Southwest Research.)

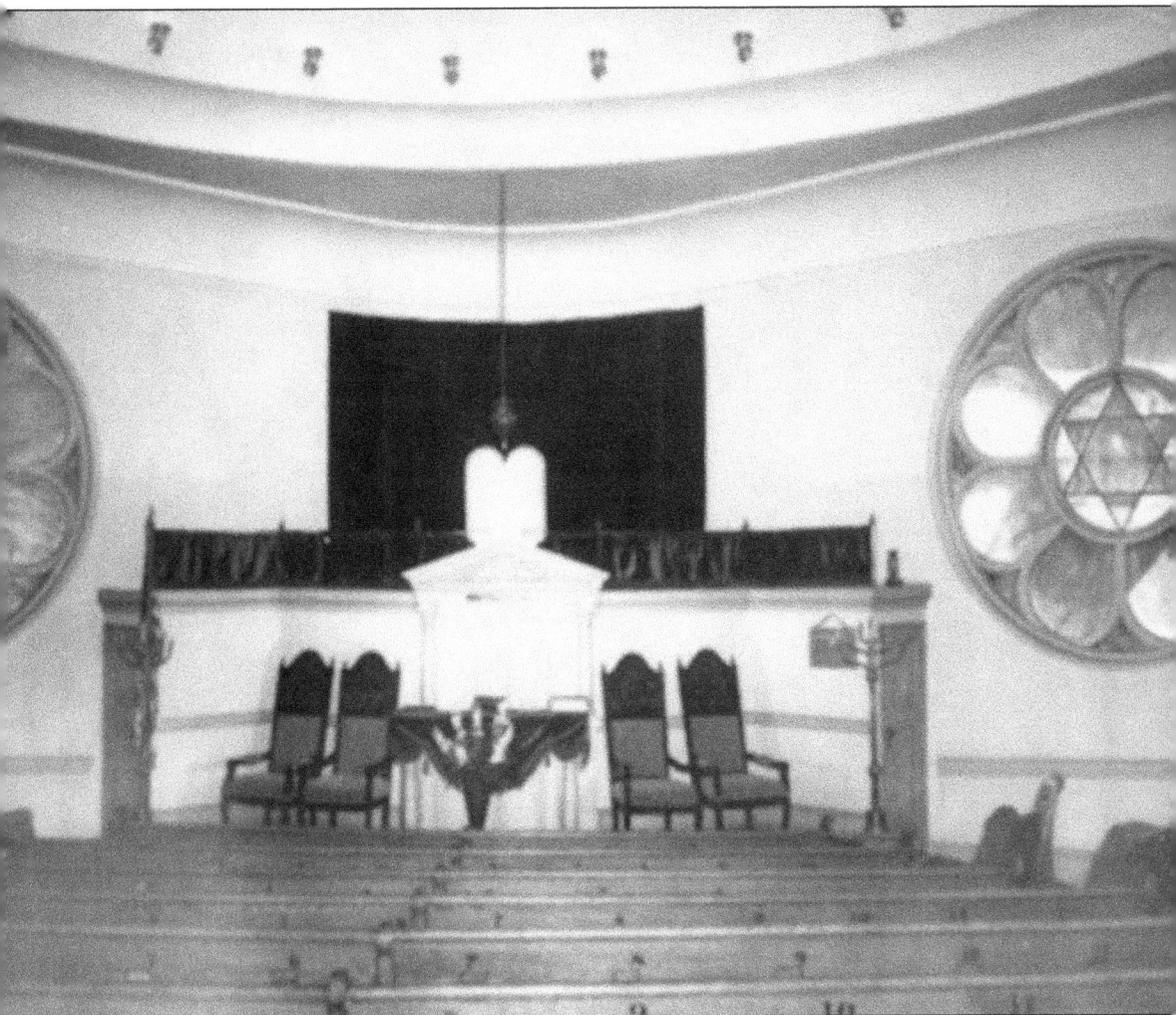

This is a view of the interior of Congregation Albert's original building. The eternal light, still in use, was donated by the Jaffa family. (Courtesy of the Israel C. Carmel Archive at Congregation Albert.)

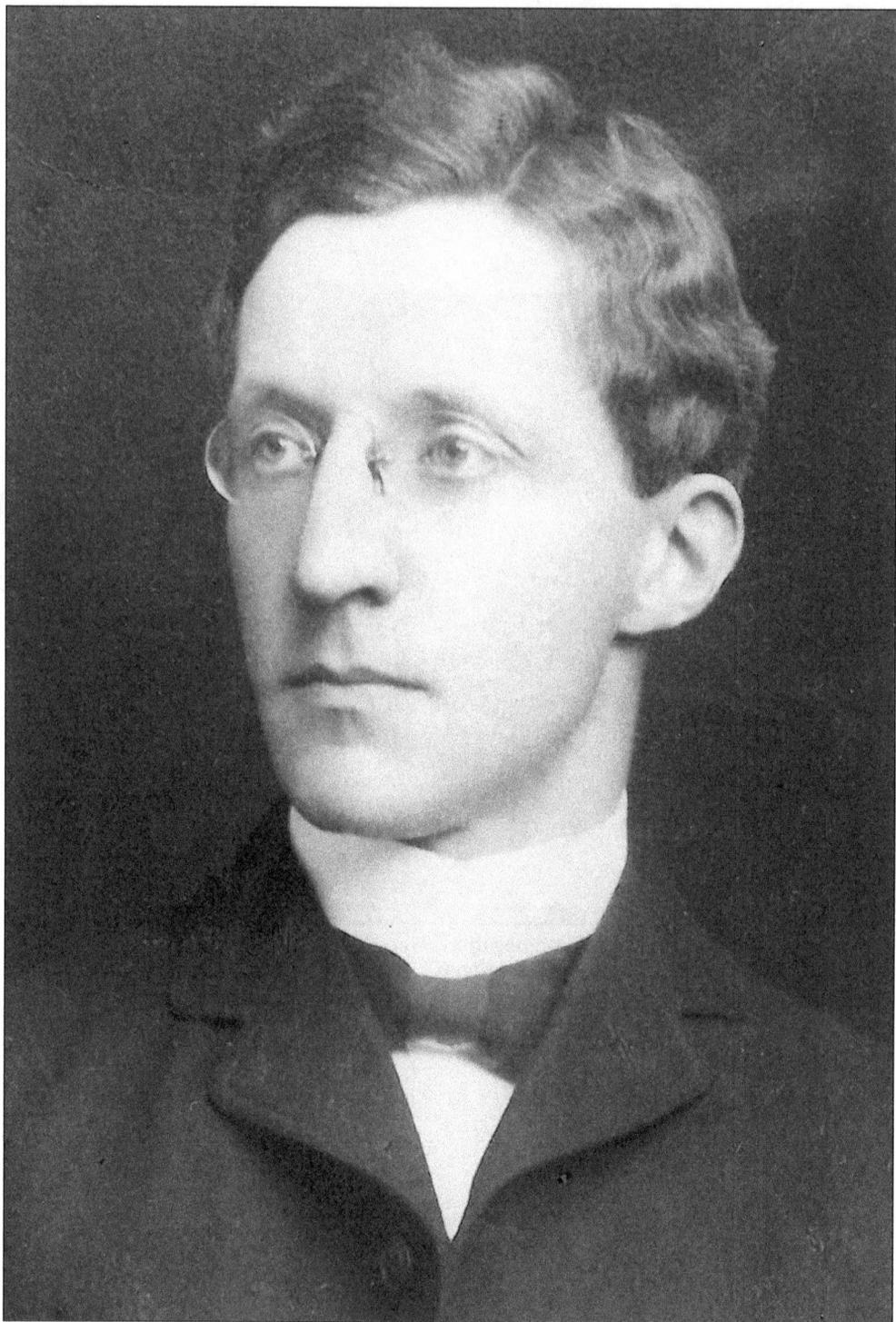

Dr. William H. Greenburg, Congregation Albert's first rabbi, came to the pulpit from London. He served as rabbi from 1898 to 1900. (Courtesy of the Israel C. Carmel Archive at Congregation Albert.)

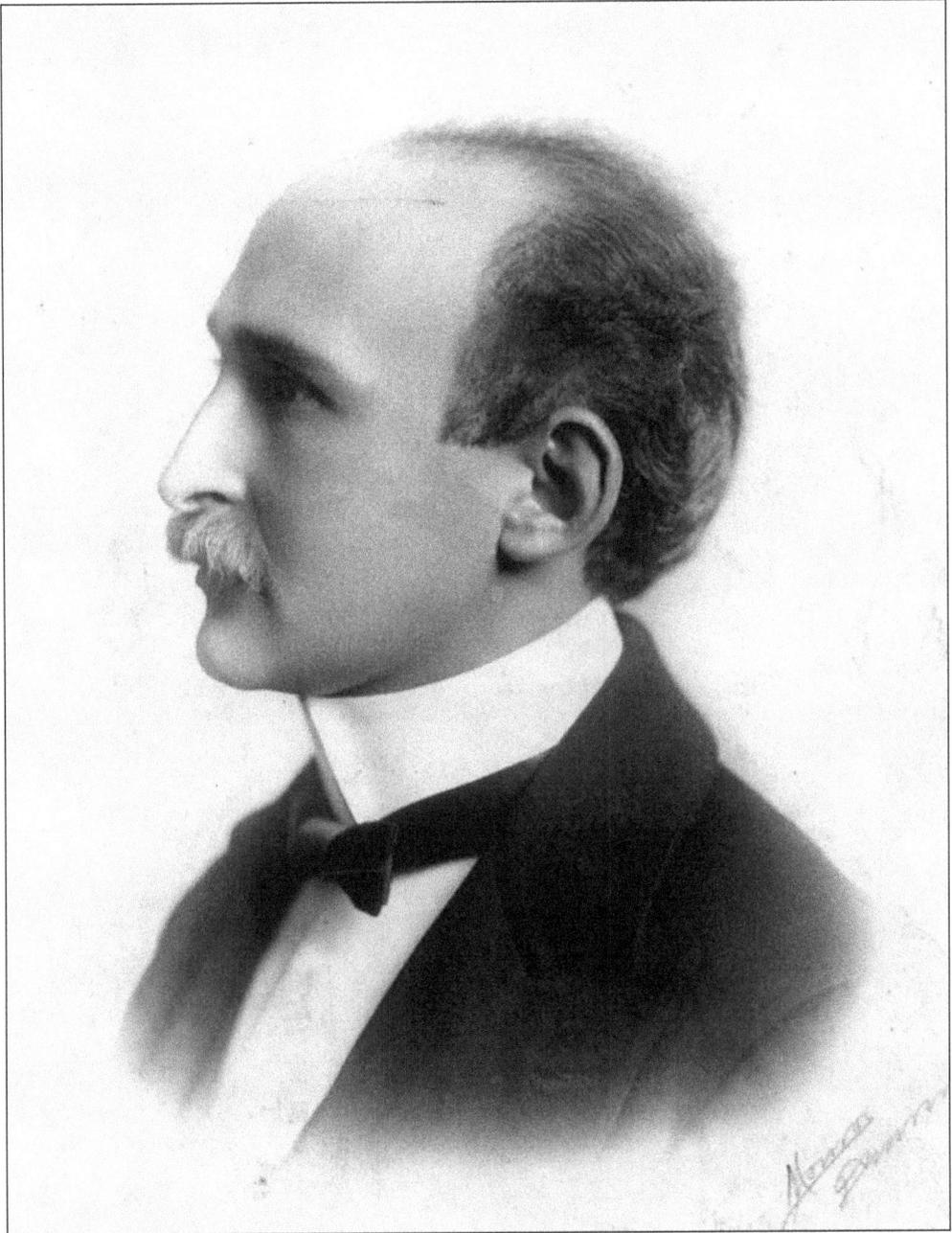

Rabbi Jacob Kaplan was Congregation Albert's spiritual leader from 1902 to 1907. An activist, Kaplan published a bulletin in conjunction with a Christian counterpart entitled *The Barbarian*. He also dispatched congregants throughout the territory to raise money for Russian Jewish relief. (Courtesy of the Israel C. Carmel Archive at Congregation Albert.)

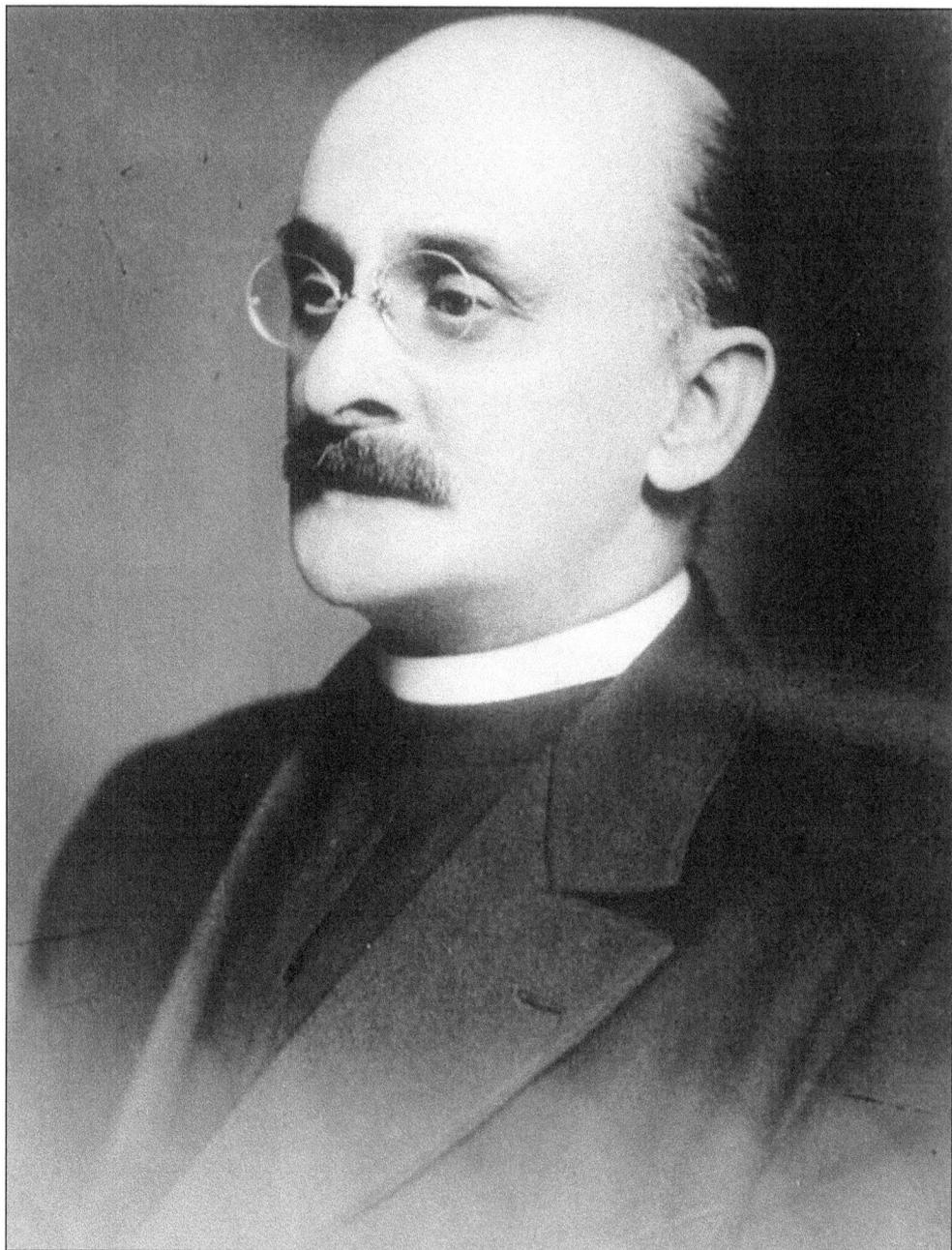

Rabbi Edward Chapman was on the pulpit for three years, from 1907 to 1910 (note his clerical collar, a practice common in Reform synagogues of the time), followed for a short time by Rabbi Mendel Silber. Rabbi Moise Bergman, a beloved community leader, served the congregation from 1914 to 1922 and led the ecumenical Albuquerque Board of Charities. During the influenza epidemic of 1918, Bergman cared for patients and advocated for Albuquerque quarantine over the objections of some of his merchant congregants. (Courtesy of the Israel C. Carmel Archive at Congregation Albert.)

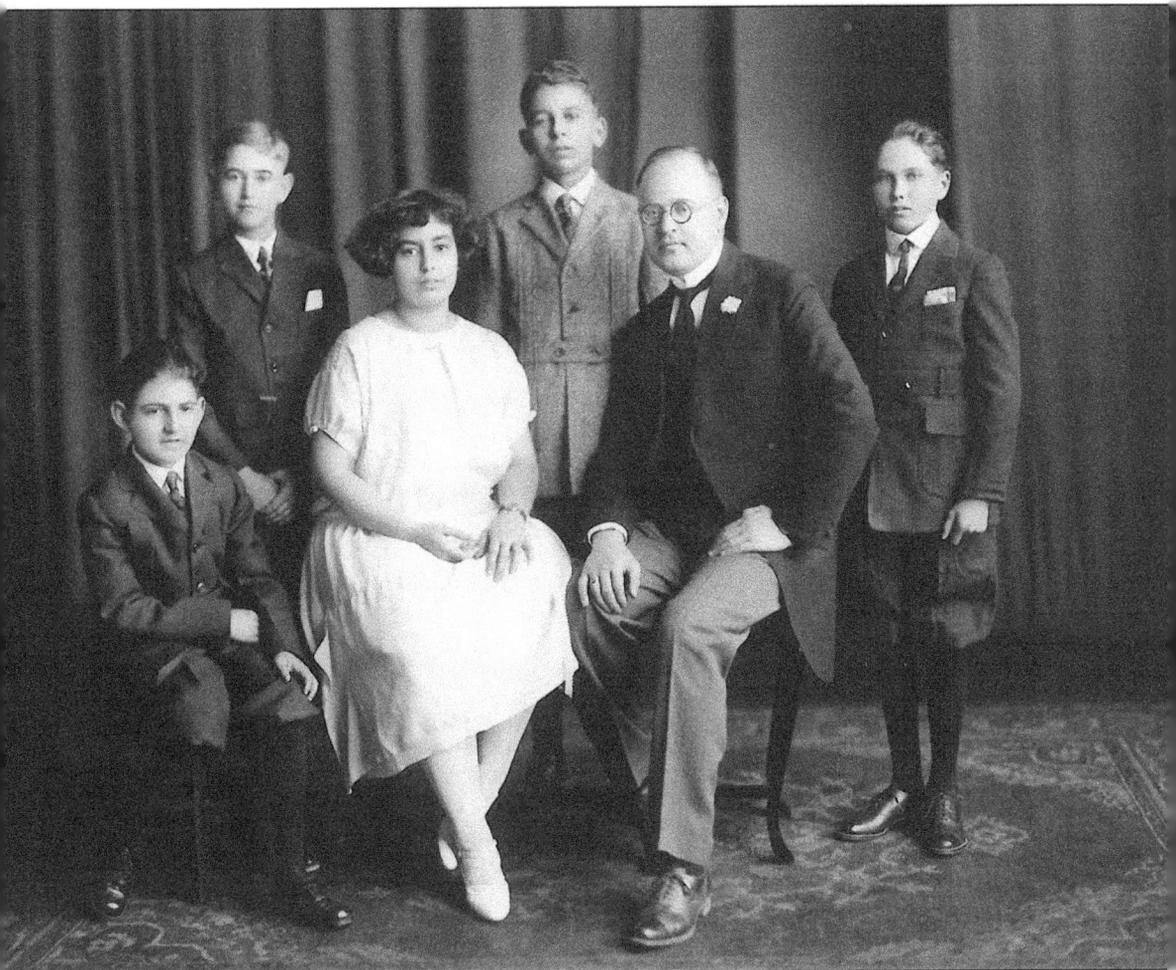

Congregation Albert students and Rabbi Raphael Goldstein are photographed during the spring holiday of Shavuot in 1923. (Courtesy of the Israel C. Carmel Archive at Congregation Albert.)

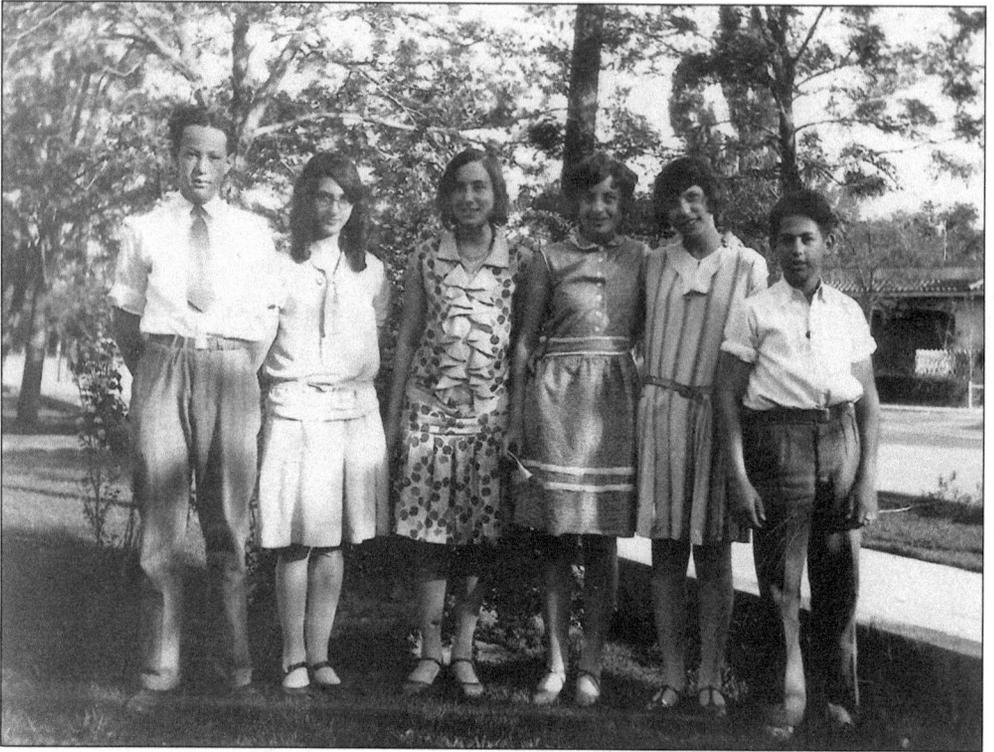

Seen here are two images of the Congregation Albert confirmation class of 1927. In those days, the classical Reform congregation did not perform B'nai Mitzvah ceremonies, but both boys and girls were confirmed. (Both courtesy of the Israel C. Carmel Archive at Congregation Albert.)

Maurice Maisel served as president of Congregation Albert five separate times, twice in the 1930s and three times in the 1940s. During his initial term, the finances of the congregation were in bad shape due to dwindling membership. However, by the following year, congregational finances were much improved. (Courtesy of Helen Horwitz.)

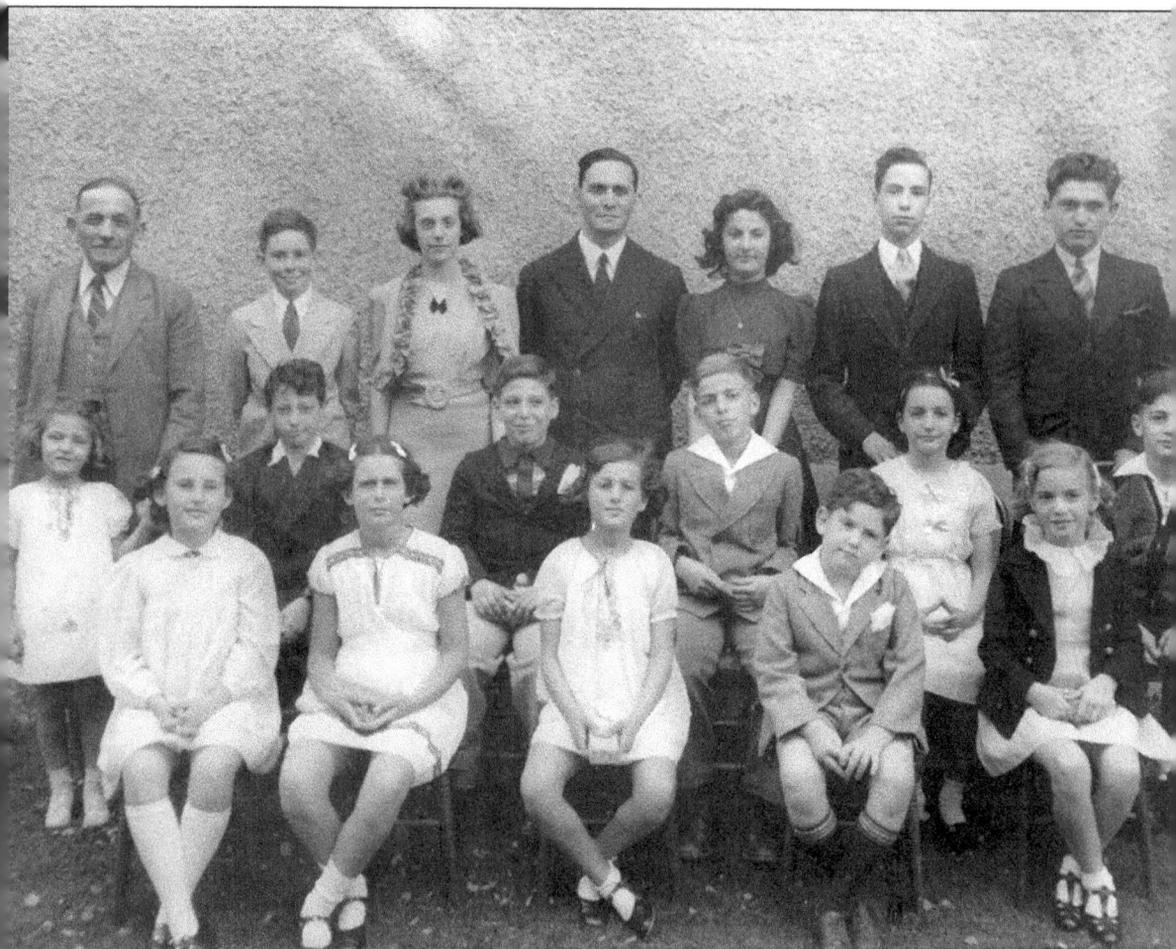

CONSECRATION SERVICE
October 16, 1938

A.FLEISCHER L.S.MAISEL KATHRYN HEYMAN RABBI STARRELS JULIETTE DREYFUSS C.M.BENJAMIN,JR. EDWARD DREYF
Pres.Congr.
BETTY JO SLOCK DAVID JUDD PAUL DREYFUSS,JR. ROBERT GOLDBERG JANE WEILLER MELVIN DREYFUSS
INGRID OPPENHEIMER JUDITH W. STARRELS RUTH E. STARRELS DONALD HORWITZ BARBARA GOLDBERG

This photograph was taken during the Consecration Service, which celebrates new Congregation Albert religious school students, in 1938. The Depression years were challenging ones for the congregation. (Courtesy of the Israel C. Carmel Archive at Congregation Albert.)

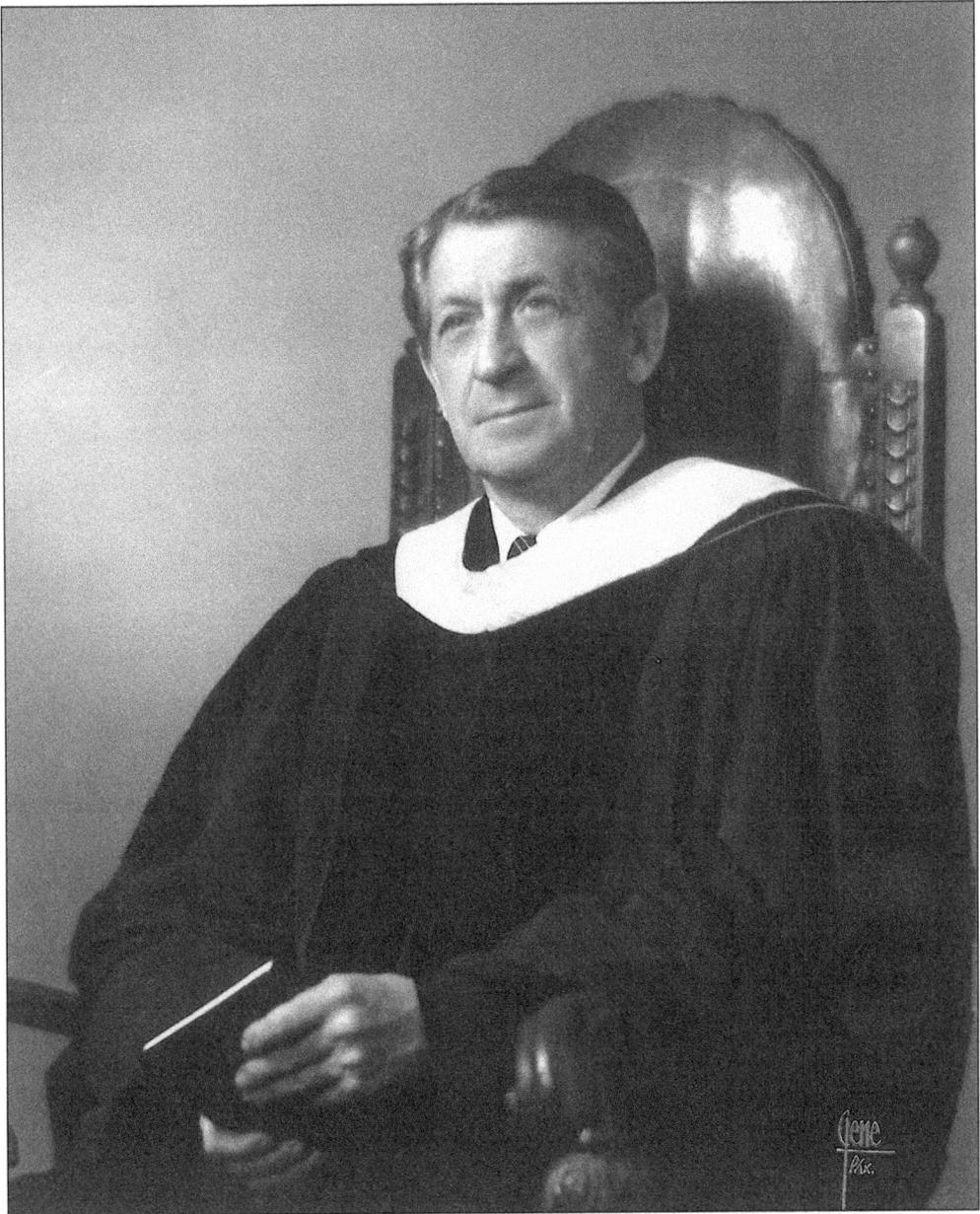

In 1935, Congregation Albert rabbi Abraham Lincoln Krohn, who served as president of the Bernalillo County School Board and an adjunct professor at the University of New Mexico, married a congregant, Eve Ginsburg. His activities on behalf of local farmers led to some controversy among congregants. Rabbi Krohn left the congregation in 1938. (Courtesy of the Israel C. Carmel Archive at Congregation Albert.)

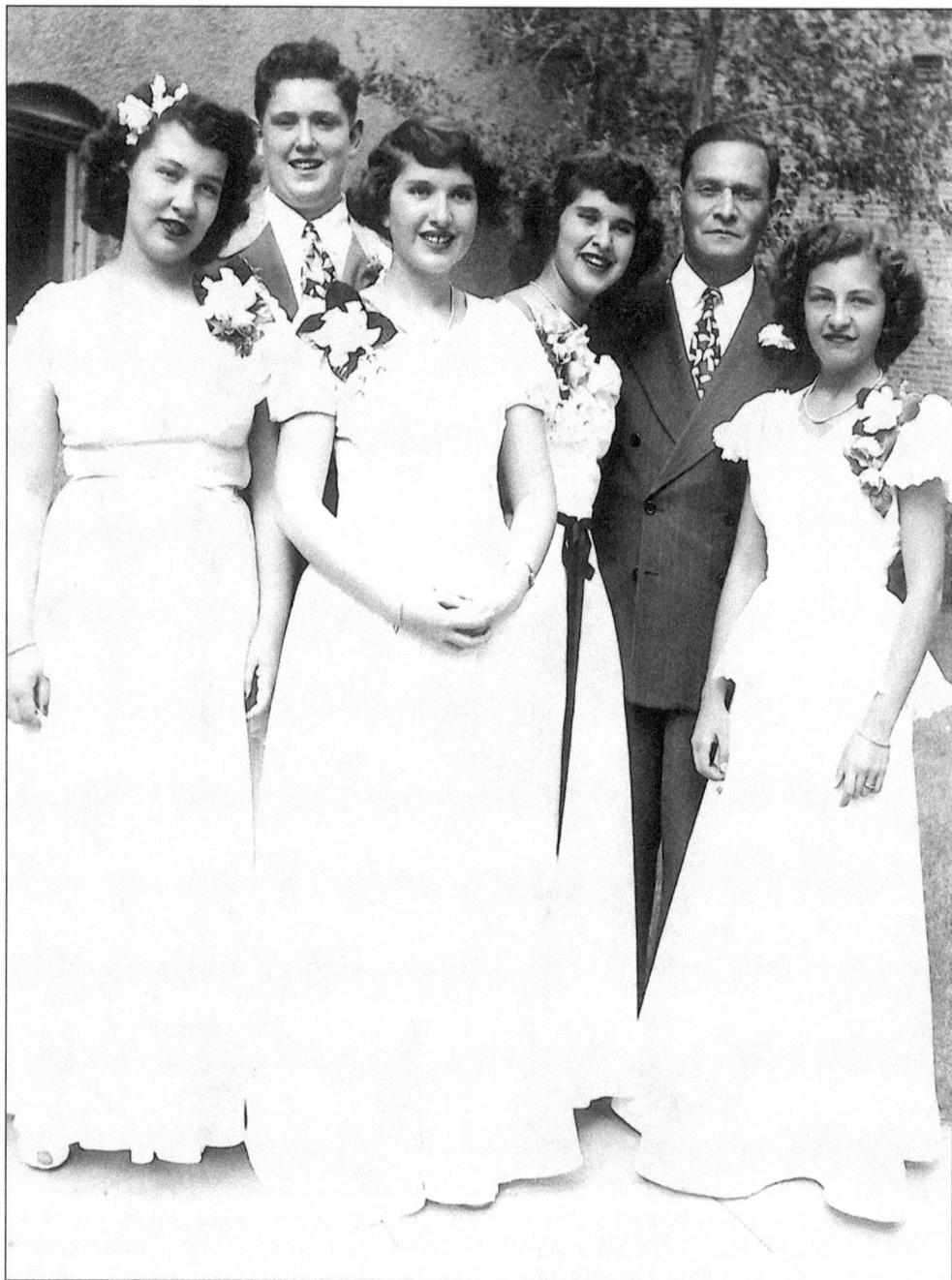

Above is a 1947 Congregation Albert confirmation class with Rabbi Solomon Starrels. In addition to serving Congregation Albert for 10 years, Rabbi Starrels made monthly visits to Los Alamos, 100 miles north, to see to the needs of the Jewish civilians and military personnel in the then-secret community. He also served as the Jewish chaplain for troops stationed nearby. (Courtesy of the Israel C. Carmel Archive at Congregation Albert.)

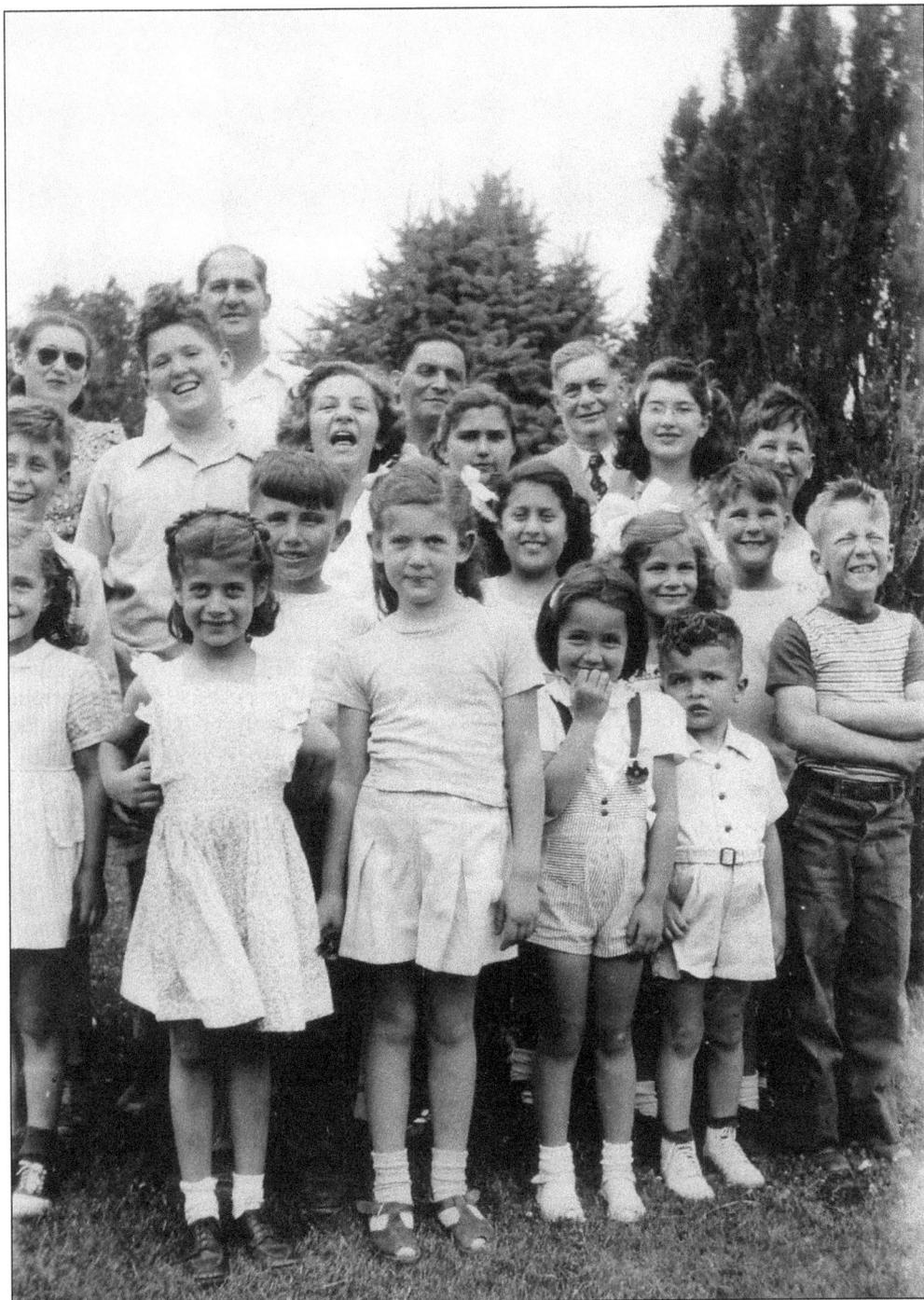

In the 1946 image seen here, Congregation Albert religious school students appear with Rabbi Solomon Sterrels (center back), congregation president Maurice Maisel (right back), Louis Sutin (second from left in back), and sisterhood president Betty Horwitz (left back). After World War II, the congregation saw an influx of families and religious school students. (Courtesy of Helen Horwitz.)

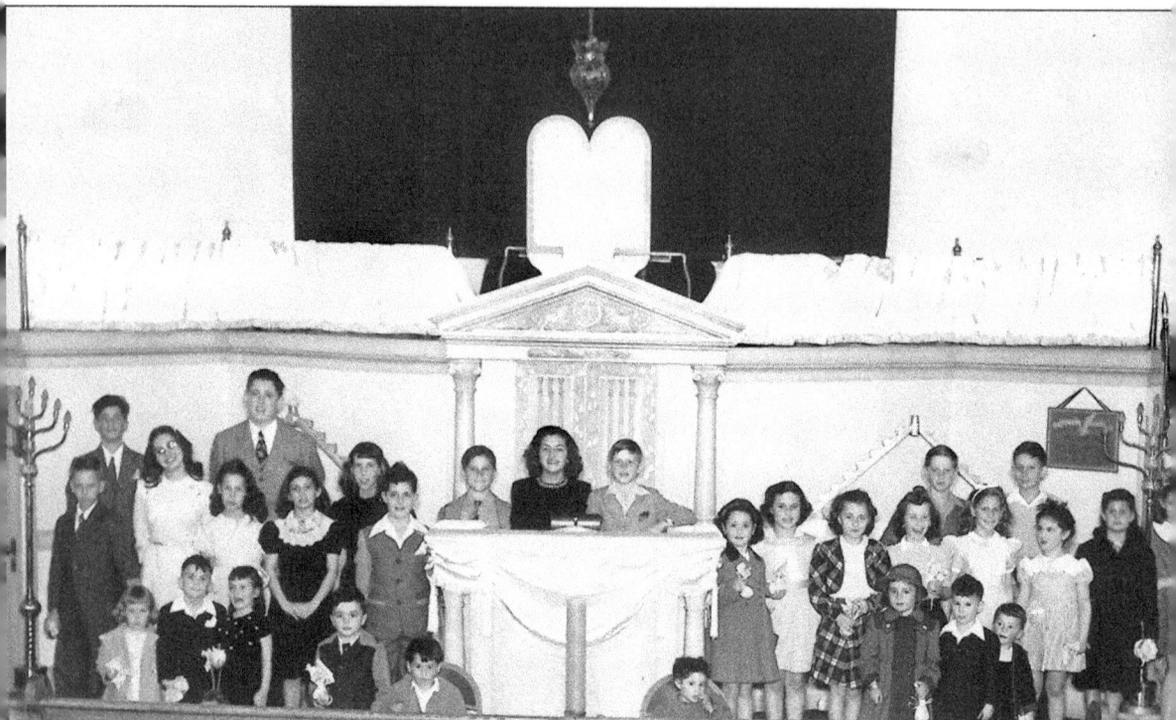

Congregation Albert outgrew its original building as the Jewish population in Albuquerque blossomed in the 1940s. This is the last religious school gathering in the original Congregation Albert building. The congregation began making plans to build a new facility. (Courtesy of the Israel C. Carmel Archive at Congregation Albert.)

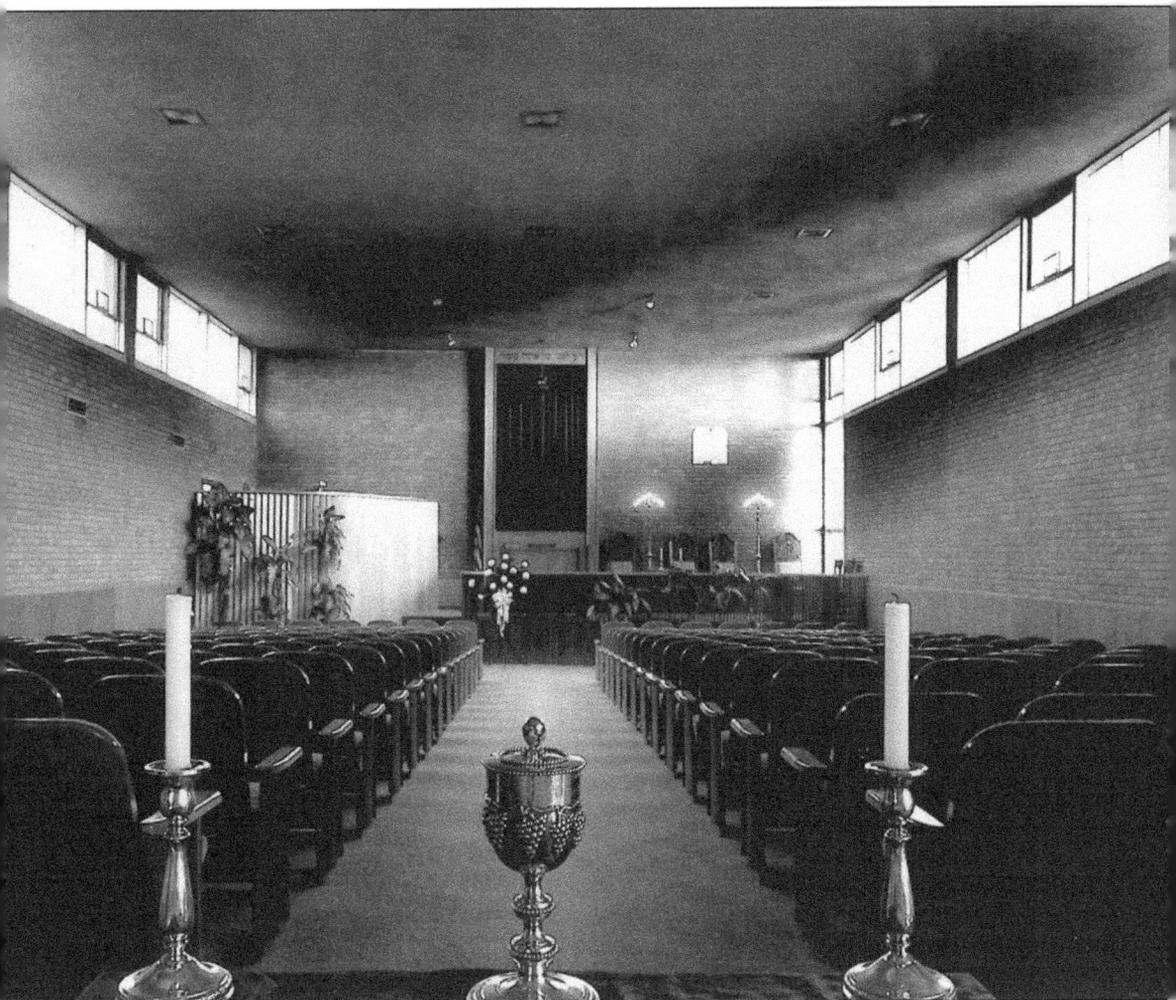

In 1950, a new Temple Albert building on Lead Avenue was dedicated by the congregation. The building was used by a number of different Jewish organizations, including Hillel, the Jewish Welfare Fund, and the Council of Jewish Youth. (Photograph by Jerry Goffe, courtesy of the Israel C. Carmel Archive at Congregation Albert.)

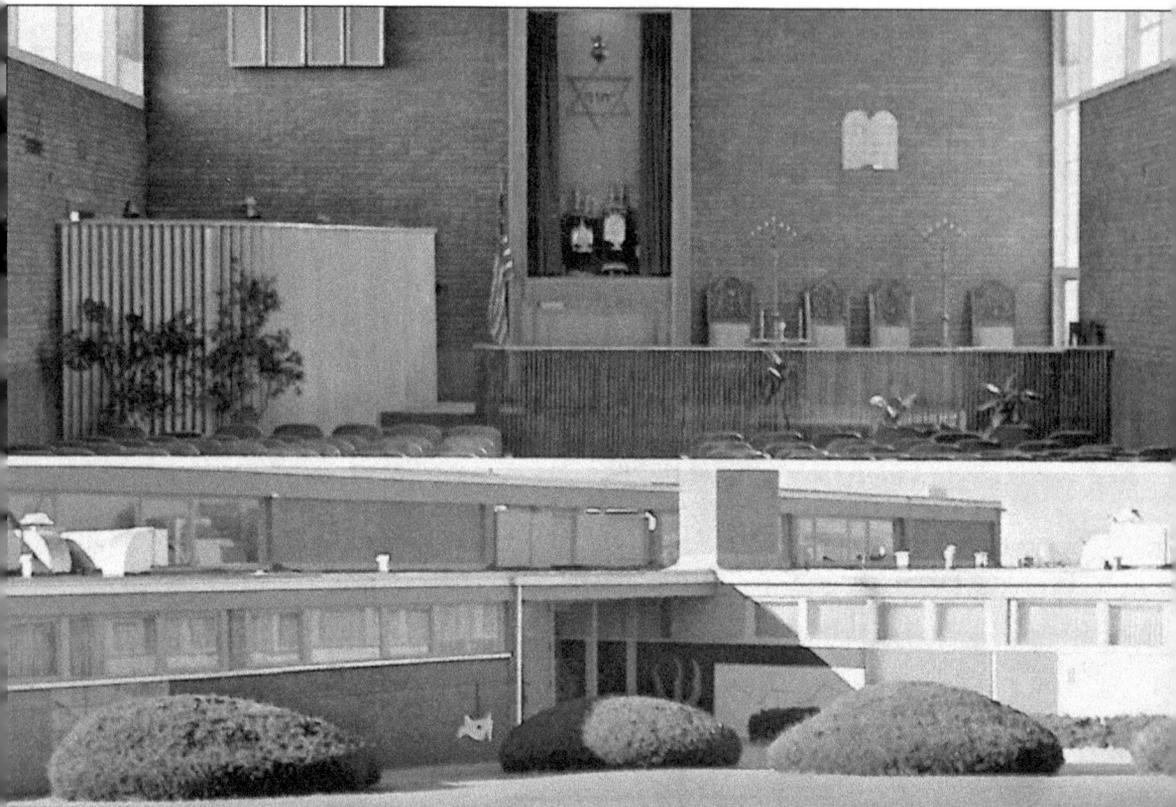

This postcard features two different views of the Congregation Albert building on Lead Avenue. The building was designed by architect and synagogue member Max Flatow. The murals on the exterior walls tell the story of Exodus and Creation. (Courtesy of the Israel C. Carmel Archive at Congregation Albert.)

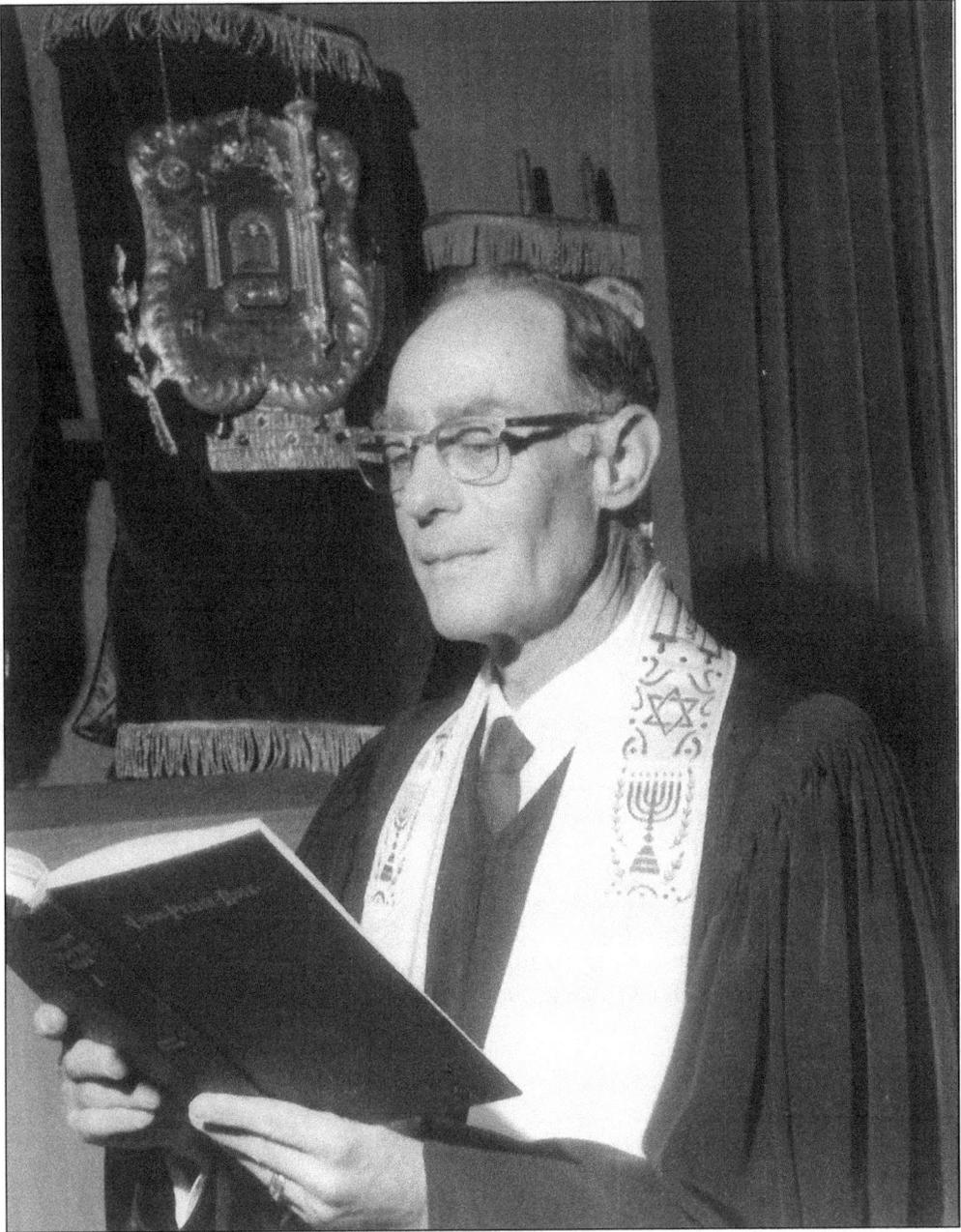

Rabbi David D. Shor, Congregation Albert's rabbi for 30 years, was sometimes known as the "Jewish Archbishop" of New Mexico. Rabbi Shor was raised in Dallas and ordained at Hebrew Union College. (Courtesy of the Israel C. Carmel Archive at Congregation Albert.)

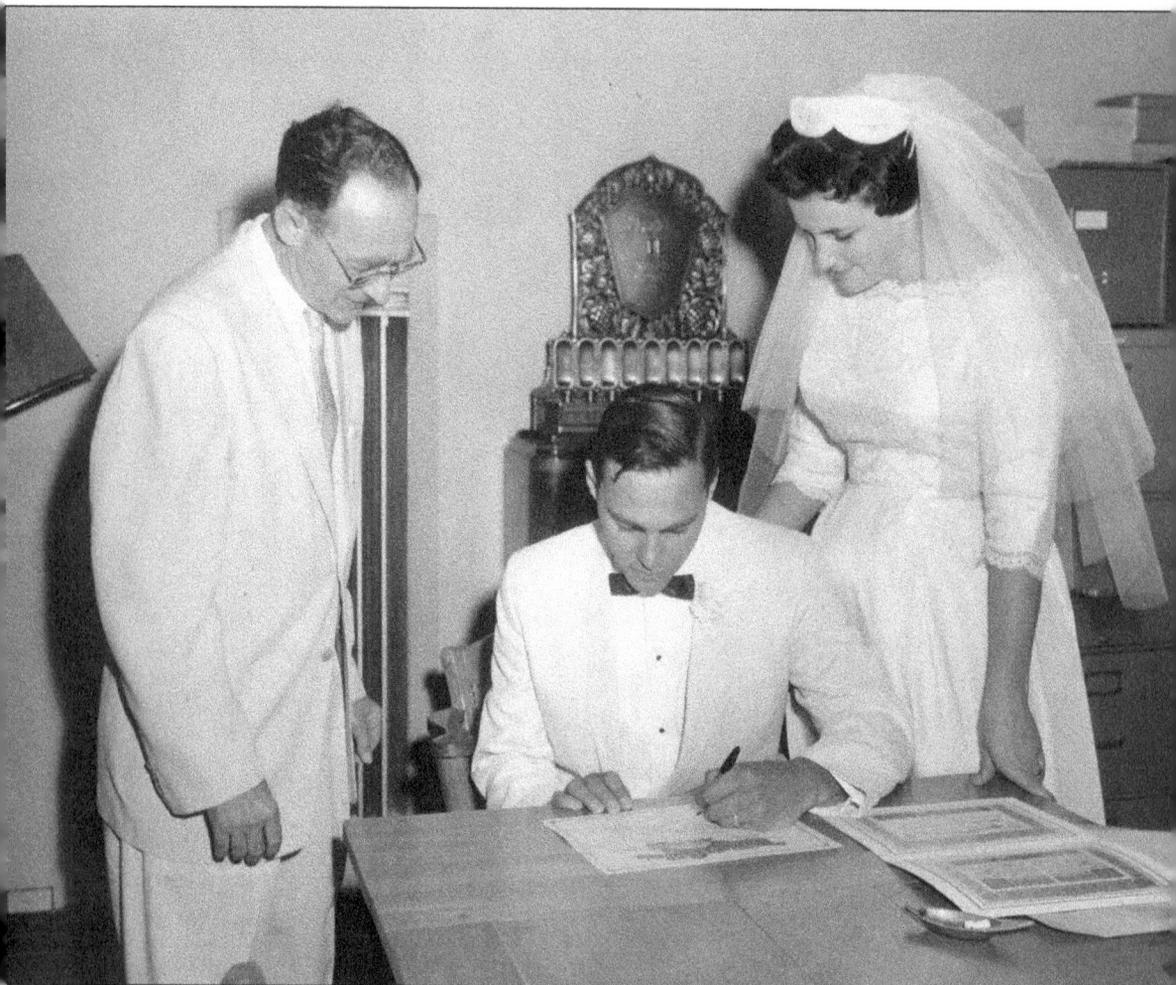

Above, Stan Feinstein and Rosalia Myers Feinstein sign the *ketubah* (Jewish marriage contract) with Congregation Albert's Rabbi Shor in 1960. (Author's Collection.)

Miriam Grunsfeld served as first president of the
Ladies Hebrew Benevolent Aid Society, a precursor to
the Congregation Albert Sisterhood. (Courtesy of the
Israel C. Carmel Archive at Congregation Albert.)

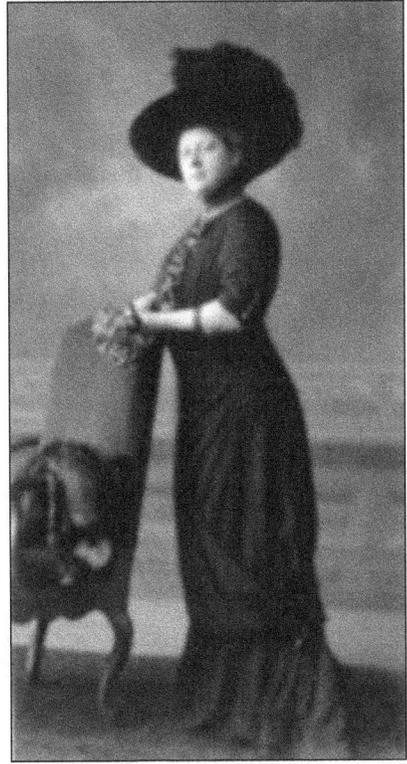

This photograph of
the Congregation
Albert Sisterhood
officers was taken in
1950. The sisterhood
was an important
force in synagogue
fund-raising and
education. Fund-
raising contributions
benefitted not only the
congregation; projects
ranged from buying
an iron lung for an
Albuquerque hospital
to sending funds to
the United Jewish
Appeal in New York.
(Courtesy of the Israel
C. Carmel Archive at
Congregation Albert.)

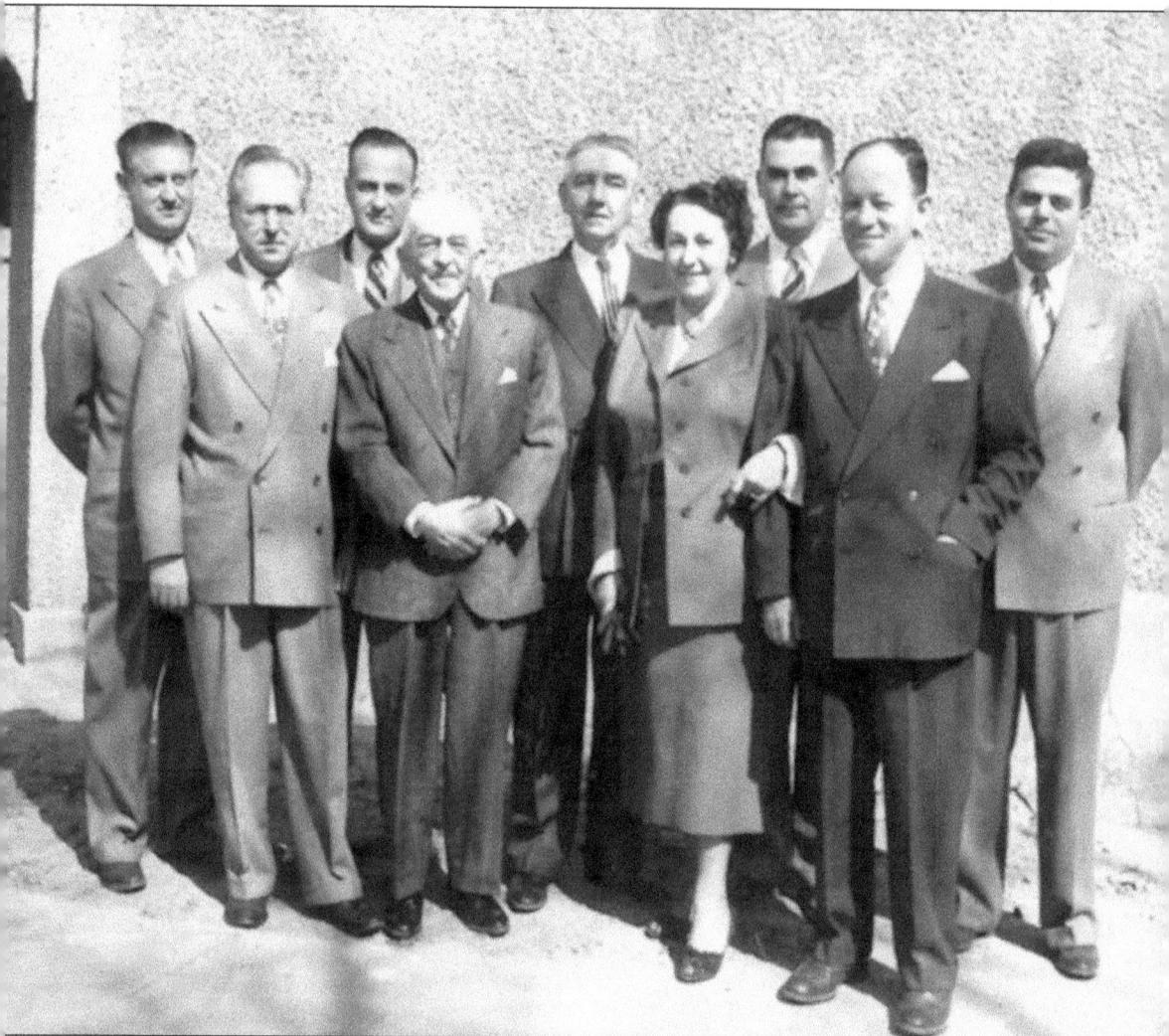

The Congregation Albert officers and trustees pose for a photograph in 1950. From left to right are (first row) Sigmund H. Blaugrund, Max Fleisher, Hanni Seligman, and Thornton Seligman; (second row) Donald S. Wise, Rudolph Dreyer, David E. Weiller, Edward Colby, and Richard S. Kaufman. (Courtesy of the Israel C. Carmel Archive at Congregation Albert.)

In 1920, Congregation B'nai Israel was chartered by a small group of Jewish citizens, most of whom had come to Albuquerque in the early 20th century. These individuals were seeking more traditional Jewish worship than was offered at Congregation Albert. The founders included D. M. Elias, Hyman Livingston, Ben Markus, Aaron Katz, and David Meyer, who is pictured right. (Courtesy of Congregation B'nai Israel.)

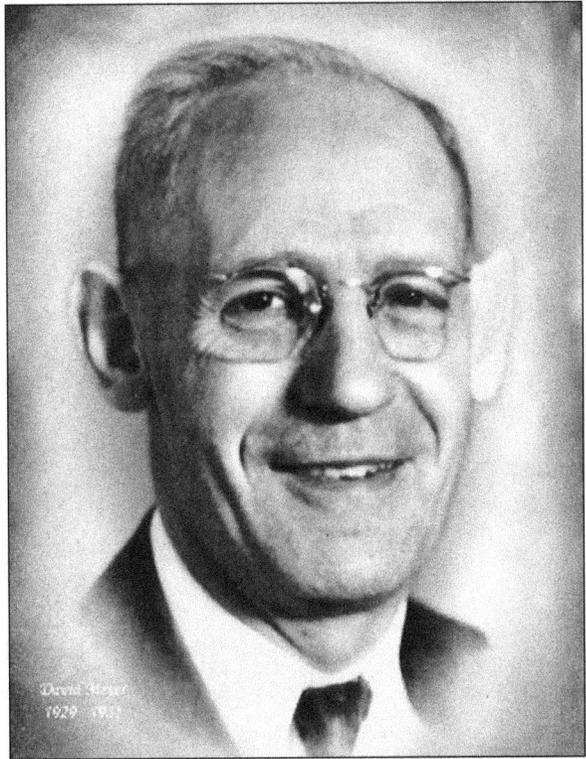

Initially, Congregation B'nai Israel, known as "the shul," held services in stores and private homes, such as David Meyer's living room, pictured below. Subsequently, in 1934, the congregation rented space at 116 1/2 West Central Avenue. (Courtesy of Marjorie Ross.)

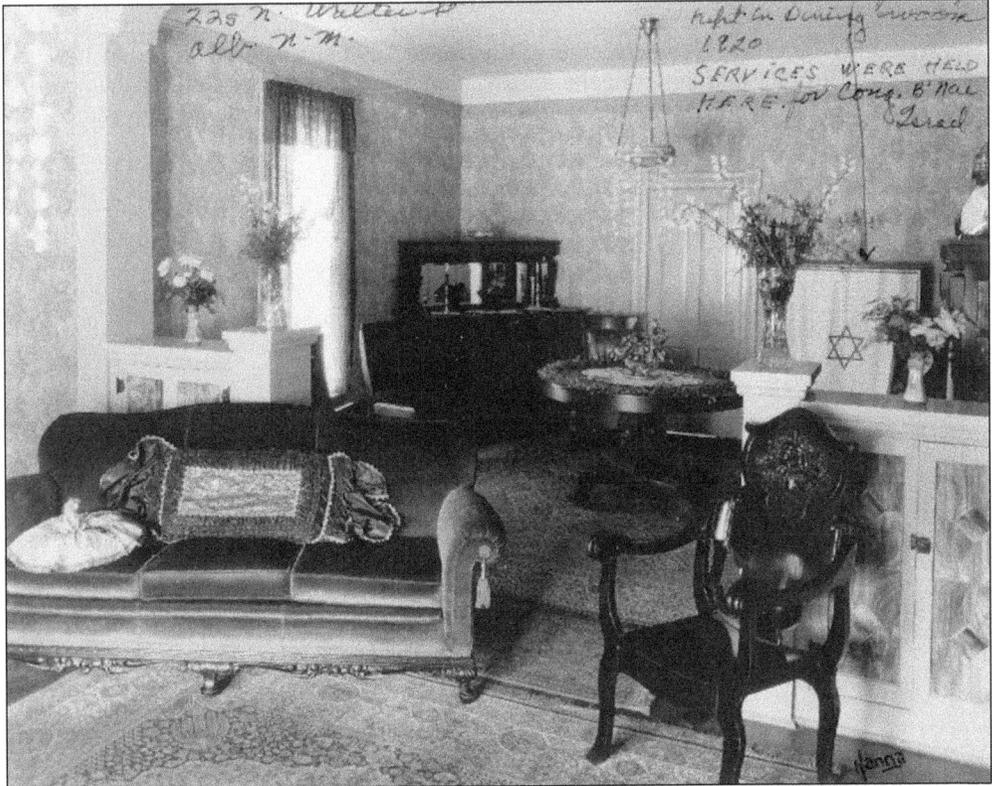

Sisterhood's 25th Anniversary
Past Presidents
Feb. 1959

DORA SPECTOR
NOT AVAILABLE FOR PIC

The B'nai Israel Sisterhood (known earlier as the Ladies Auxiliary) was established in 1934 and proved a powerful force for supporting the congregation. Fund-raising efforts included supporting the religious school and purchasing the lot for the original synagogue building. There were several two-generation leaders of the sisterhood. (Courtesy of Marjorie Ross.)

B'nai Israel Sunday School Picnic participants joyously celebrated Lag B'Omer in 1935. From left to right are Fernie Turner, Sheldon Bromberg, Myra Ravel Gasser, Melborne Bernstein, unidentified, and Alan Ravel. Teacher Harry Levin stands behind the children. (Courtesy of Myra Gasser and Congregation B'nai Israel.)

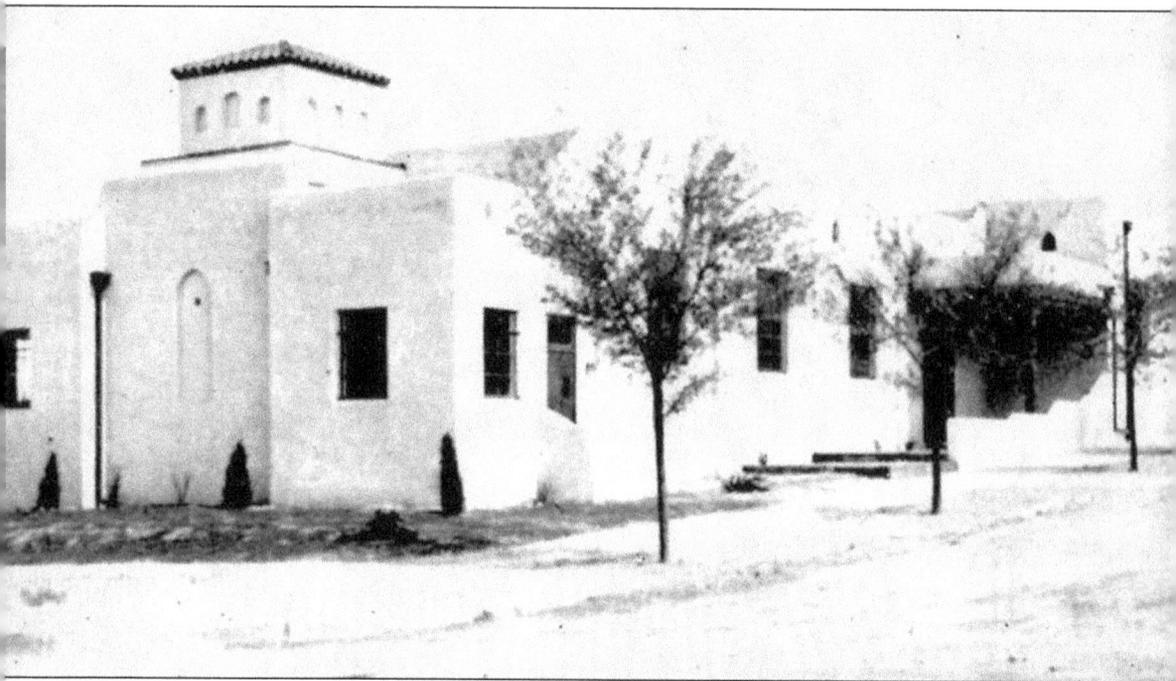

In 1941, over 20 years after it was established, Congregation B'nai Israel dedicated a synagogue at Coal and Cedar Avenues and employed its first full-time rabbi, Philip Pincus. Then-president Arthur Ravel reminded congregants not to rest on their laurels but to make good use of the synagogue that they had worked so hard to build. (Courtesy of Frances Katz.)

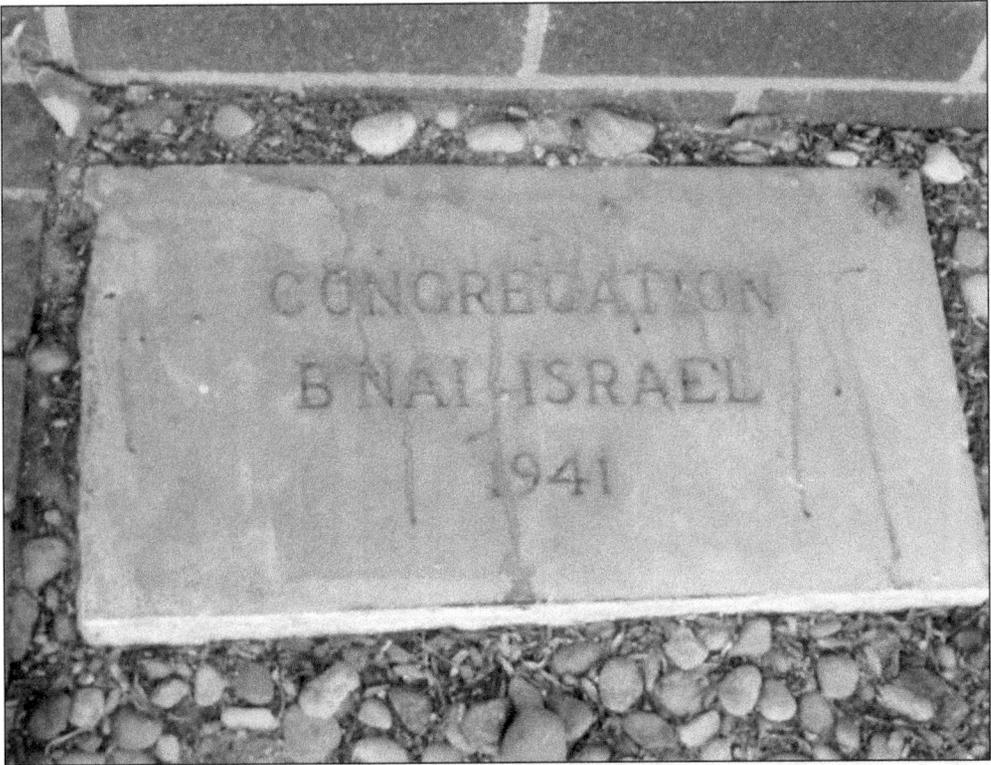

Above is the cornerstone of Congregation B'nai Israel. The Ladies' Auxiliary purchased the lot at Cedar and Coal Avenues in 1937, and the cornerstone was laid on February 9, 1941. (Author's Collection.)

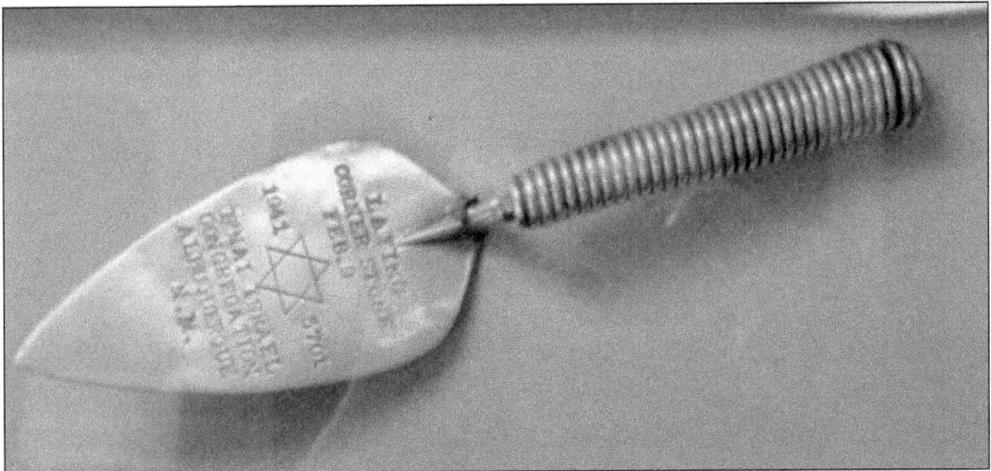

Seen here is the commemorative trowel used at the Congregation B'nai Israel dedication. Philip Pincus, Congregation B'nai Israel's rabbi and a graduate of the Jewish Theological Seminary of America, officiated at the event. (Author's Collection.)

This is a photograph of a B'nai Israel confirmation class. Confirmation students include, from left to right, Nancy Levick, Marjorie Meyer, Elaine ?, and Leila Bromberg. (Courtesy of Congregation B'nai Israel.)

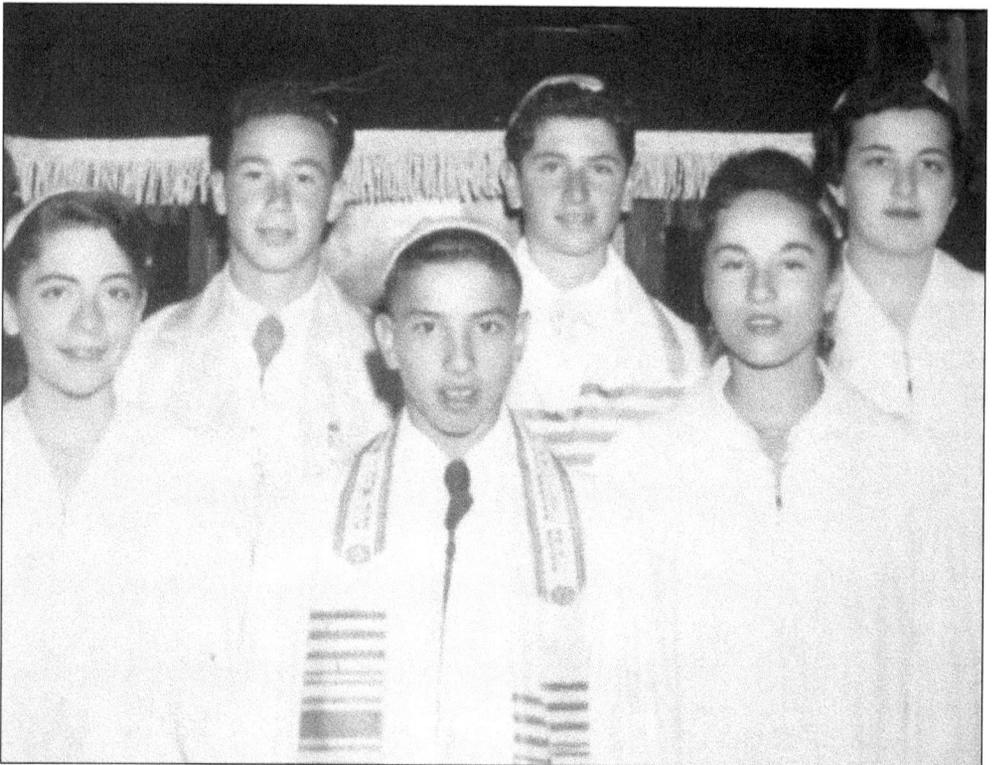

Pictured above is a B'nai Israel confirmation class in 1958. Students included Robert Engle, Ronald Taylor, Michael Rueckhaus, Michelle Rosenbaum, and Hedy Berger. (Courtesy of Congregation B'nai Israel.)

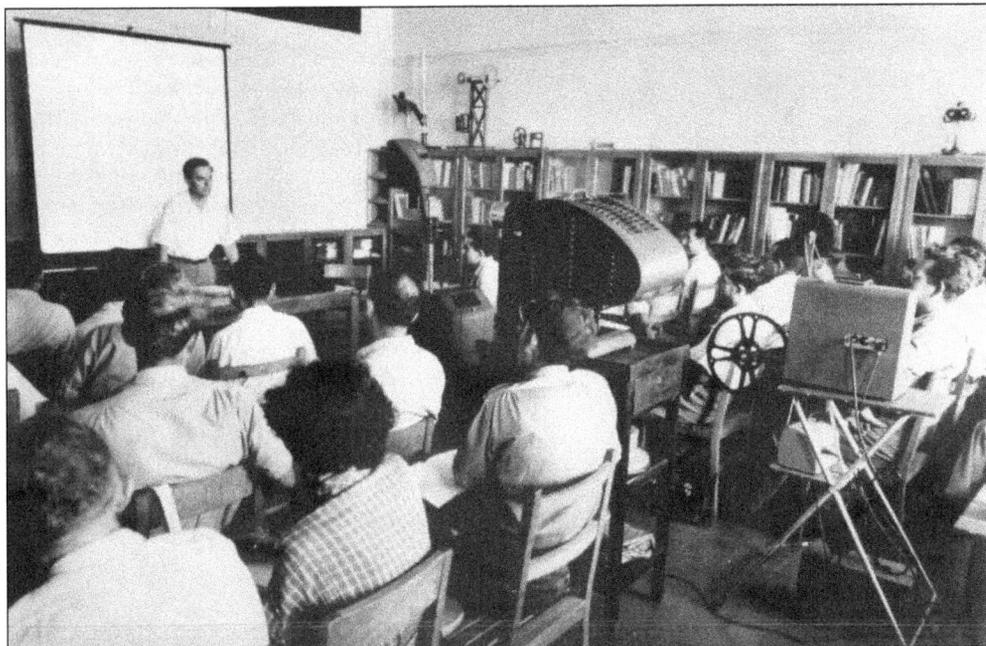

Rabbi Abraham Shinedling (1897–1982) provided services to numerous communities, including Albuquerque. He served as a teacher and in various leadership positions at Congregation Albert, in addition to serving as a rabbi at the Los Alamos Jewish Center. (Courtesy of the University of New Mexico Center for Southwest Research.)

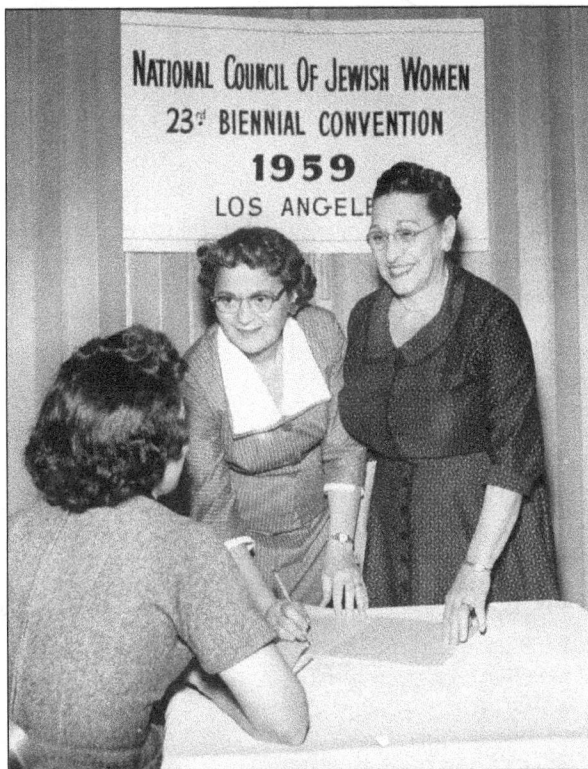

Helen Shinedling was a leader of the Albuquerque chapter of the National Council of Jewish Women, representing the organization at national meetings, such as this one in Los Angeles in 1959. (Courtesy of the University of New Mexico Center for Southwest Research.)

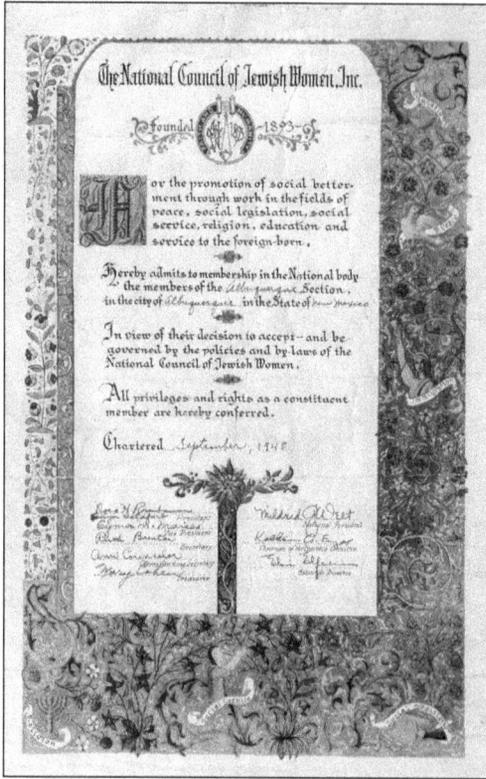

Chapters of national Jewish women's organizations were chartered in Albuquerque in the 1940s. The National Council of Jewish Women, whose Albuquerque charter is seen here, sponsored speakers for their members on Jewish affairs and ran numerous charitable projects, including a day camp at the University of New Mexico. Hadassah, the Jewish women's Zionist organization, also established an Albuquerque chapter. (Courtesy of the University of New Mexico Center for Southwest Research.)

Members of Hillel at the University of New Mexico pose for this picture some time during the 1960s. Sources vary somewhat as to when the University of New Mexico Hillel chapter was founded. However, by 1946, the organization was clearly in place and advised by Lewis R. Sutin. Two years later, in 1948, Congregation Albert's Rabbi Shor took over the role of advisor. That same year, a group of students and Albuquerque Zionists sent a telegram to President Truman urging him to end the arms embargo on Israel. (Courtesy of the University of New Mexico Center for Southwest Research.)

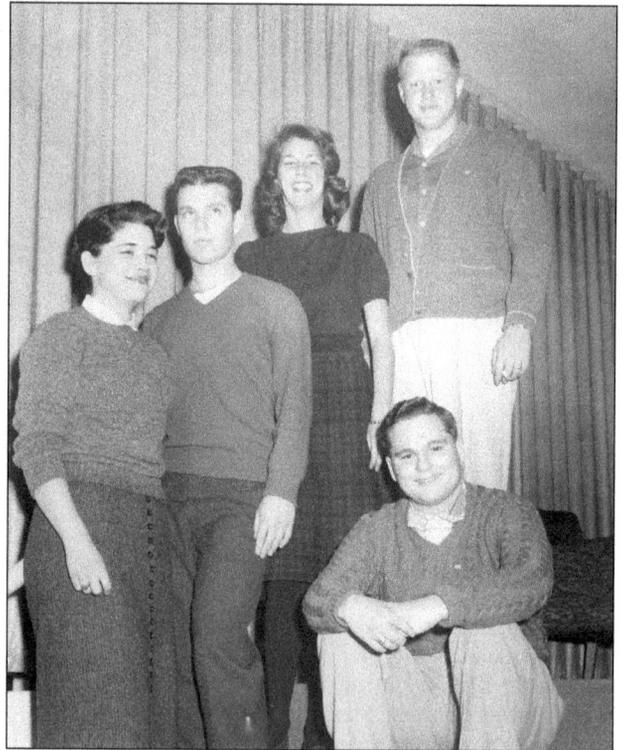

Three

COMMERCE

After the initial business boom of the 1880s, Jewish newcomers arrived in Albuquerque and went into business for themselves. These new arrivals were attracted to town for a variety of reasons such as health, opportunity, and climate. Some had operated shops elsewhere in the United States before coming to Albuquerque. Brothers Jack and David Meyer were English by birth and used their tailoring skills in Salt Lake City before establishing their men's clothing shop.

During the first four decades of the 20th century, most of Albuquerque's Jewish families were self-employed. From pawnshops and small groceries to larger enterprises such as clothing factories and furniture stores, Albuquerque's Jewish residents were concerned with taxes, infrastructure, and customers. In fact, in 1918, many of the businesspeople were directly at odds with Congregation Albert's Rabbi Bergman, who was instrumental in enacting the city's influenza quarantine. While some individuals held on to their businesses by the skin of their teeth, others experienced fabulous economic success.

Several European families found refuge in Albuquerque on the eve of America's entrance into the Second World War. Duke City Lumber Company co-owner Jack Grevey, born in Poland and educated in France, was arrested by the German secret police before he escaped and made his way to Albuquerque. Leopold and Joanna "Hanni" Boehm Seligman escaped Germany, arriving in Albuquerque in 1938 with a Rembrandt painting hidden among their belongings. The couple, who had operated Europe's third largest clothing factory, started Albuquerque's Pioneer Wear, a clothing manufacturer which eventually employed 100 people.

After World War II, a professional class of Jewish scientists, physicians, lawyers, and educators began to emerge in Albuquerque. Some of the professionals were homegrown, but others were attracted to the city's tremendous postwar growth, educational opportunities at the University of New Mexico, and federal employment opportunities.

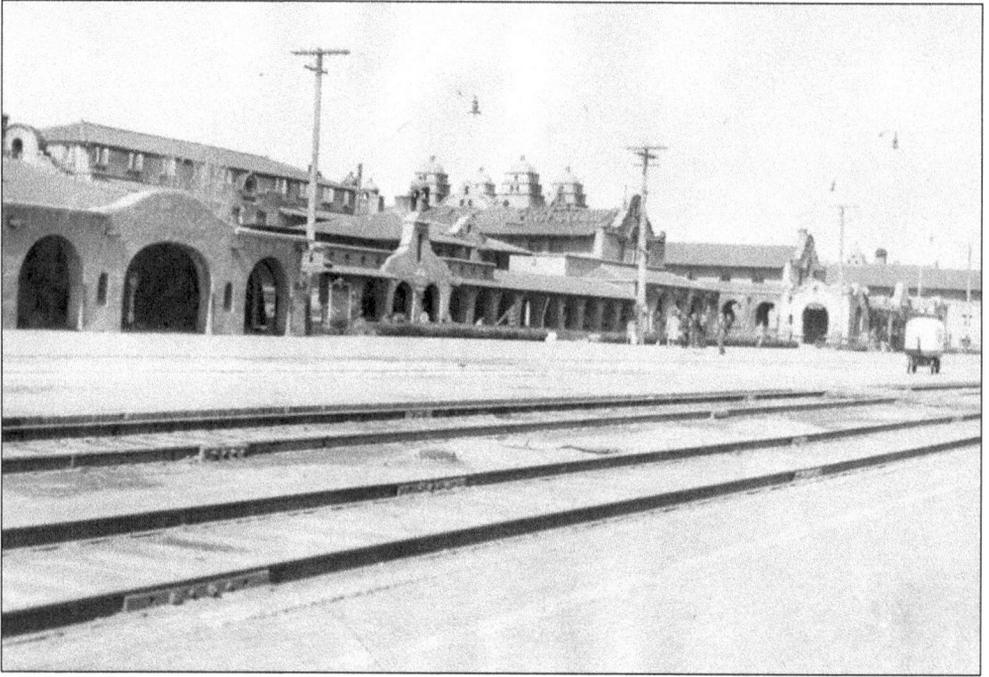

The Santa Fe Railroad depot and the Alvarado Hotel (built in 1903) were the primary forces in driving Albuquerque's early-20th-century growth. Like other immigrants, Jewish newcomers came to Albuquerque for business opportunities. As a group, Albuquerque's immigrants prospered. Dry goods and groceries were the businesses of choice for most of Albuquerque's Jewish merchants. (Courtesy of the University of New Mexico Center for Southwest Research.)

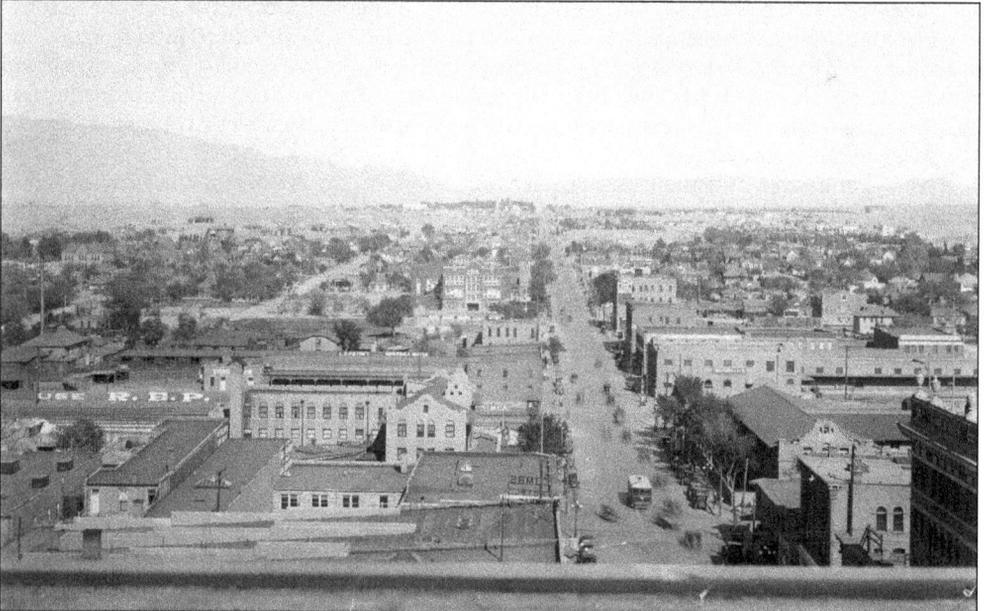

This is a view of Albuquerque facing toward the east. As the city's population grew, Albuquerque expanded eastward, where businesses, hospitals, and the University of New Mexico were erected. (Courtesy of Stan Feinstein.)

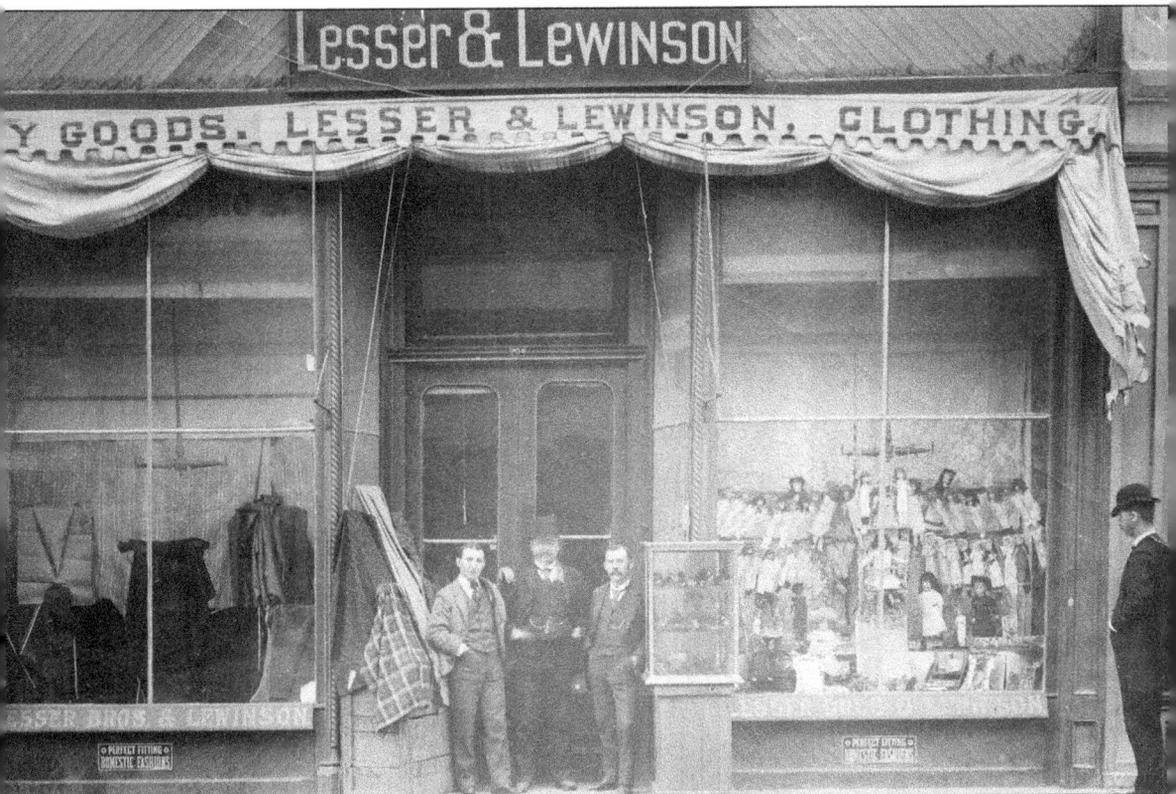

This photograph of Lesser and Lewinson Store was taken in 1900. By 1901, Louis and David Lesser had left Albuquerque ,and Sussman Lewinson went into business with his son-in-law David Weinman. (Courtesy of the University of New Mexico Center for Southwest Research.)

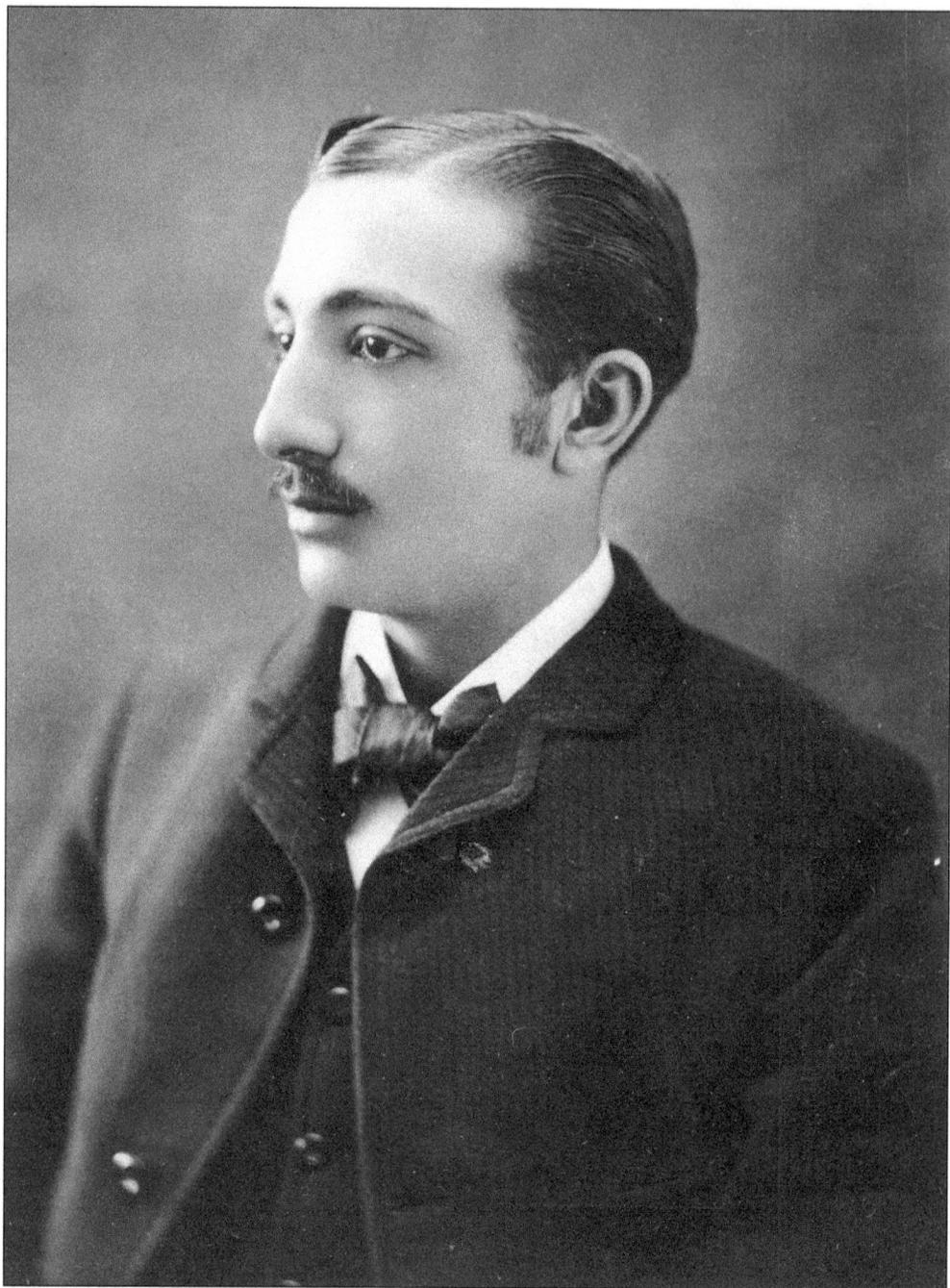

David Weinman poses for a portrait in 1890. Weinman ran an Albuquerque dry goods store with his father-in-law, Sussman Lewinson, who had been engaged in business in Albuquerque with another partner, Louis Lesser. By 1910, many of the early Jewish families were neighbors on North Eight Street. The Rosenwalds, Jaffas, Grunsfelds, Weinmans, Uhlfelders, and Ilfelds all lived on the same block. In 1904, Weinman served as president of Congregation Albert, and he joined the Albuquerque Elks Club in 1900. (Courtesy of the University of New Mexico Center for Southwest Research.)

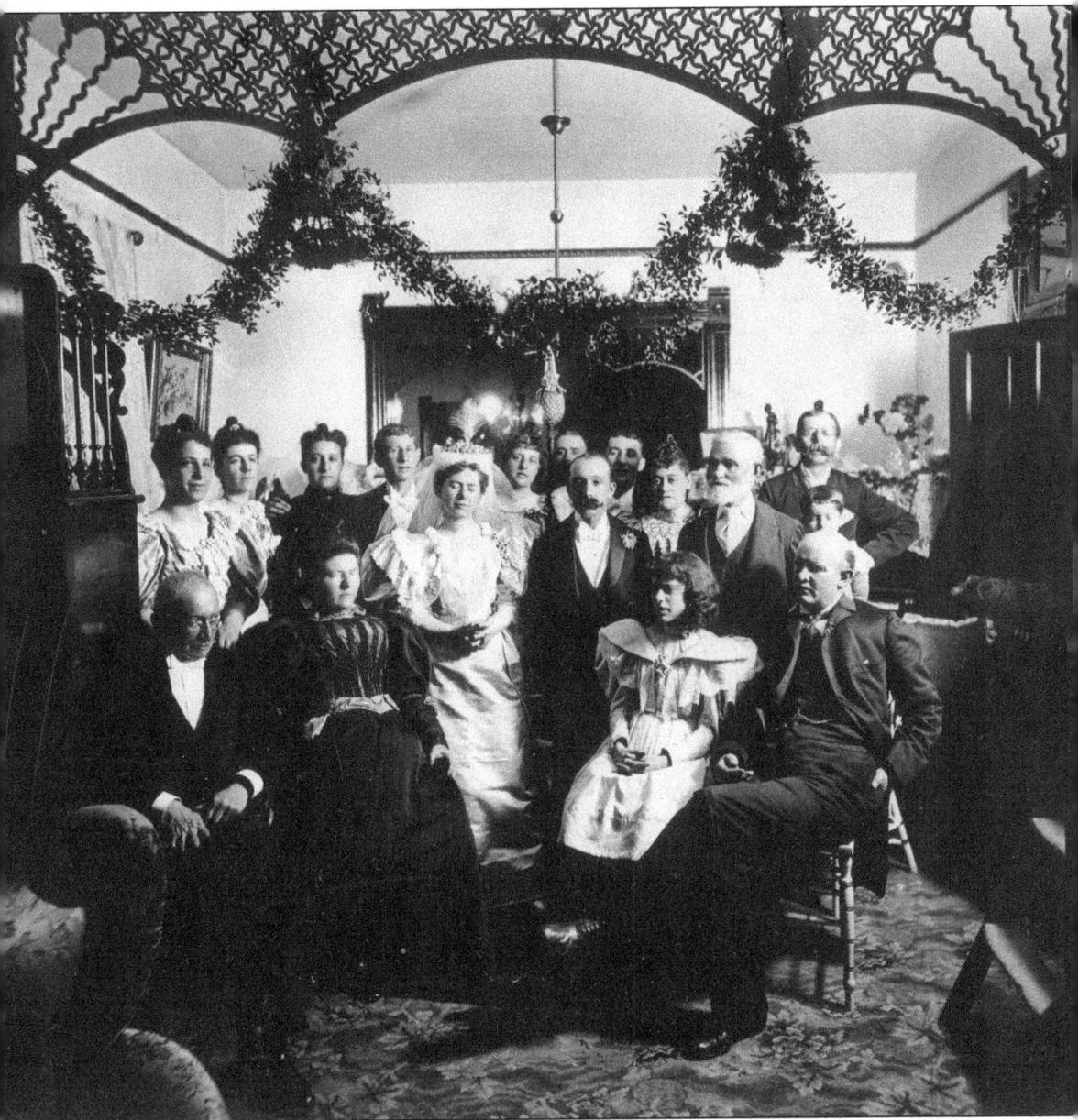

David Weinman and Belle Lewinson celebrate their Albuquerque wedding in November 1894. Belle was 16 years younger than Weinman. The couple lived in Albuquerque for 40 years. (Courtesy of the University of New Mexico Center for Southwest Research.)

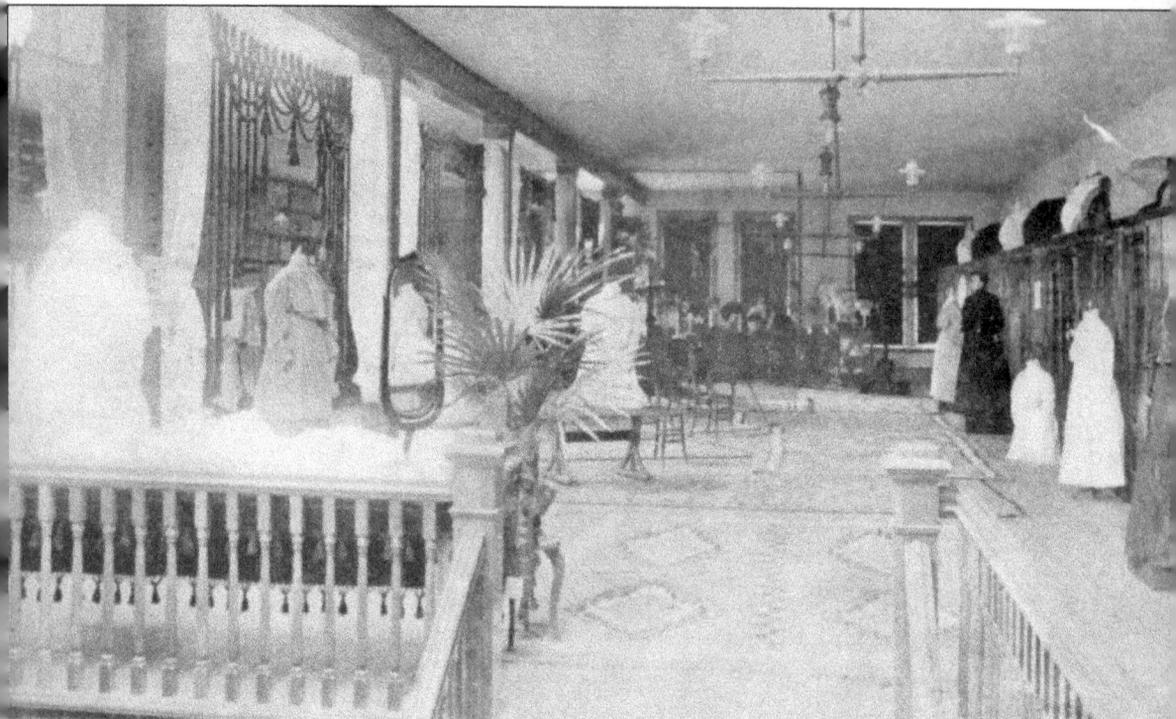

SUIT ROOM OF WEINMAN & LEWINSON DRY GOODS STORE, ALBUQUERQUE, N. M.

The Lewinson and Weinman shop was quite extensive. There were separate suit and millinery departments. The shop was later known as the Economist. In 1910, Sussman Lewinson retired from the business, and his son, Seymour Lewinson, took his place. Seymour's son, Leo, attended the University of Pennsylvania, worked as a salesman in the family store, fought in World War II, and later served several terms as president of Congregation Albert. (Courtesy of Nancy Tucker.)

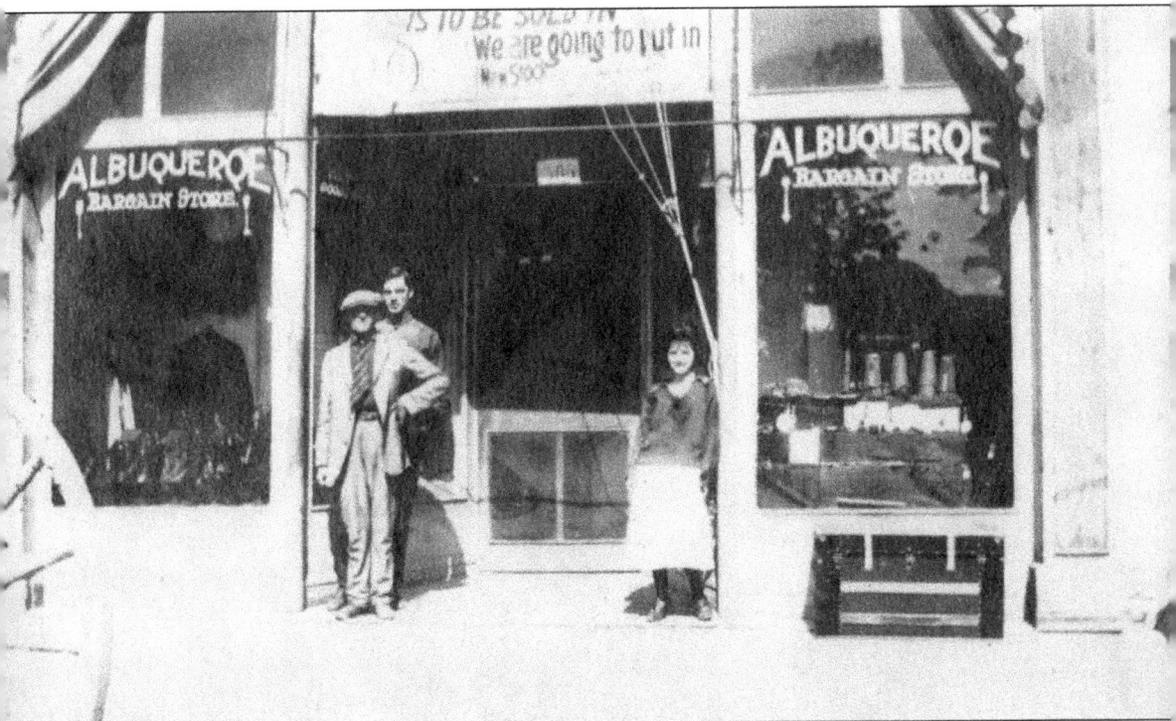

Aaron Katz, seen above in a cap, poses in front of his Albuquerqe [*sic*] Bargain Store at 205 South First Street some time around 1920. Katz came to Albuquerque in 1916 after avoiding a second stint in the czar's army. When he got off the train and heard Yiddish spoken by shopkeepers nearby, Katz decided to make Albuquerque his home. In addition to running his shop, he helped found Congregation B'nai Israel and served as its cantor for 14 years. (Courtesy of Frances Katz.)

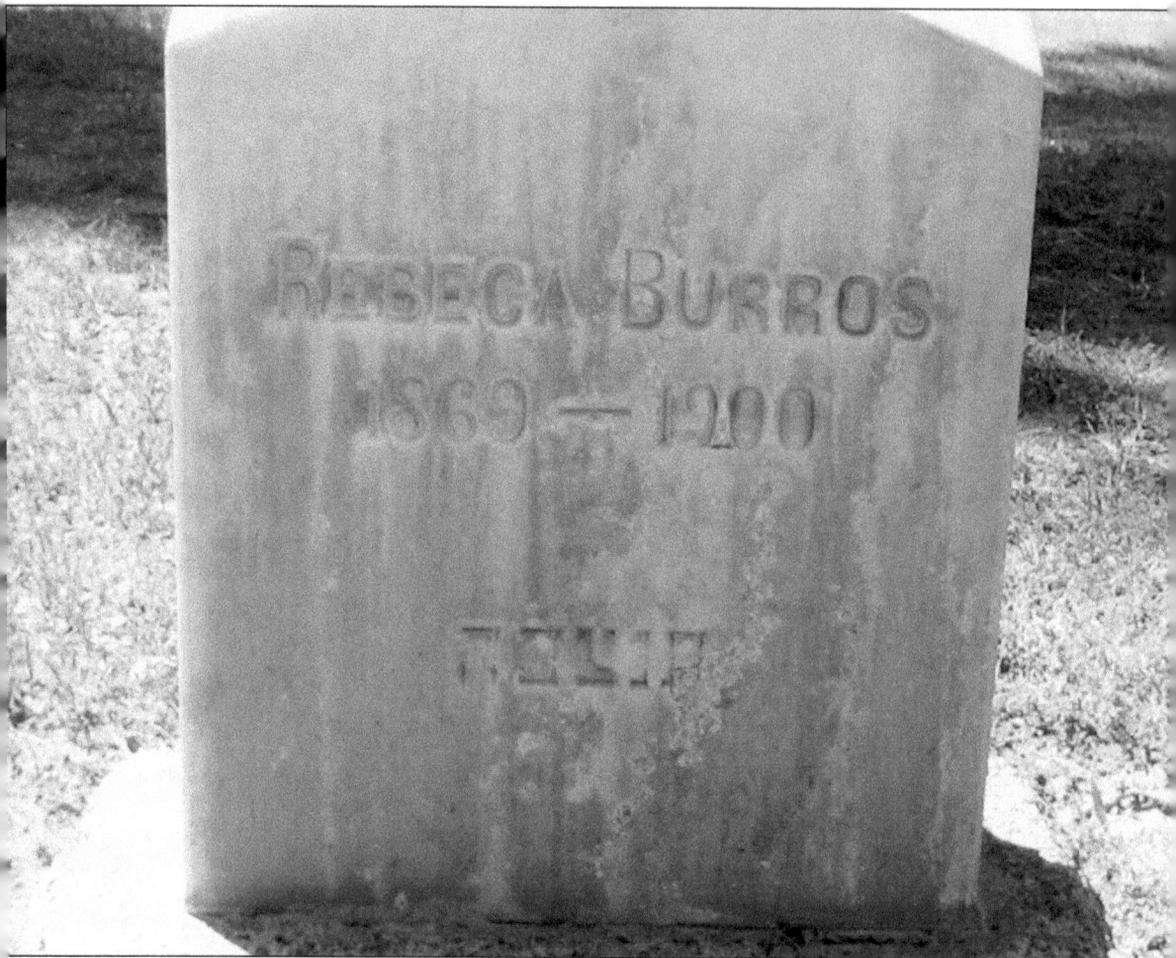

Pictured is the grave marker of Rebeca Burros. For some Jewish immigrants, Albuquerque was but one stop on their American journey. Two Russian families, the Maharams and the Burroses, made Albuquerque their home in 1900, working in dry goods and manufacturing and renting their homes. Rebeca Burros, the 31-year-old wife of Isador and mother of four children, died in Albuquerque in 1900. Her husband and children moved back to New York, where her husband remarried. By 1920, the Maharams had left for Los Angeles. (Author's Collection.)

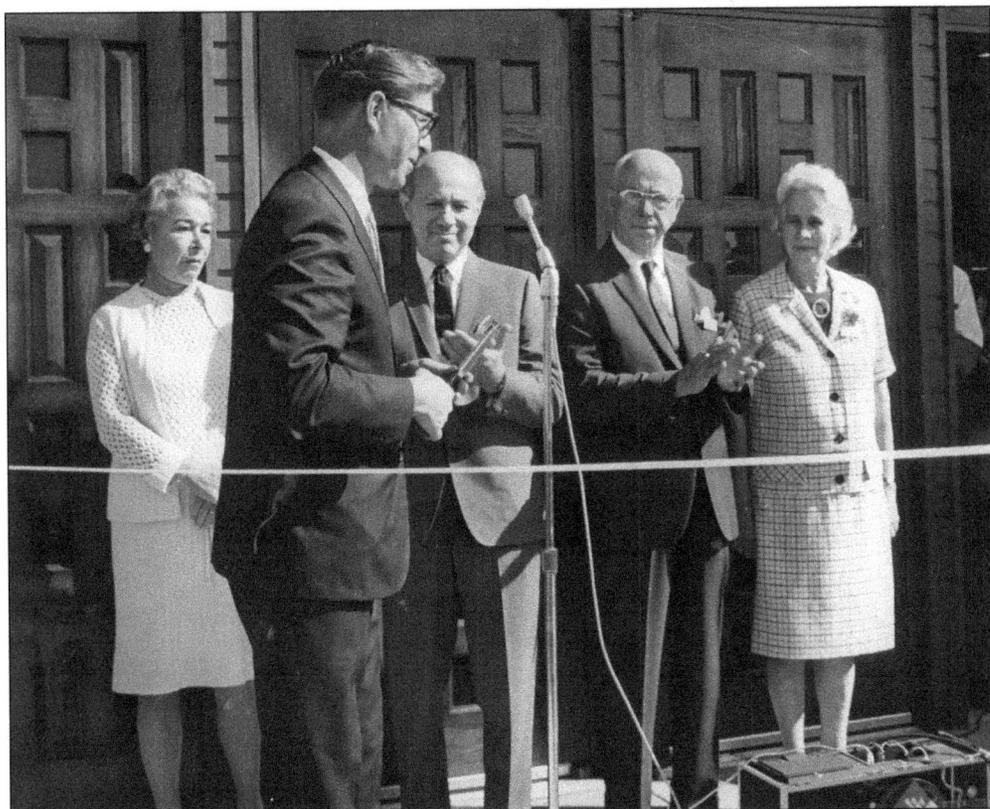

Originally from Czechoslovakia, E. Mannie Blaugrund worked in his brother's El Paso furniture store before opening his own store, American Home Furnishings, in Albuquerque in 1935. The store was at 212 Central Avenue SW until 1950, when the operation moved to a 46-000-square-foot facility on Fourth Street and later to an immense retail store on Carlisle and Menaul Avenues. The family-owned operation expanded during the next few decades, supplying not only home furnishings but office furniture as well. This photograph shows the ribbon-cutting for the retail store on Carlisle and Menaul Avenues. Future U.S. Senator Pete Dominici is seen with Mannie and Freida (left) and Henry and Ruth Blaugrund (right). (Courtesy of Leah Sandman.)

Henry and Ruth Blaugrund were longtime members of Albuquerque's Jewish organizations, including Congregation Albert and B'nai B'rith. (Courtesy of Leah Sandman.)

Pictured at left in 1909 are, from left to right, David Meyer, Abe Mann, and Louis Meyer. The Meyers came to Albuquerque in 1914 from Latvia via Manchester, England; Philadelphia; St. Louis; and Salt Lake City. (Author's Collection.)

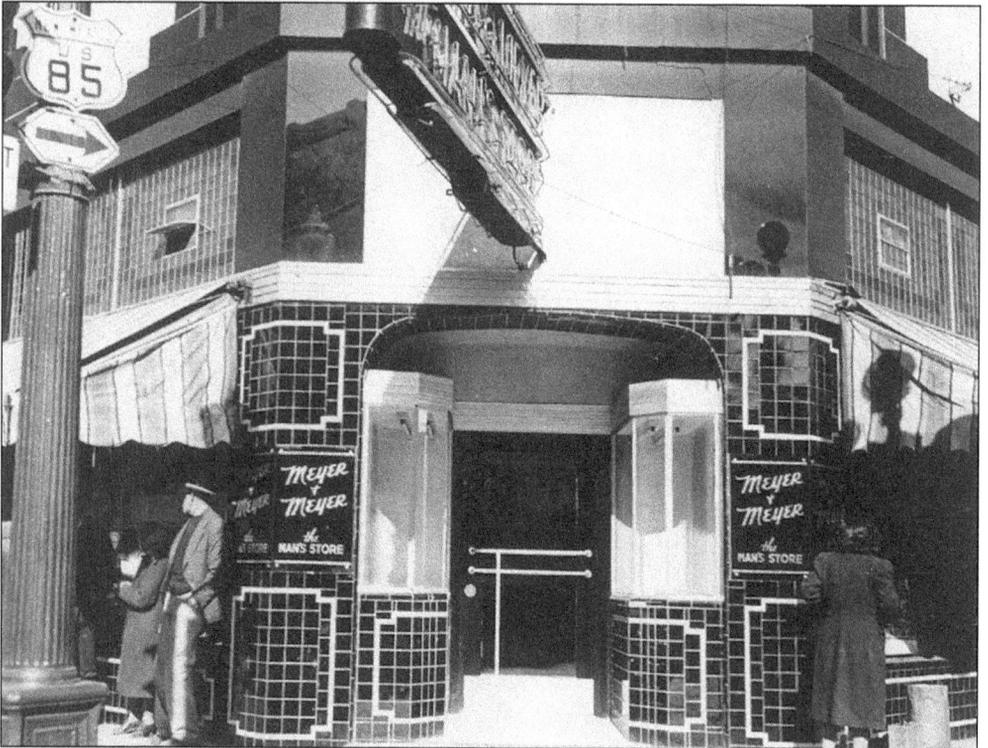

In Albuquerque, David and Louis Meyer started a tailoring business that grew into a menswear shop at 401 West Central Avenue, pictured here in 1937. (Courtesy of the Albuquerque Museum.)

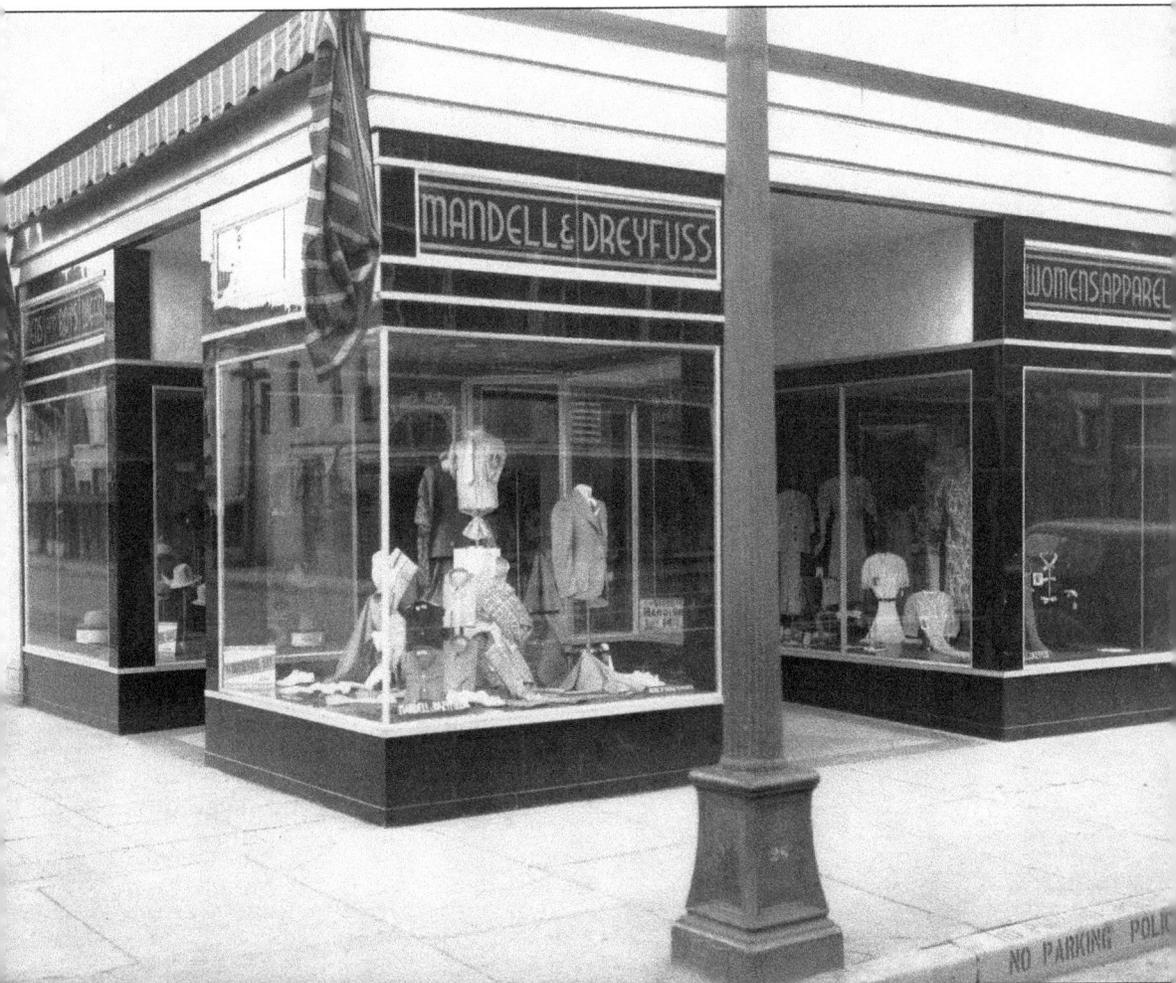

Seen here is the Mandell and Dreyfuss store during the 1930s. Julian Dreyfuss and his wife, Julia, immigrated to the United States in 1912. By 1920, they had settled in Albuquerque and partnered with the Mandell family in a ladies wear store, pictured. By 1938, the business name had been changed from Mandell and Dreyfuss to Julian Dreyfuss. Dreyfuss, a nephew of the Weillers, served as president of Congregation Albert in 1947 and 1948. (Courtesy of the Albuquerque Museum.)

Arthur Ravel served as president of Congregation B'nai Israel, a post his daughter later held in the 1970s. During Arthur's early years in Columbus, New Mexico, he was captured by Pancho Villa's men. The exciting account is recorded in *Jewish Pioneers of New Mexico: The Ravel Family*: "The Villanistas dragged Arthur from his one-room house. . . . His captors smashed the [Ravel] storefront, pushed Arthur inside, and ordered him to open the safe. Arthur played dumb. The Mexicans then marched Arthur to the Commercial Hotel. . . . Villa's men set the hotel on fire. The Villanistas saved Arthur, ordering him to open the safe of the Columbus State bank. As his captors drove him toward the bank, gunshots killed both Villanistas." (Courtesy of Congregation B'nai Israel.)

The Ravel family began immigrating to the United States from Lithuania in the late 19th century. Arriving at the port of Galveston, Texas, the family came to Albuquerque via southern New Mexico. After they relocated to Albuquerque in the 1930s, Arthur and Louis Ravel operated feed and farm stores throughout Albuquerque, as described in this 1956 ad that appeared in the guide to Albuquerque's 250th anniversary. (Courtesy of the Albuquerque Public Library Special Collections.)

American-born Sidney Weil arrived in Albuquerque in 1916. He was elected to the city commission in Albuquerque, served as director of the Albuquerque Chamber of Commerce, and was a member of Kiwanis, B'nai Brith, and the Albuquerque Country Club. (Courtesy of the University of New Mexico Center for Southwest Research.)

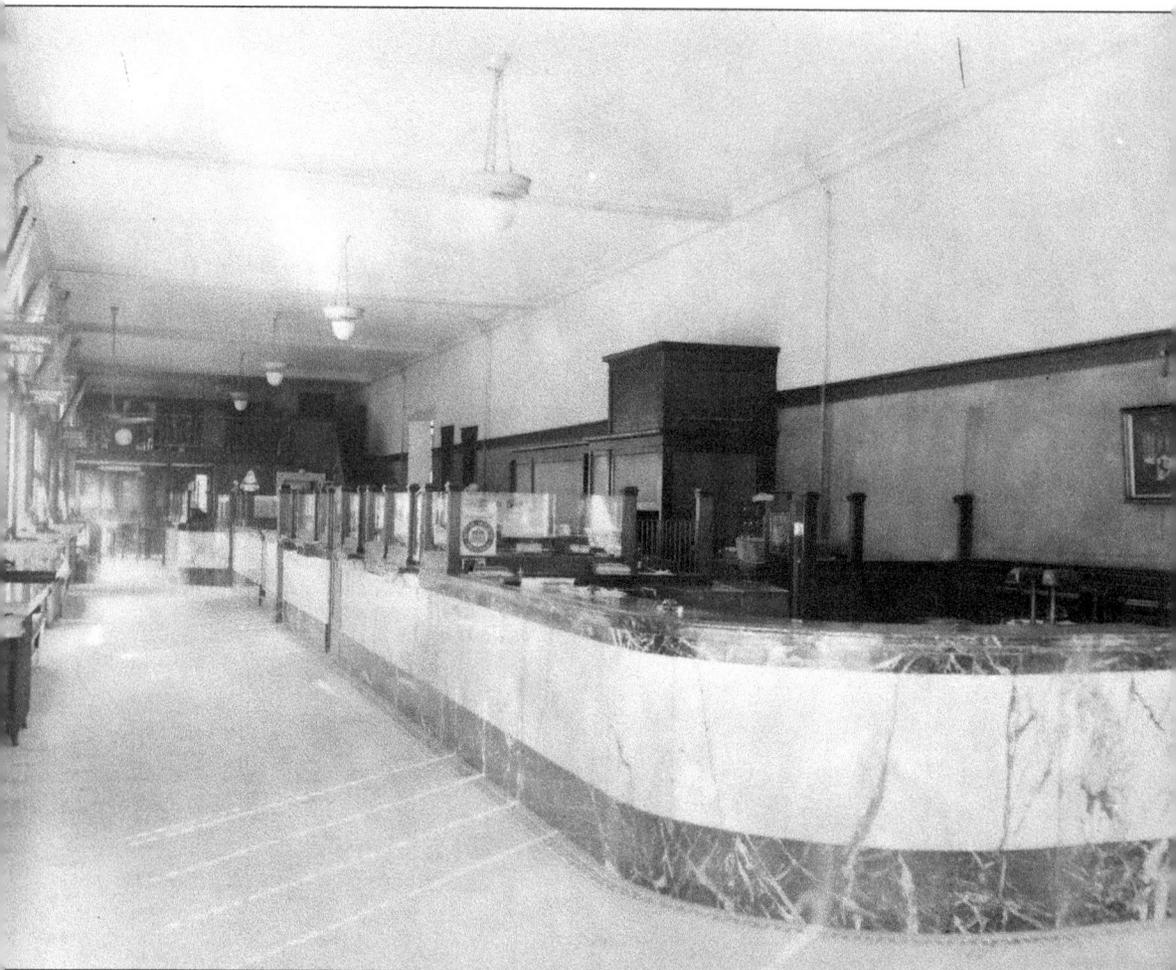

Legend has it that Louis Ilfeld saved this Albuquerque bank during the Depression. To inspire confidence among his customers, Jack Raynolds, president of Albuquerque's First National Bank, asked his longtime friend Ilfeld to overtly deposit a large amount of cash. Apparently, the plan worked. (Courtesy of the Albuquerque Museum.)

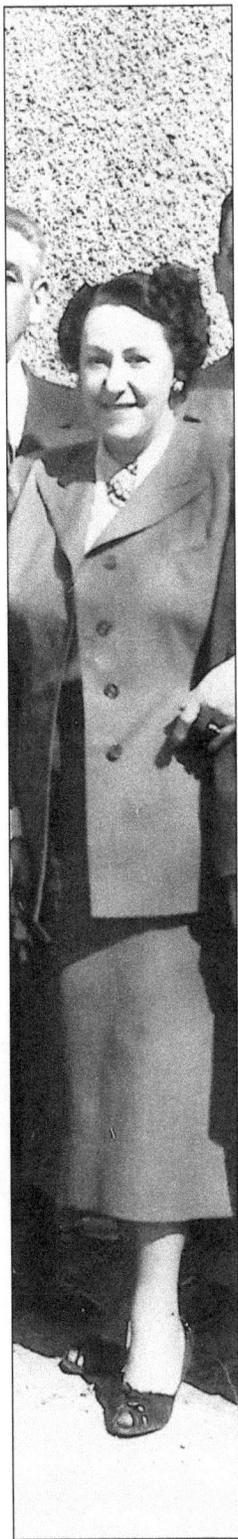

Pioneer Wear grew to be New Mexico's largest clothing manufacturer, employing nearly 100 people. Leopold Seligman and his family started the firm in 1938. The Seligmans, who had operated a large and prosperous clothing factory in their hometown, escaped Germany on the eve of the Second World War to live near their relatives in New Mexico. In addition to her work at Pioneer Wear, Hanni Seligman (right) introduced local girls to the domestic arts. She is remembered as a "grande dame" by student Helen Horwitz, who recalls admiring the Rembrandt painting that the Seligmans smuggled out of Europe. (Courtesy of the Israel C. Carmel Archive at Congregation Albert.)

Si Goldman was born in Russia, the son of a rabbi, and was raised in Denver. After moving to Albuquerque in 1940, Si and his wife, Becky, bought a general store, converting it into a large western wear and uniform shop. Si served as president of B'nai Israel, and his wife was president of Albuquerque Hadassah, a branch of the women's Zionist organization. (Author's Collection.)

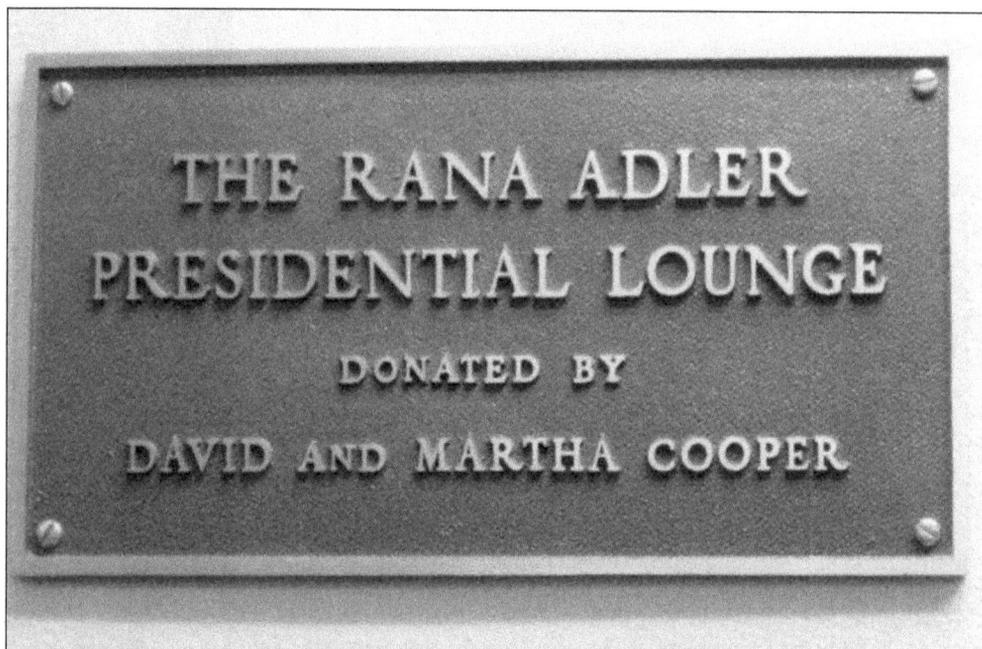

THE RANA ADLER
PRESIDENTIAL LOUNGE

DONATED BY

DAVID AND MARTHA COOPER

Rena Adler (1912–1980) served as executive secretary of the Albuquerque Jewish Welfare Fund for 25 years. She helped resettle refugee families in Albuquerque after World War II. The Presidential Lounge at Congregation B'nai Israel was donated and named in her honor by David and Martha Cooper, longtime Albuquerque businesspeople. (Author's Collection.)

In the photograph to the right is
Irwin Moise, chief justice of the
Supreme Court of New Mexico.
The Moise family of Santa Rosa
attended religious services at
Congregation Albert, a trip of 140
miles each way. Moise served as
president of Congregation Albert
in 1955 and 1956. (Courtesy of
the Museum of New Mexico.)

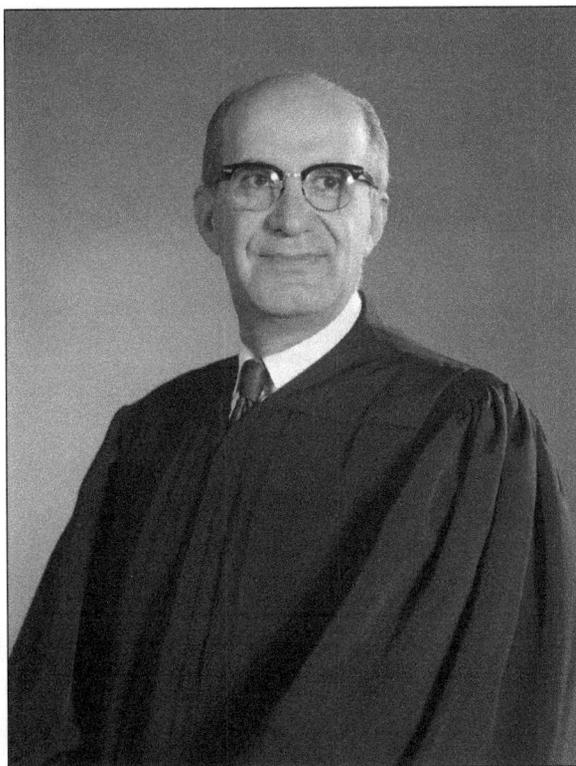

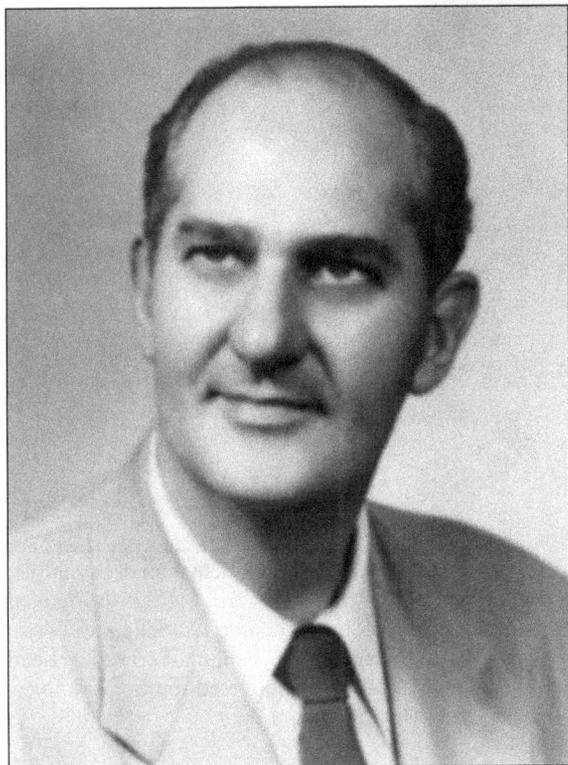

Lewis R. Sutin (1908–1992) moved
to Albuquerque in 1946 after
earning a law degree from the
University of Illinois. He practiced
law in Albuquerque with partner
Irwin S. Moise and served on the
New Mexico Court of Appeals. He
also served as the first University
of New Mexico Hillel advisor, as
president of Congregation Albert,
and as president of the Jewish
Welfare Federation. (Courtesy
of the Israel C. Carmel Archive
at Congregation Albert.)

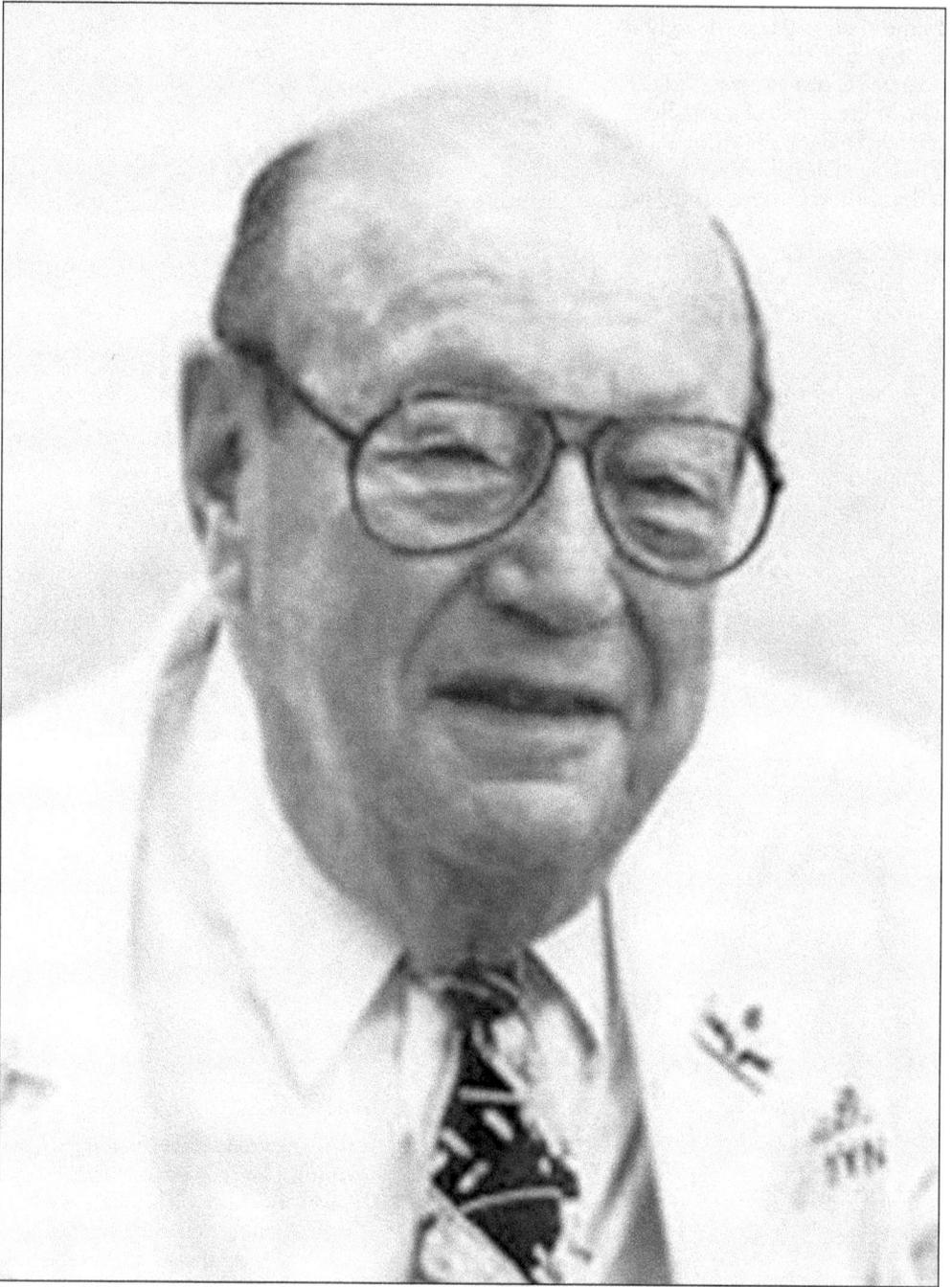

Randolph "Randy" Seligman (1915–1996), a son of Julius and Blanche Block Seligman of Bernalillo, received his Jewish education at Congregation Albert. After graduating from Jefferson Medical College in Philadelphia and serving as an army major in the Pacific theater, Dr. Seligman began medical practice as an obstetrician and gynecologist in Albuquerque. Seligman served as head of the OB/GYN program at Bernalillo County Indian Hospital. He delivered some 10,000 New Mexico babies during his career. (Courtesy of the *New Mexico Jewish Link*.)

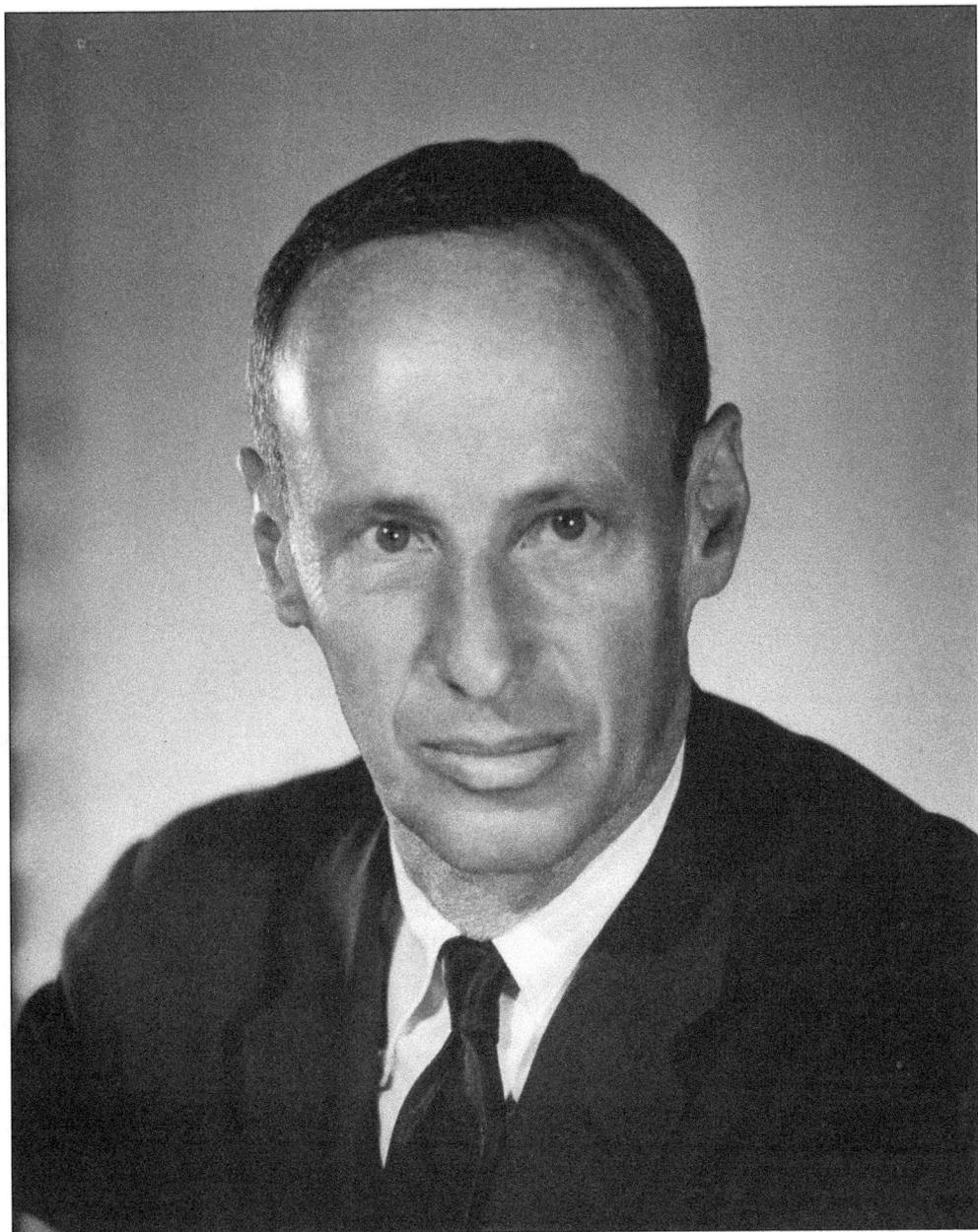

Robert Nordhaus, a son of Max and Bertha Staab Nordhaus, attended Yale University and then opened an Albuquerque law firm specializing in Native American issues. (Courtesy of Betty Messeca.)

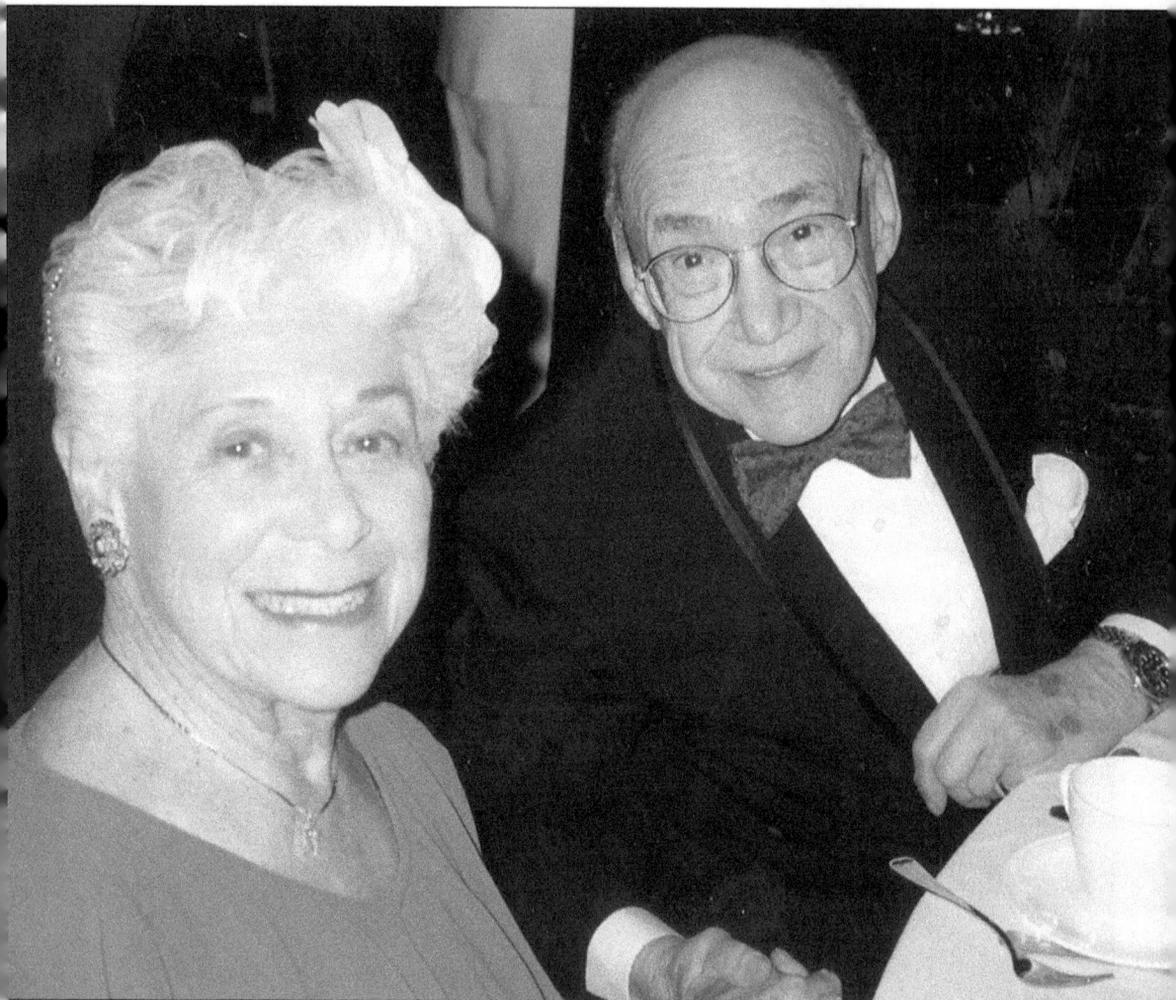

Shirley and Harold Gardenswartz both grew up in Denver and were married in 1940. In 1939, they opened H. Cook Sporting Goods on Central Avenue, which they ran for 25 years. Harold was president of the Jewish Federation, and Shirley was president of Hadassah. (Courtesy of the *New Mexico Jewish Link*.)

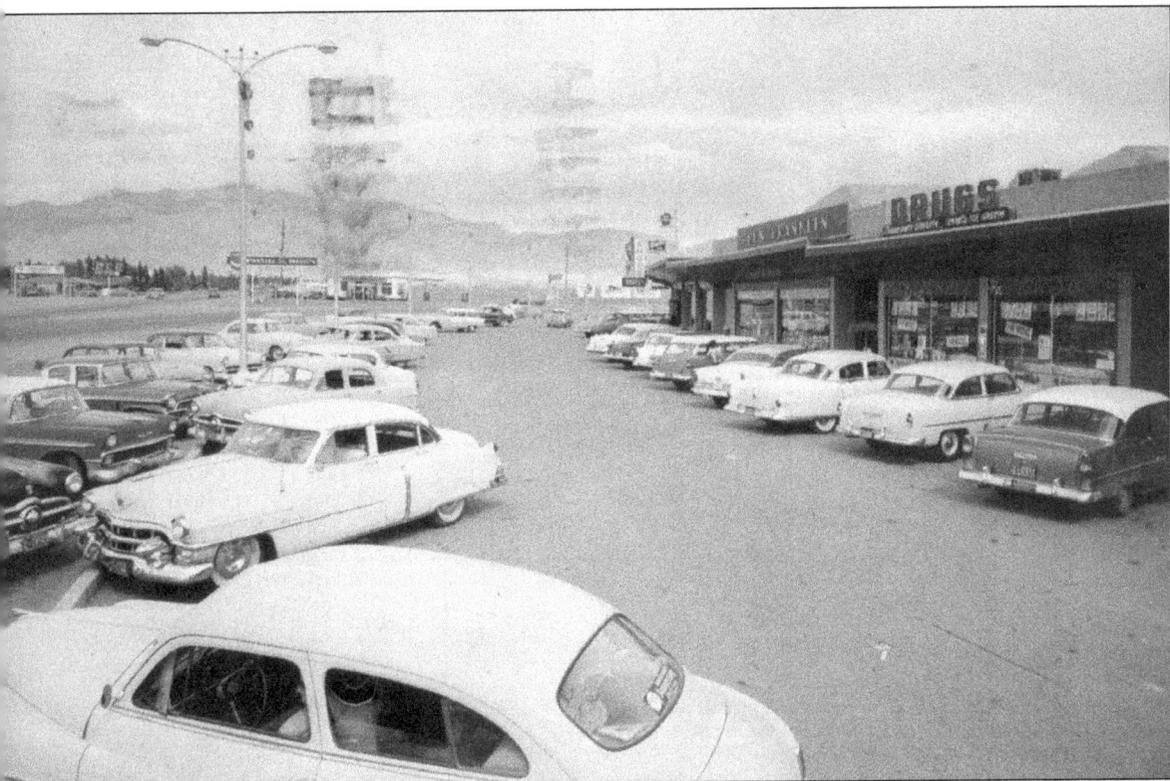

Hoffmantown Shopping Center opened in 1951 at the corner of Wyoming and Menaul Boulevards. It was one of the many building projects spearheaded by Samuel Hoffman (1901–1959). Hoffman built a residential housing development, Hoffmantown, between Pennsylvania and Wyoming Boulevards in the Northeast Heights of Albuquerque. Tragically, in October 1959, Hoffman killed himself and his wife of 36 years. (Courtesy Nancy Tucker.)

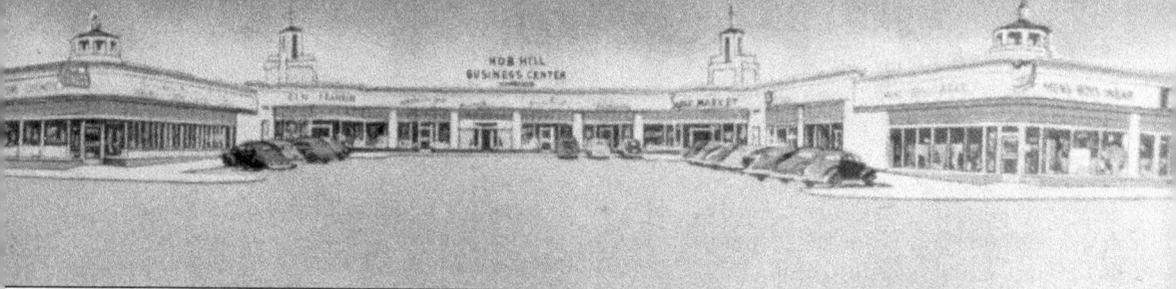

Above is a photograph of Nob Hill Business Center, located at 3500 East Central Avenue. Nob Hill was an early Albuquerque suburb, located east of downtown and the University of New Mexico. In the 1940s and 1950s, Jewish citizens began to move their homes and businesses into Nob Hill from downtown. (Courtesy of the University of New Mexico Center for Southwest Research.)

Four

NATIVE AMERICAN TRADE AND TOURISM

Exchange between Jewish businesspeople and Native Americans began early. Solomon Bibo, who had come to New Mexico to work for his relatives, the Spiegelbergs, conducted business with members of Acoma Pueblo, 60 miles west of Albuquerque, in the 1880s. Eventually, Bibo married an Acoma woman, Juana Valle, and was elected governor of the pueblo in 1885 and for several additional terms.

Later, Jewish businesspeople created opportunities for visitors to purchase Native American arts and handcrafts. Bernalillo's Siegfried Seligman sent employees to purchase pottery from local pueblos. A particular focus for Native American arts in Albuquerque was Fred Harvey's Alvarado Hotel, which opened in 1902. The Hotel's Indian Curio Room was overseen by Herman Schweizer, a German-born Jew who was considered Harvey's "anthropologist." Navajos knew Schweizer from his many trips to purchase Navajo blankets.

Other trading posts, such as Maisel's and Wright's, employed Native American artisans who attracted tourists to their businesses and created additional markets for Native American goods. Later, businesses such as Manny Goodman's Covered Wagon catered to tourists traveling the "Mother Road," Route 66, which ran directly through Albuquerque.

In later years, Jewish citizens saw other opportunities for tourism and recreation. Robert Nordhaus, an attorney and avid outdoorsman, envisioned and eventually founded the Sandia Peak Ski area and 2.7-mile-long tramway.

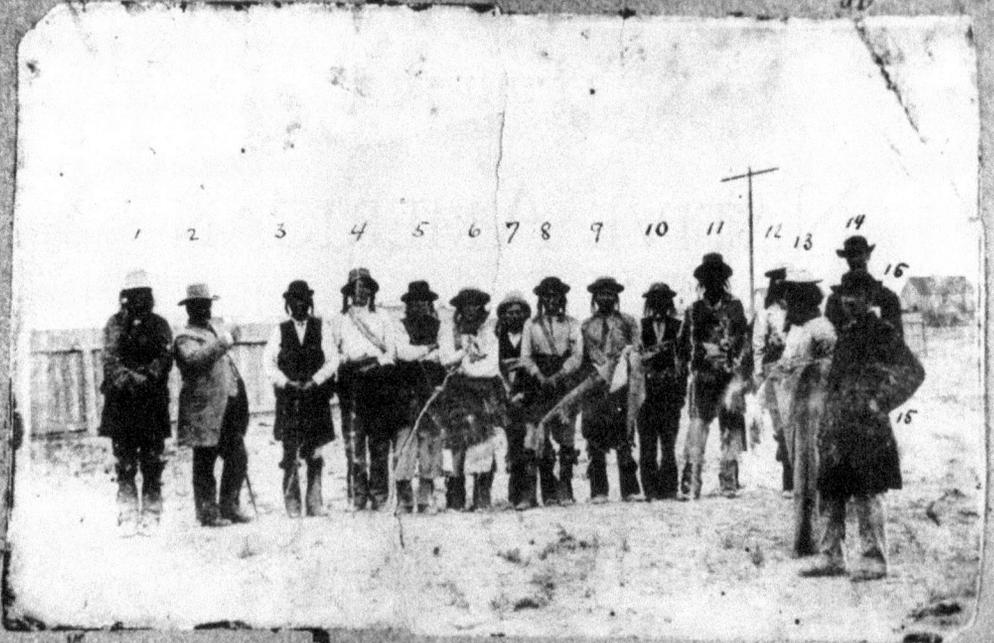

Solomon "Don Solomono" Bibo (1853–1934), son of a cantor, had business contracts with the pueblos, aided by his knowledge of English, German, Yiddish, and Keresan. Bibo married an Acoma Pueblo woman, Juana Valle, who adopted the Jewish religion. He was elected governor of Acoma in 1885 and served for three additional terms. Here he is seen, identified as "15," with his officers. (Courtesy of the Bloom Southwest Jewish Archives, University of Arizona Library Special Collections.)

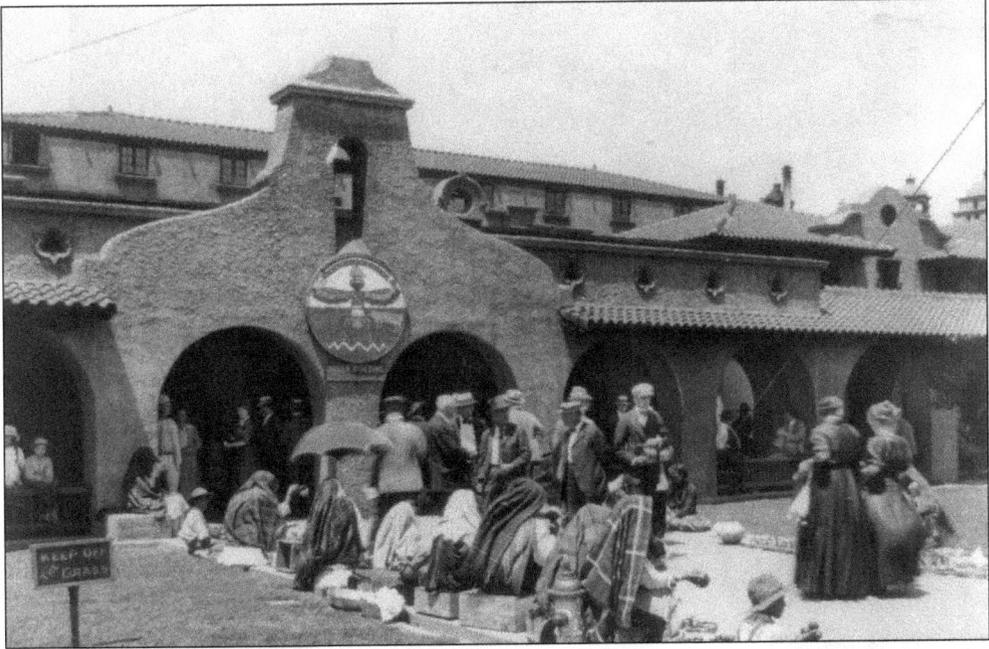

The Fred Harvey Company's Alvarado Hotel opened in 1902 in Albuquerque. Designed by architect Mary Colter, one of its many features was the Indian Curio building, where tourists were directed after they exited the train. The building featured rugs, pottery, and other Native American goods artfully presented in a Southwestern-themed room. (Courtesy of the University of New Mexico Center for Southwest Research.)

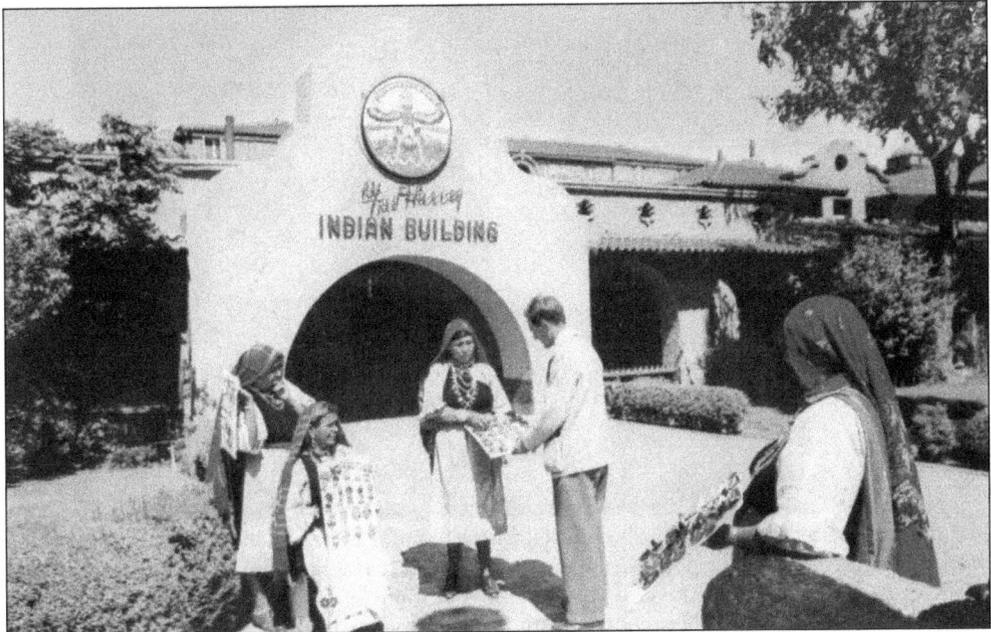

Native Americans often demonstrated their craft work in front of the Alvarado Indian Building. Other businesses, such as Maisel's and Wright's trading posts, also employed Native American demonstrators in order to attract customers. (Courtesy of Stan Feinstein.)

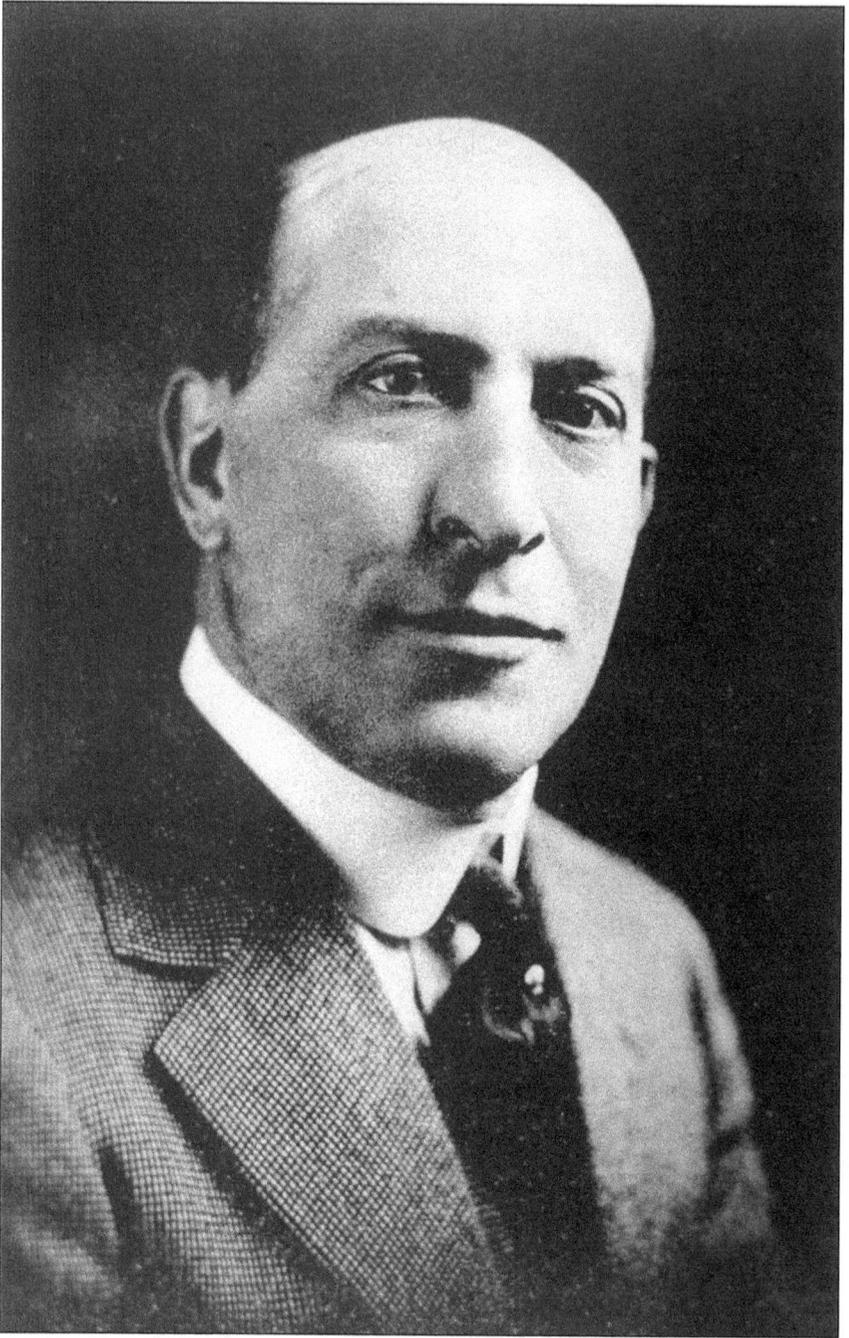

Herman Schweizer (1871–1943), who arrived in the United States in 1885, was considered the anthropologist of the Fred Harvey Company. As manager of the Fred Harvey Indian department in Albuquerque, Schweizer traveled throughout the Southwest, purchasing Native American handicrafts. Apparently the Navajos called him Hostean Tsani, translated as "bald-headed man." According to Fred Harvey biographer Stephen Fried, Schweizer's personal collections included those purchased from the Seligman and Spiegelberg families. Schweizer is buried at Congregation Albert cemetery. (Courtesy of the Museum of New Mexico.)

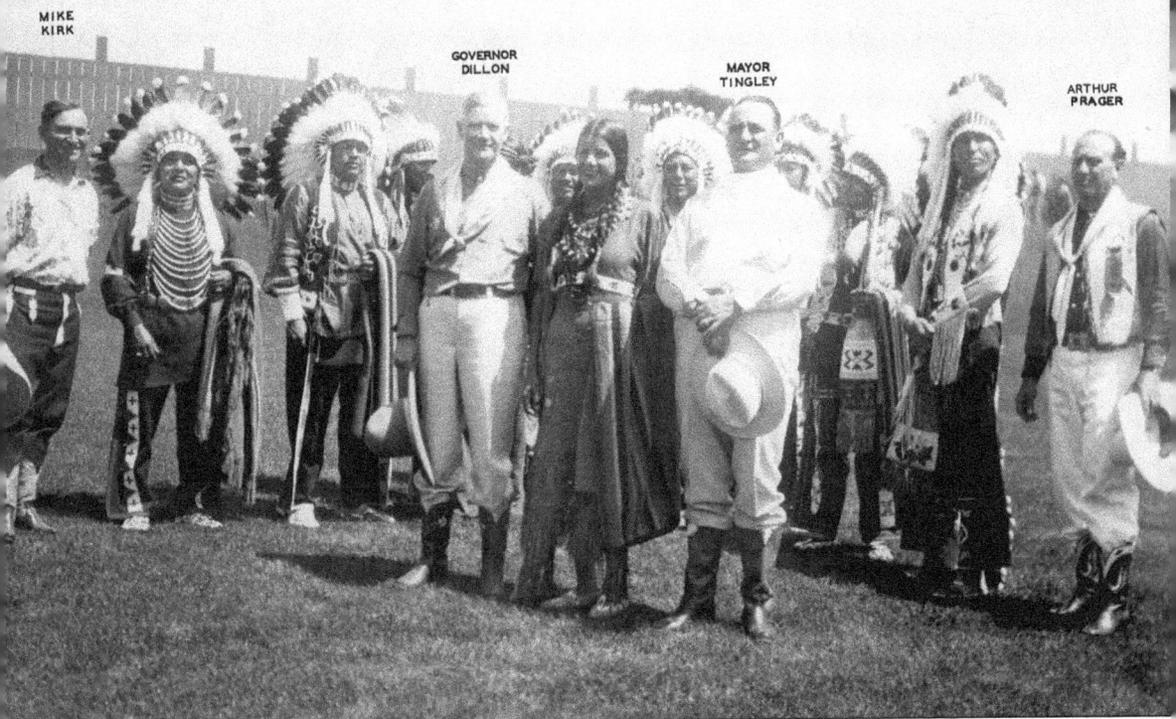

ALBUQUERQUE NEW MEXICO
AUGUST 1931

MIKE KIRK

GOVERNOR DILLON

MAYOR TINGLEY

ARTHUR PRAGER

Arthur Prager is pictured above with state and local officials and Native Americans in Albuquerque, 1931. Prager served as president of the Public Service Company of New Mexico and was a member of Congregation Albert. He was also heavily involved in organizing and promoting Albuquerque's First American Pageant and Golden Jubilee in 1935. The Prager and Jaffa families were business partners in Roswell, New Mexico. (Courtesy of the University of New Mexico Center for Southwest Research.)

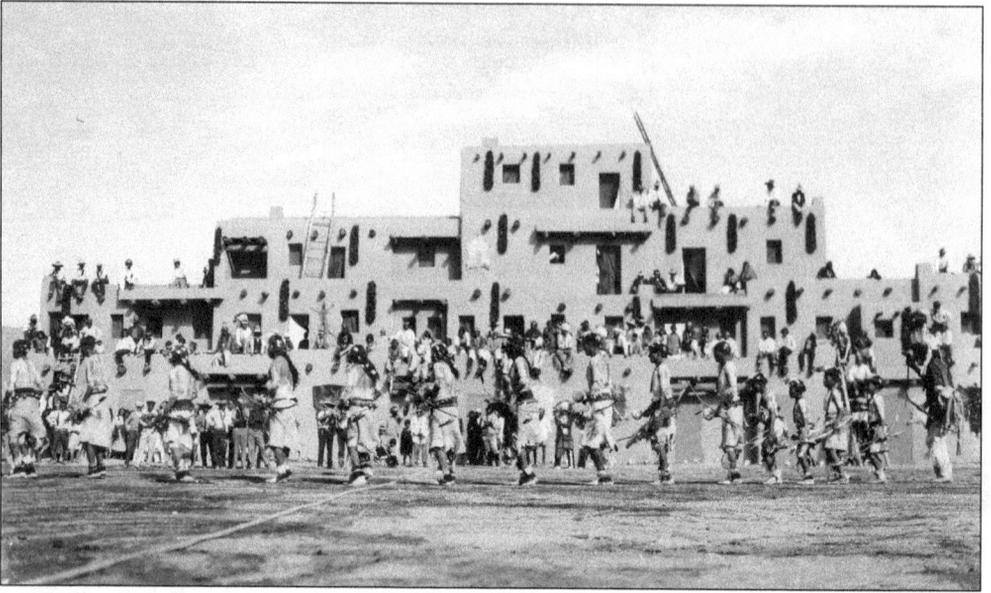

The First American Pageant, an event organized by the Albuquerque Chamber of Commerce, was designed to compete with Gallup's authentic Indian Ceremonial. A replica pueblo village was built. The event ran for several years but eventually folded due to the Depression. (Courtesy of the University of New Mexico Center for Southwest Research.)

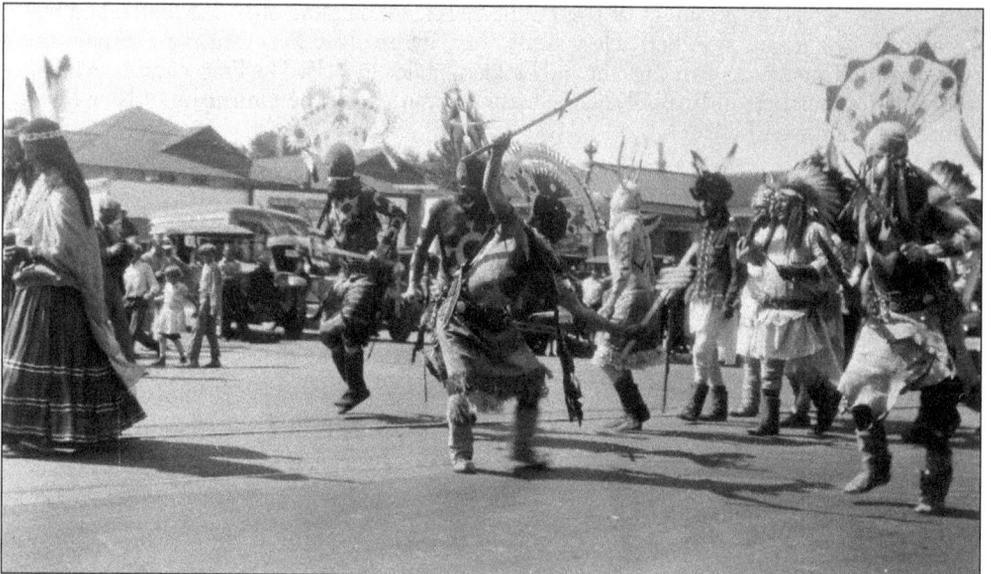

This image was taken during the First American Pageant parade, an event spearheaded by Arthur Prager and Sol Benjamin. (Courtesy of the University of New Mexico Center for Southwest Research.)

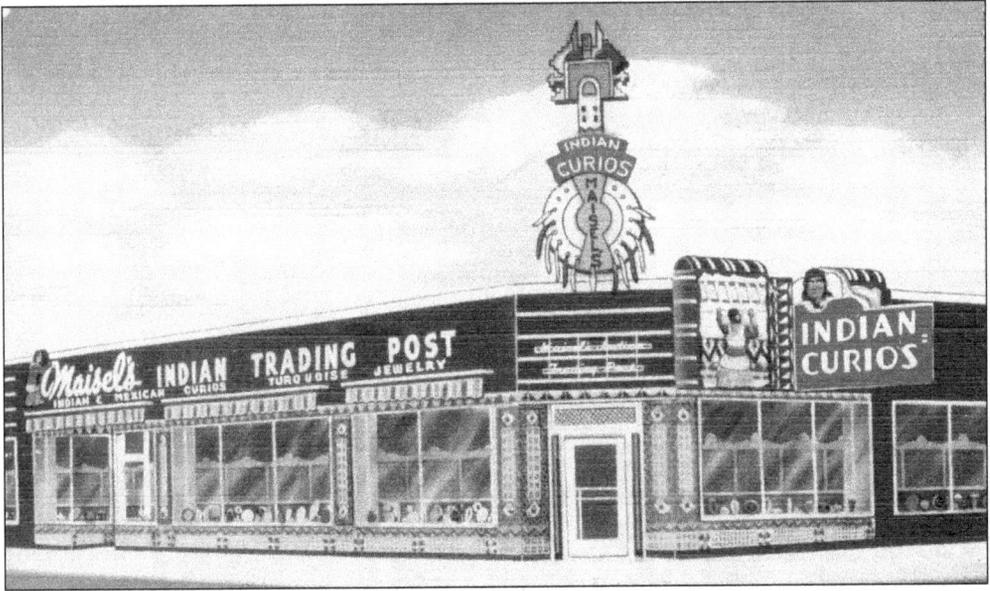

Maisel's Indian Trading Post, at 400 West Central Avenue, was operated by Jewish merchants Maurice and Syma Maisel. Their store was designed by famed architect John Gaw Meem in the distinctive Pueblo Deco style. Ten different Native American artists worked to create the store's frieze. Tourists were attracted by the design and to the Native American artisans working in the shop. The business is still in operation today. (Courtesy of Nancy Tucker.)

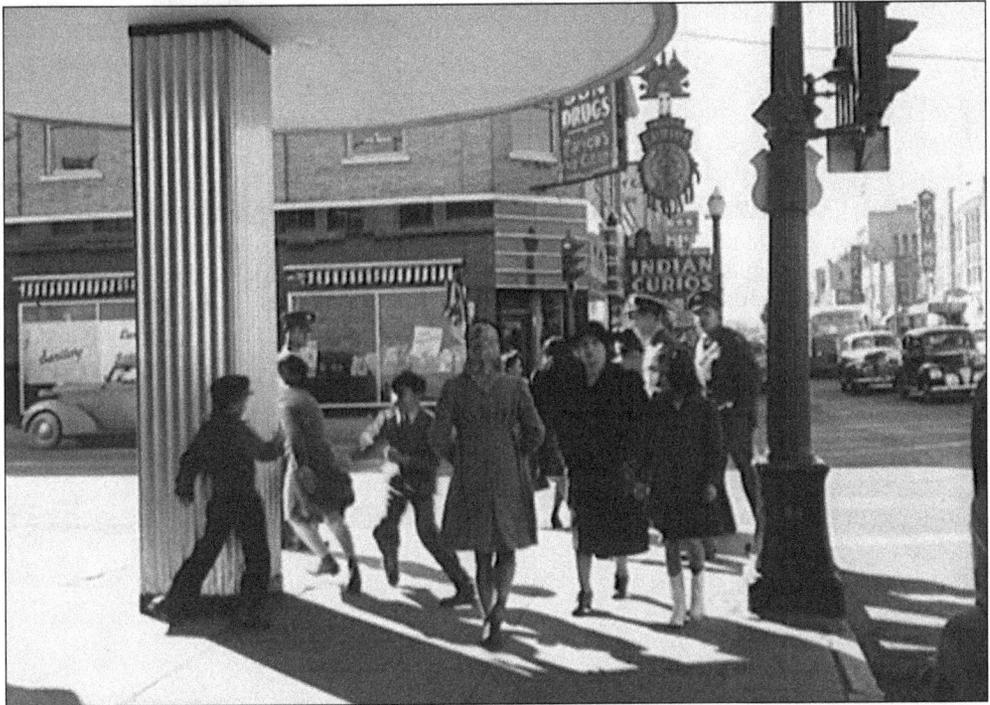

In this view of a bustling downtown Albuquerque in 1943, the Maisel's Indian Curios sign appears on the left. The business still remains at this location. (Photograph by John Collier, courtesy of the Library of Congress.)

Wright's, a pueblo-style trading post, was built at Fourth Street and Gold Avenue SW in 1907. The business was purchased by the Chernoffs, who ran a business in Mexico prior to coming to Albuquerque in the 1930s. Although the original building no longer stands, the business remains in the family. (Courtesy of Stan Feinstein.)

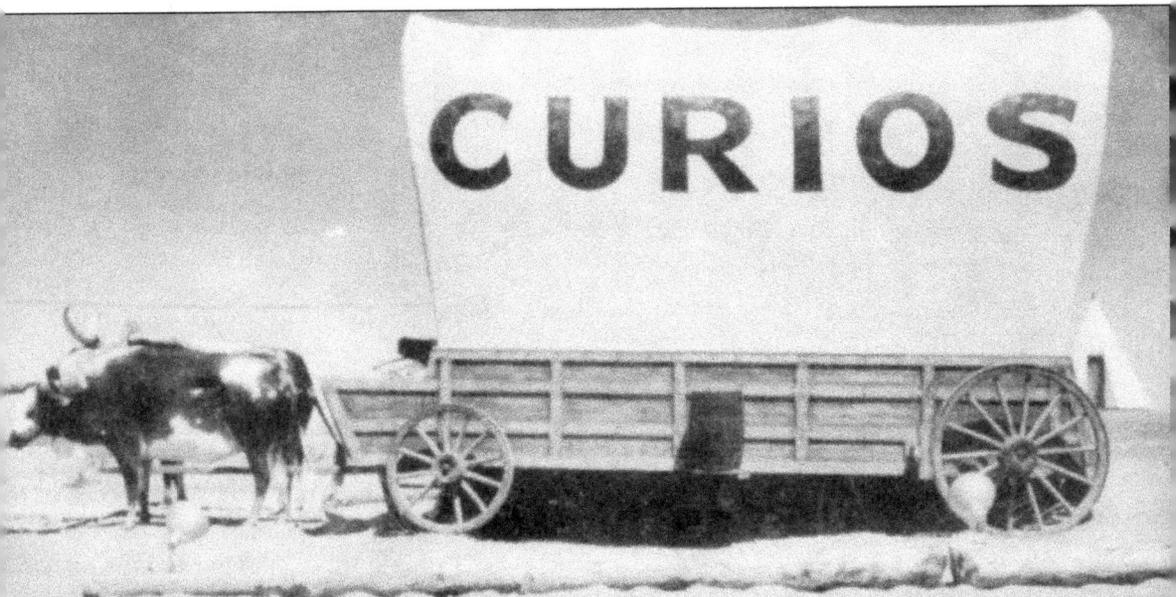

SEE THE LARGEST COVERED WAGON IN THE WORLD
ALBUQUERQUE, NEW MEXICO

A Route 66 institution, the Covered Wagon, operated by Manny Goodman, was a fixture along the tourist highway. Goodman eventually moved his business to Albuquerque in 1937 and installed a 152-pound turquoise nugget in the store's window. (Courtesy of Nancy Tucker.)

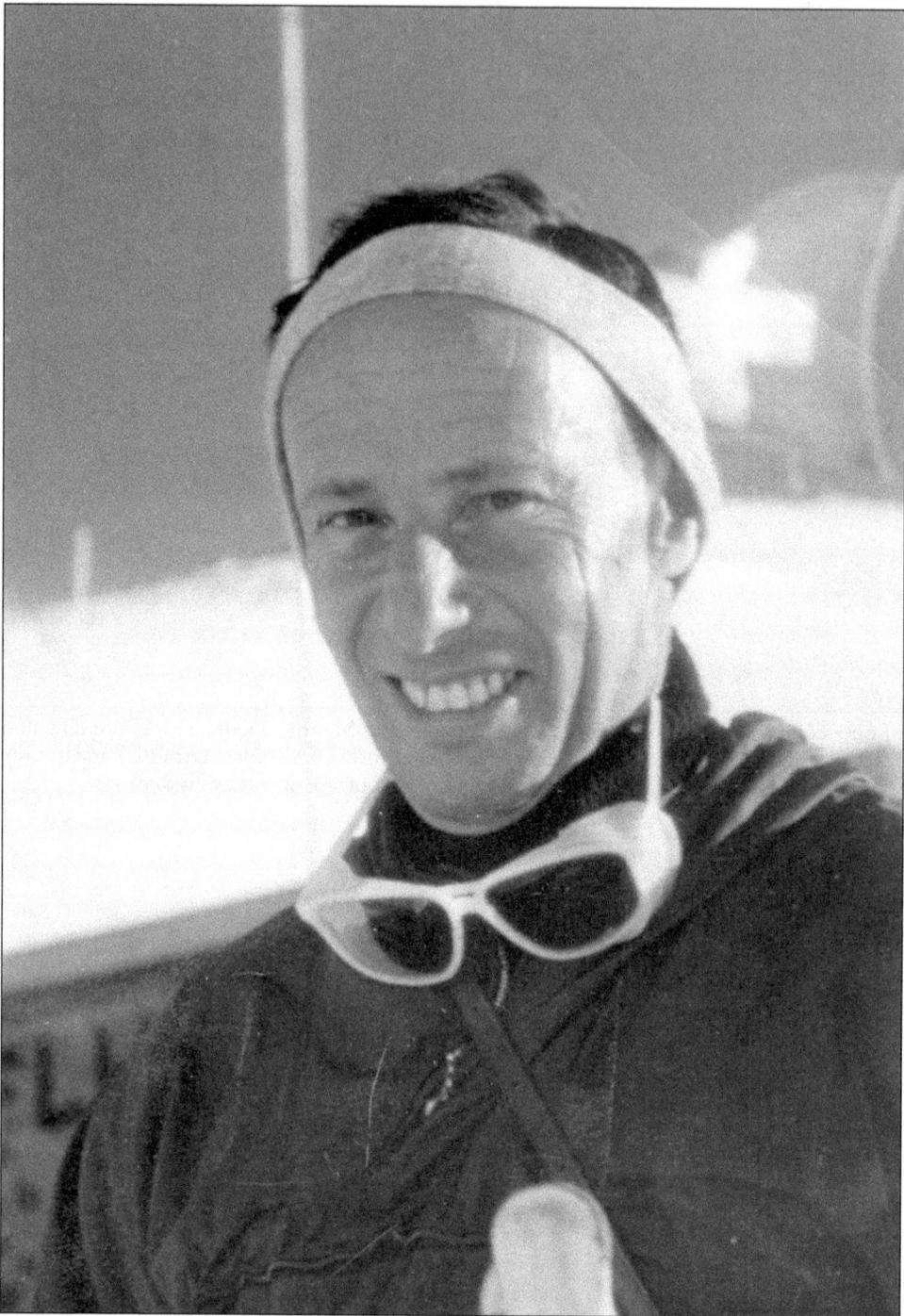

The Sandia Peak Tramway was founded by Robert Nordhaus (1909–2007), son of New Mexico pioneer merchants Max Nordhaus and Bertha Staab Nordhaus. The tram is an Albuquerque tourist destination and the longest aerial tram of its kind. Nordhaus, an avid skier, was inspired to build the tram as a result of his experience in Europe during World War II, when he served in the U.S. Army's 10th Mountain Division. (Courtesy of Betsy Messeca.)

Five

CIVIC AND SOCIAL LIFE

In addition to the rich social opportunities provided by the town's two Jewish congregations, Jewish citizens were instrumental in helping to found and build many of Albuquerque's secular, civic, and social institutions. From the start, Albuquerque's Jewish merchants were very active in local Masonic groups, as were their counterparts in other New Mexico towns. In the 1890s, Alfred Grunsfeld helped found the city's grand Commercial Club and served as its first officer. Thirty years later, Jewish citizens were among those who helped found and support the Albuquerque Country Club, which was always open to Jews.

The city's earliest Jewish citizens, while boosters of the community, were not particularly supportive of New Mexico statehood. Despite their protests, New Mexico achieved statehood in 1912. Once admitted, New Mexico's Jewish residents could not have been more patriotic. During World War I, a flag was sewn with stars for each of Congregation Albert's service members. Later, during World War II, both congregations welcomed service people stationed at Kirtland Air Force Base to attend services and celebrations.

The community celebrated its own landmarks, such as the 50th anniversary of Congregation Albert, which took place in 1947 at the Alvarado Hotel, the site of many large social gatherings. Of course, families were just as likely to gather for outings to the Jemez Mountains at each other's homes, or even for Sunday-night picnics at local parks. Before Albuquerque's geographic expansion, many families were neighbors, seeing each other on a daily basis.

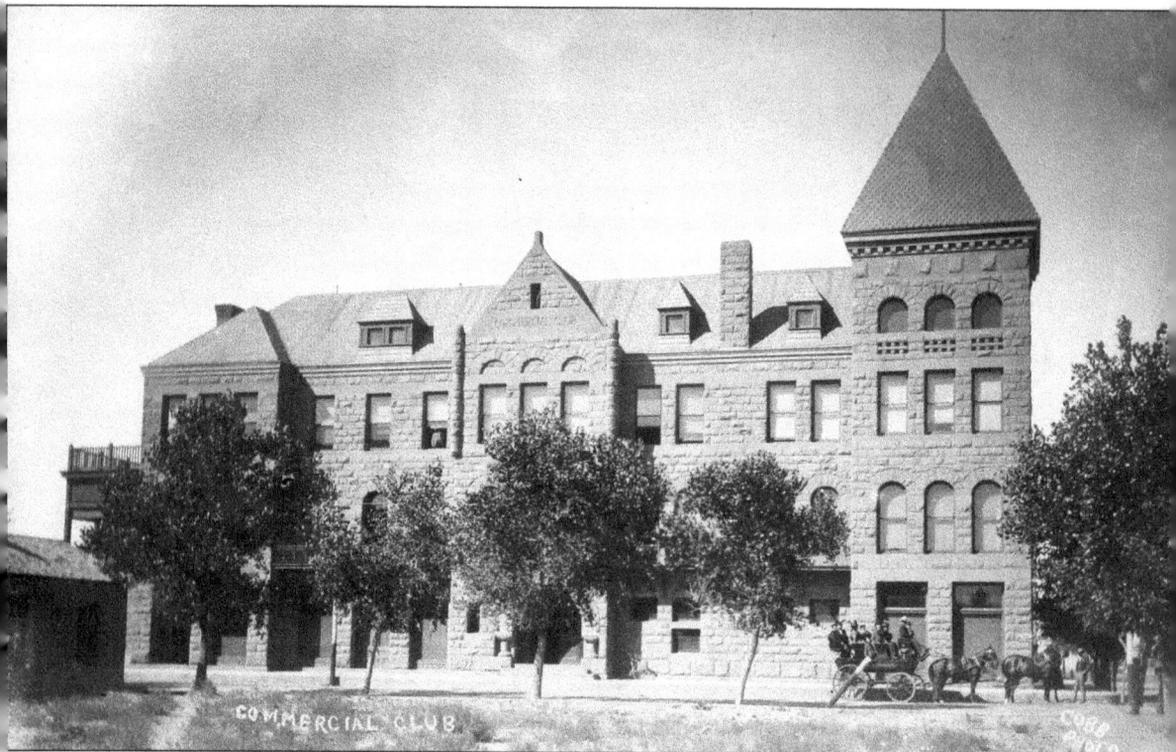

Albuquerque's Commercial Club was founded in 1890 by a group of prominent businessmen, including Albert Eisemann, a wool dealer, and Alfred Grunsfeld, who also served as one of the club's first officers. The club touted Albuquerque's health benefits, claiming "Albuquerque's climate nurtures sovereign remedy for all diseases of the lungs" and petitioned city council for the building of a hotel. In 1903, Pres. Theodore Roosevelt accepted an honorary club membership during a Southwest speaking tour. (Courtesy of the University of New Mexico Center for Southwest Research.)

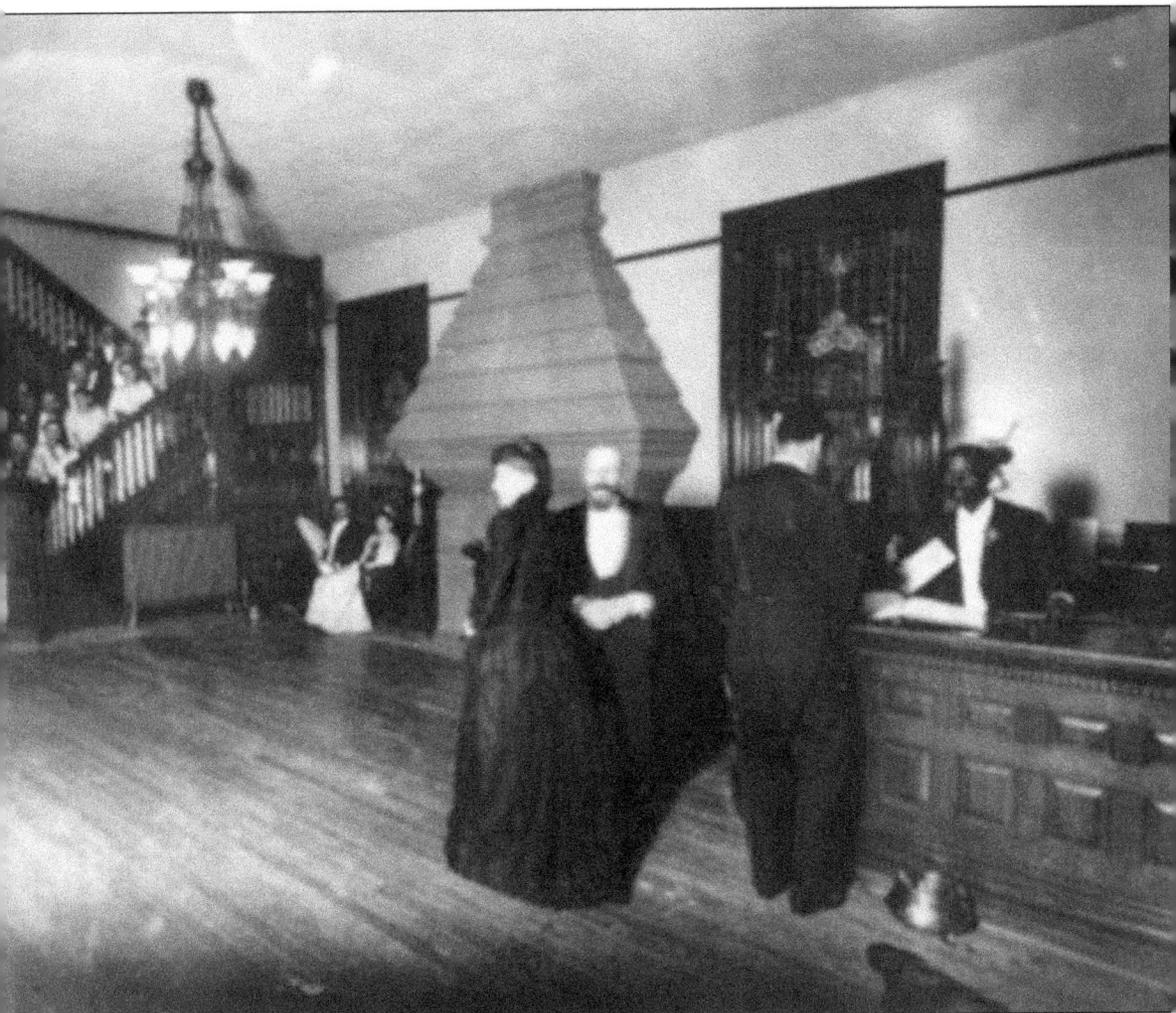

This photograph was taken during an opening-night party at the Commercial Club. Henry Jaffa and his wife are pictured at the reception desk. Jaffa was Albuquerque's first mayor. (Courtesy of the University of New Mexico Center for Southwest Research.)

The Elks Opera House, at the corner of Gold Avenue and Fifth Street, is visible in the right of the picture above. Jewish citizens were among the founders of the Albuquerque Elks Lodge; Alfred Grunsfeld and David Weinman assumed leadership positions. The Commercial Club is visible on the left. (Courtesy of the University of New Mexico Center for Southwest Research.)

108

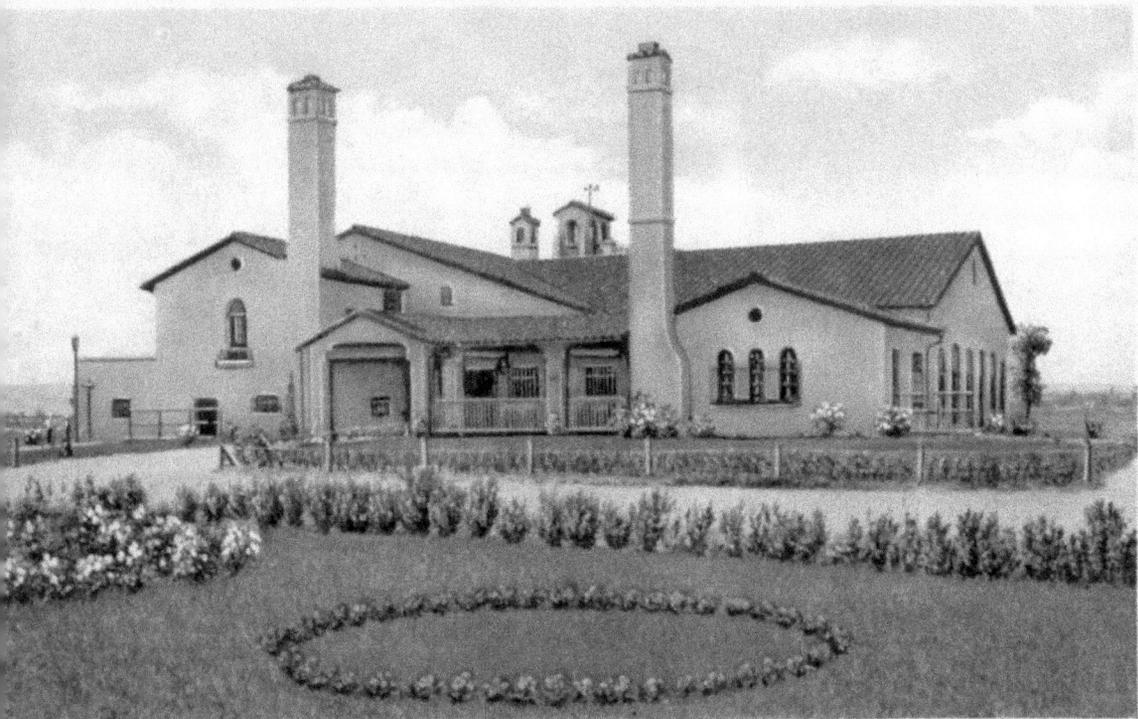

COUNTRY CLUB, ALBUQUERQUE, N. M. 2386-30

Membership at the Albuquerque Country Club, illustrated in this 1910 postcard, was open to Jews. Arthur Prager, a member of Albuquerque's Jewish community, served as president of the club in 1916. Prager subsequently served as president of the Albuquerque Chamber of Commerce in 1923. (Courtesy of Nancy Tucker.)

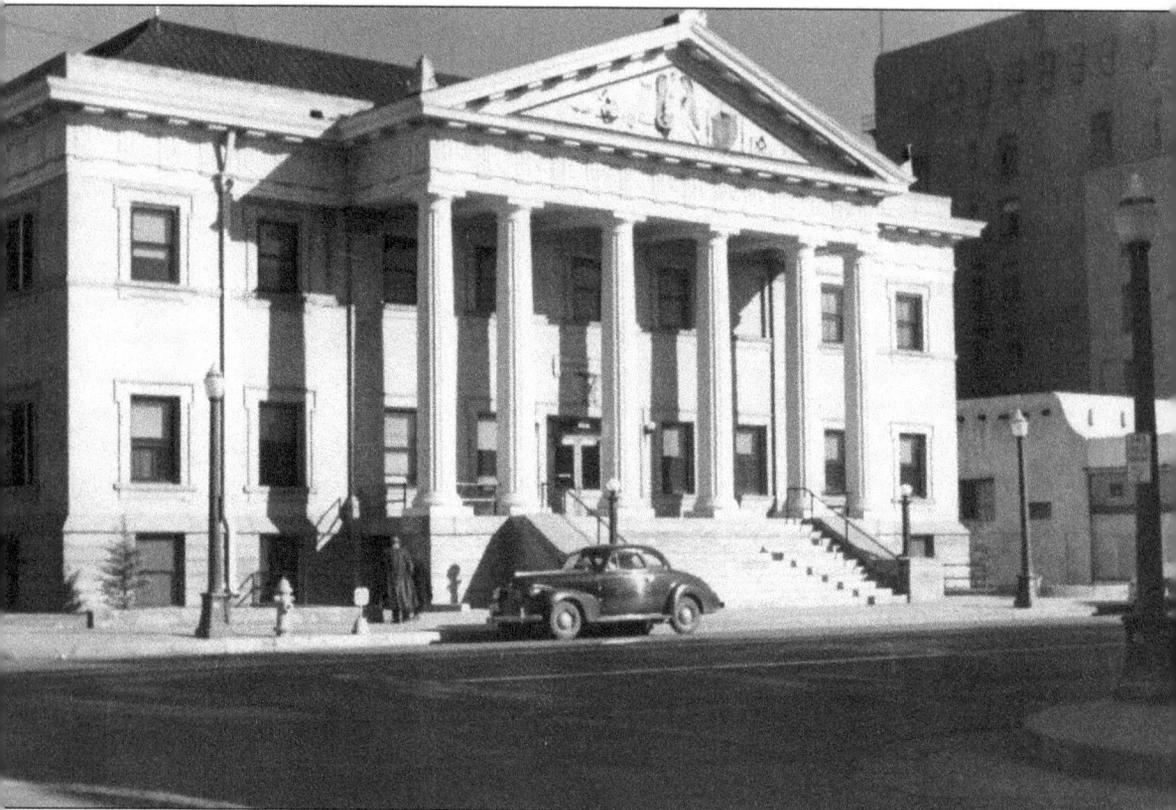

The Freemasons were another fraternal group that welcomed Jewish members, not only in Albuquerque but throughout New Mexico. The Masons' organization helped break ground for Congregation Albert. The Albuquerque Masons' building was located at Central and Seventh Avenues. (Author's Collection.)

William F. "Willi" Myer (1889–1980) was 27 years old and working as a traveling salesman for the Charles Ilfeld Company when he registered for the draft in 1917. Years later, he served as chairman of the Albuquerque Joint Distribution Committee for International Relief. Fifteen other young men in Congregation Albert served in World War I. A flag with a star for each serviceman was sewn and displayed at the synagogue. (Courtesy of the Israel C. Carmel Archive at Congregation Albert.)

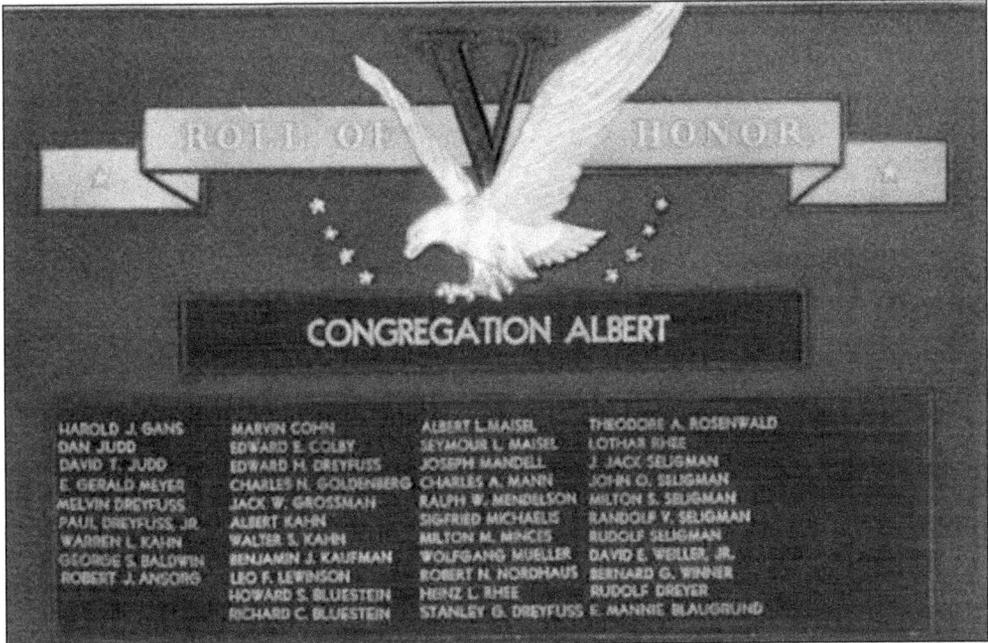

ROLL OF HONOR

CONGREGATION ALBERT

HAROLD J. GANS	MARVIN COHN	ALBERT L. MAISEL	THEODORE A. ROSENWALD
DAN JUDD	EDWARD E. COLBY	SEYMOUR L. MAISEL	LOTHAR RHEE
DAVID T. JUDD	EDWARD H. DREYFUSS	JOSEPH MANDELL	J. JACK SELIGMAN
E. GERALD MEYER	CHARLES N. GOLDENBERG	CHARLES A. MANN	JOHN O. SELIGMAN
MELVIN DREYFUSS	JACK W. GROSSMAN	RALPH W. MENDELSON	MILTON S. SELIGMAN
PAUL DREYFUSS, JR.	ALBERT KAHN	SIGFRIED MICHAELIS	RANDOLF Y. SELIGMAN
WARREN L. KAHN	WALTER S. KAHN	MILTON M. MINCES	RUDOLF SELIGMAN
GEORGE S. BALDWIN	BENJAMIN J. KAUFMAN	WOLFGANG MUELLER	DAVID E. WEILER, JR.
ROBERT J. ANSORG	LEO F. LEWINSON	ROBERT N. NORDHAUS	BERNARD G. WINNER
	HOWARD S. BLUESTEIN	HEINZ L. RHEE	RUDOLF DREYER
	RICHARD C. BLUESTEIN	STANLEY O. DREYFUSS	E. MANNIE BLAUGRUND

Over 40 members of Congregation Albert served in the armed forces during World War II. A plaque honoring their service was erected at the synagogue. Guest books from the era show that military personnel stationed in Albuquerque were welcomed to the congregation. (Courtesy of the Israel C. Carmel Archive at Congregation Albert.)

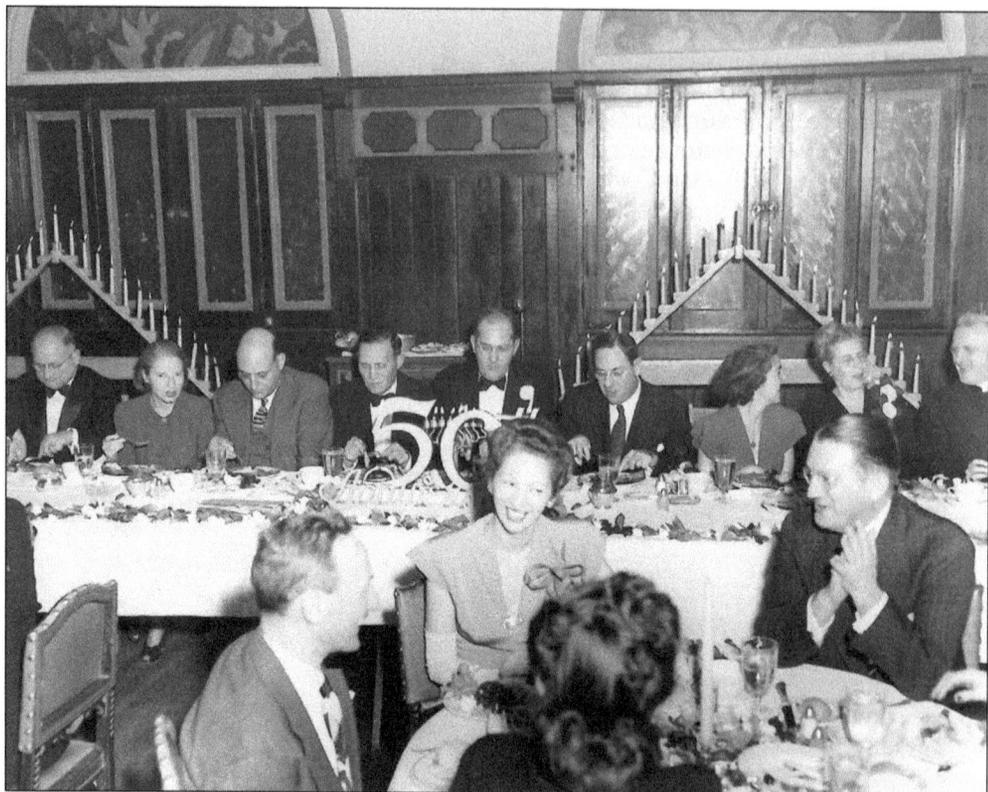

In 1947, Congregation Albert commemorated its 50th anniversary with a celebration and banquet at the Alvarado Hotel. (Courtesy of the Israel C. Carmel Archive at Congregation Albert.)

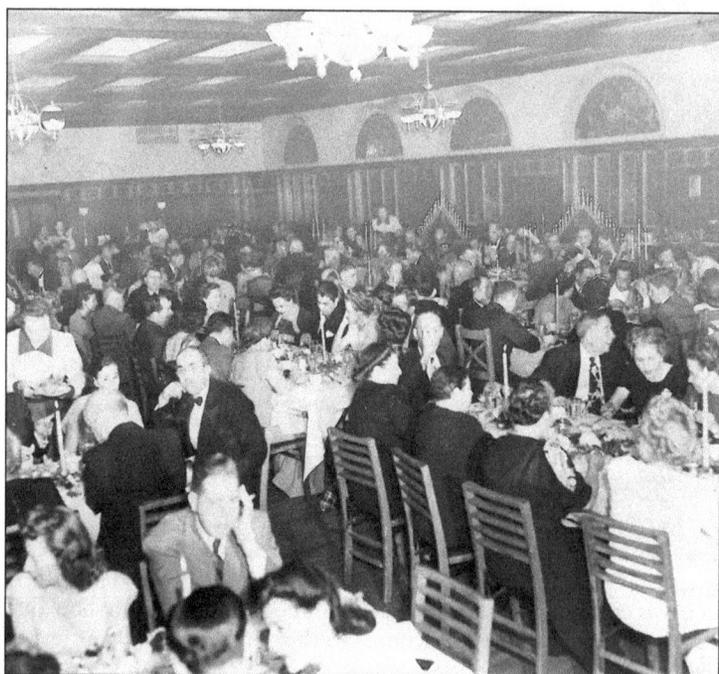

An elegant dinner was served at the Congregation Albert 50th anniversary banquet at the Alvarado Hotel. It was clearly a well-attended event. (Courtesy of the Israel C. Carmel Archive at Congregation Albert.)

MAGIDSON'S

Restaurant

and

Delicatessen

•

Specializing

in

Kosher Style Cooking

•

211 Central Ave., NW

•

(Heart of Downtown
Albuquerque)

Magidson's Restaurant at 211 Central Avenue promoted their "kosher style" food in a 1956 publication. In addition to the Jewish residents who frequented the restaurant, six-term senator Pete Domenici was a regular customer. His family, like those of many other Italian immigrants, were friendly with their Jewish neighbors. It was not easy to keep kosher in Albuquerque; residents who observed kosher dietary laws ordered meats from El Paso or Denver and stored them in freezers. (Courtesy of the Albuquerque Public Library Special Collections.)

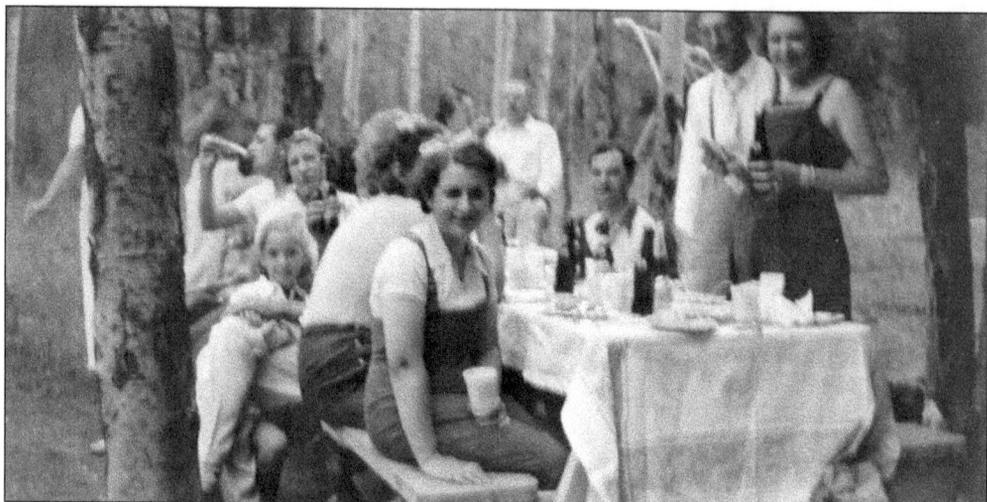

Members of Albuquerque's Jewish community met regularly to socialize, have tea and enjoy card games and other events. Picnics at the Jemez and Sandia Mountains were also popular within the closely knit community. Seated from left to right are Barbara Ansorg, Abe Goldberg, Florence Goldberg, and Annette Ginsburg. On the opposite side of the picnic table are, from left to right, Maurice Osoff, Sam Ginsburg, and Leo and Betty Horwitz. (Courtesy of Helen Horwitz.)

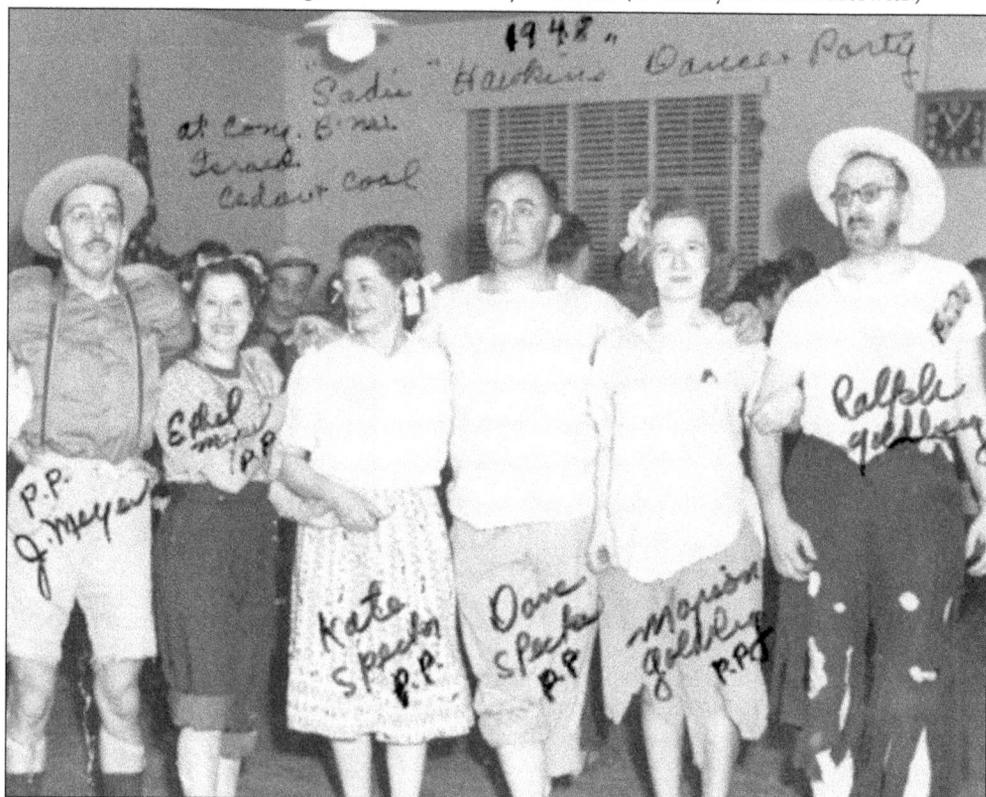

Numerous social events, such as the 1948 Sadie Hawkins dance and party at Congregation B'nai Israel pictured above, were enjoyed over the years. Some were synagogue fund-raisers, such as the Albuquerque performances by Ella Fitzgerald and Duke Ellington. (Courtesy of Marjorie Ross.)

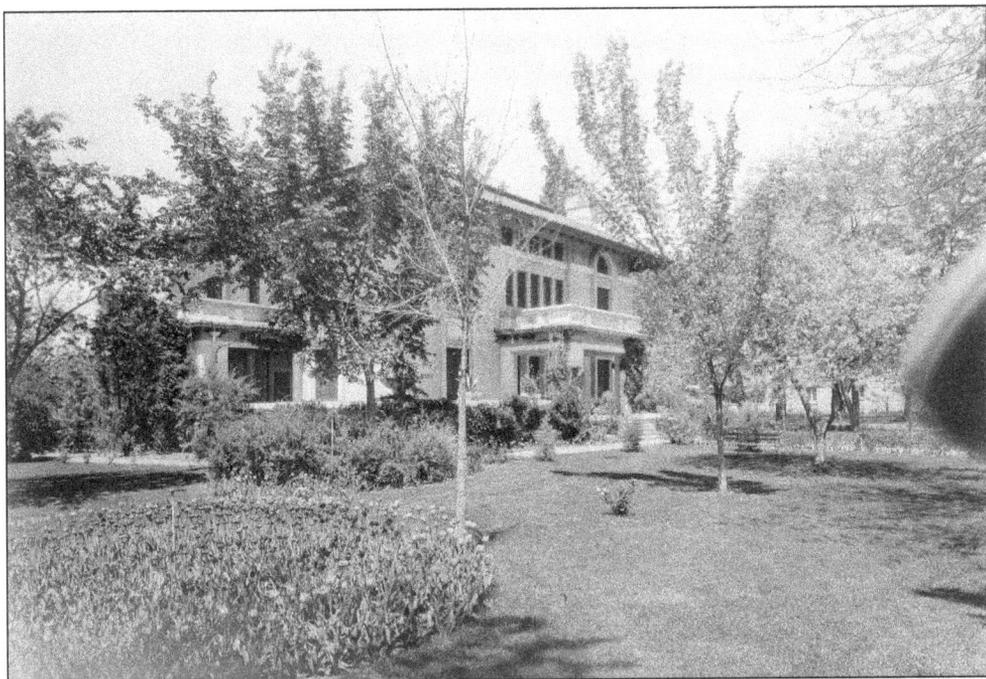

The elegant Nordhaus home is in the Huning Highlands area of Albuquerque. While Nordhaus's home was exceptional, many Jewish merchants lived above their stores until they had saved enough to purchase a residence. (Courtesy of the Albuquerque Museum.)

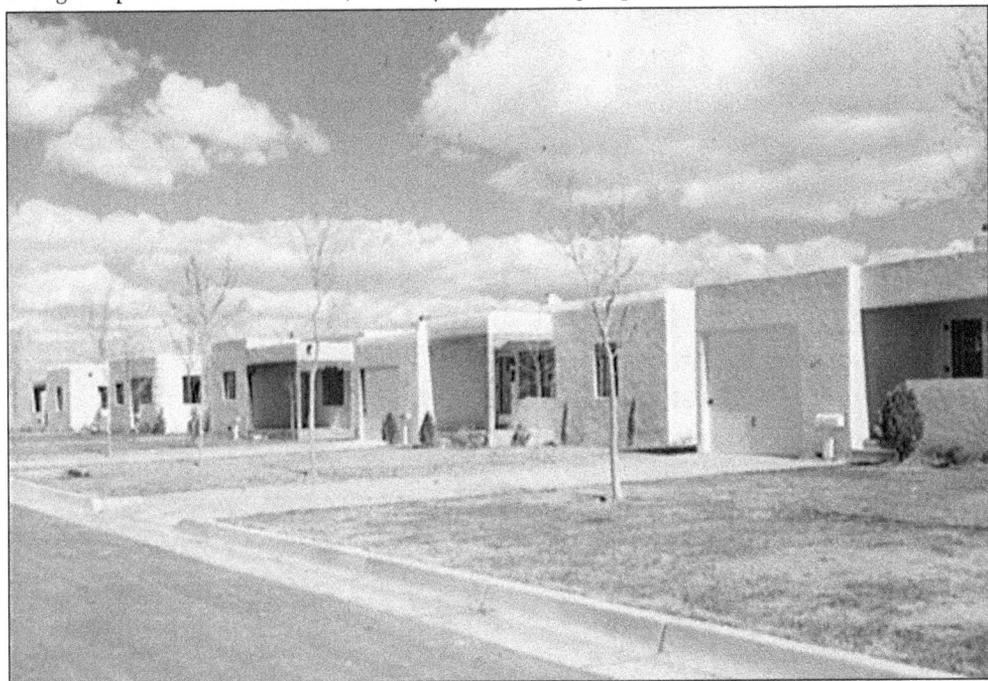

Between 1940 and 1950, Albuquerque's population almost tripled from 35,000 to 96,000. Homes, such as those shown above, were quickly erected to accommodate the new arrivals. (Photograph by John Collier, courtesy of the Library of Congress.)

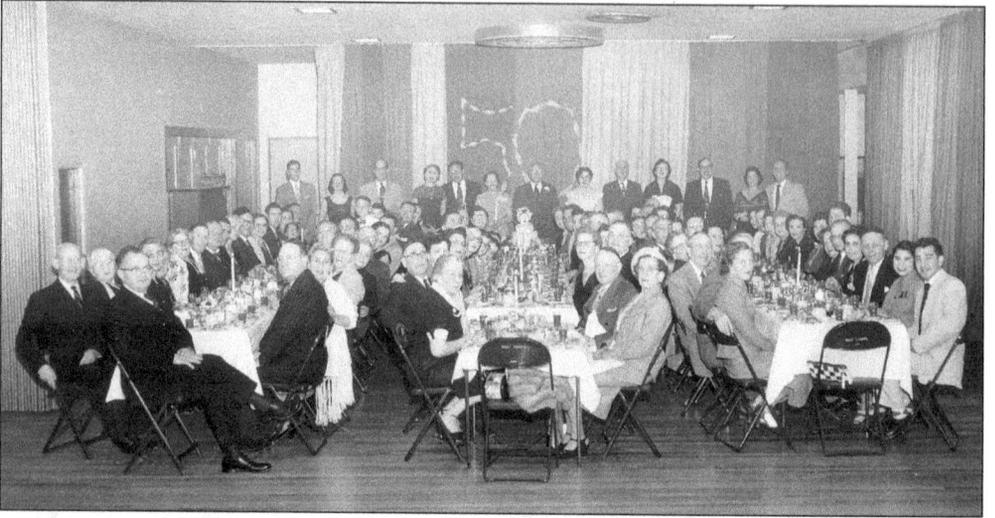

Above, Emil and Minnie Pollock celebrate their 50th wedding anniversary with their friends and family at Congregation B'nai Israel on Coal and Cedar Avenues in 1953. The couple had run a furniture shop downtown. Their son Max Pollock and his wife, Ruth, came to Albuquerque and opened People's Flowers in 1944. The shops are still in the family today. (Courtesy Fernie Caplan and Congregation B'nai Israel.)

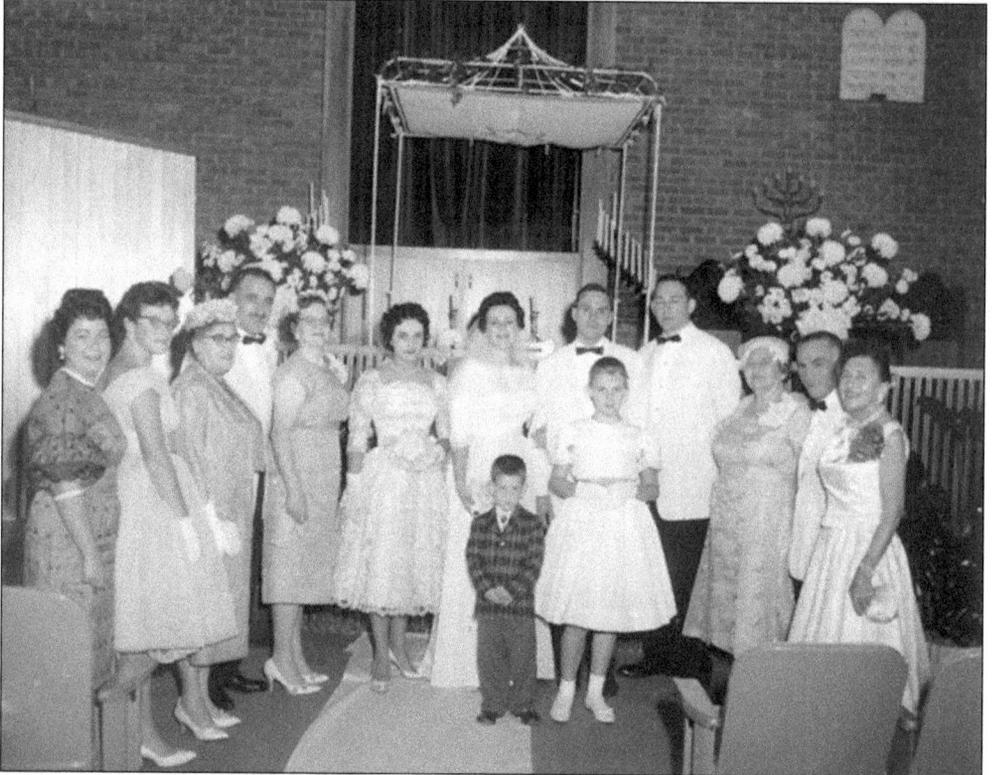

The wedding of Stan Feinstein and Rosalia Myers took place at Congregation Albert in 1960. The bride's parents were members of Congregation B'nai Israel, making the wedding an "interfaith" union in the eyes of Albuquerque's Jewish community. (Courtesy of Stan Feinstein.)

Six

MODERN JEWISH ALBUQUERQUE

The period between 1860 and 1960 provided the foundation for the robust and diverse Jewish Albuquerque of today. In 1997, Congregation Albert celebrated its 100th birthday, and in 2010, Congregation B'nai Israel celebrated 90 years of existence. Besides the two early synagogues, Jewish residents worship at Congregation Nahalat Shalom, Chabad, or Chavurah Hamidbar.

While enrollment in New Mexico's original B'nai B'rith chapter dwindled, other organizations sprang to life, including the New Mexico Jewish Federation, the New Mexico Jewish Historical Society, the Jewish War Veterans, a branch of the Anti-Defamation League, and a New Mexico Holocaust and Intolerance Museum, founded by survivor Werner Gellert and his wife, Frankie.

A Jewish Community Center (JCC) and Jewish elementary school (Solomon Schechter Day School) were erected in 2000. At the University of New Mexico, Hillel remains a campus presence: a Hillel house (Jewish student center) was donated in 1995. Jewish news is reported in the monthly publication *New Mexico Jewish Link,* and community members are cared for by staff at the David Specter Shalom House (a senior living facility) and Jewish Family Services.

Jewish citizens, many of whom arrived after World War II to study at the University of New Mexico or work for expanding organizations such as Sandia Corporation, live throughout the city of half a million. Jewish residents are engaged in every profession, including the arts, science, education, and elected office. While Albuquerque was not an artist's colony on the scale of Taos or Santa Fe, Jewish artists based in Albuquerque have explored Jewish themes and created art for area synagogues. Arthur Sussman (1927–2008) was a well-known Jewish painter.

Good relations continue to exist between Jewish residents and their neighbors. The community has long participated in a New Mexico Catholic-Jewish dialogue, and a recent program, Celebrate!, has brought Hispanic and Jewish communities together.

Albuquerque's early Jewish pioneers would be proud of the fruit that their seeds have borne.

Congregation Albert moved to a new building on Louisiana Avenue in 1983. It remains the largest Jewish congregation in New Mexico. In addition to religious services, the congregation is a meeting place for community events such as candidate forums and debates. At the corner of Gold Avenue and Seventh Street in downtown Albuquerque, a plaque commemorates the original Congregation Albert building. (Author's Collection.)

Congregation B'nai Israel erected a new building in 1971. In 2010, the congregation celebrated its 90th anniversary. (Author's Collection.)

Congregation Nahalat Shalom, a Jewish Renewal synagogue, was founded in 1982. In 2000, the congregation purchased an old church in Albuquerque's North Valley and converted it into a synagogue. The congregation's doors were created by Hershel Weiss and are a replica of Jewish temple doors in Spain. (Author's Collection.)

The Aaron David Bram Hillel House at the University of New Mexico was donated in 1995 by Paula Amar and Mel Schwartz in memory of their son. (Author's Collection.)

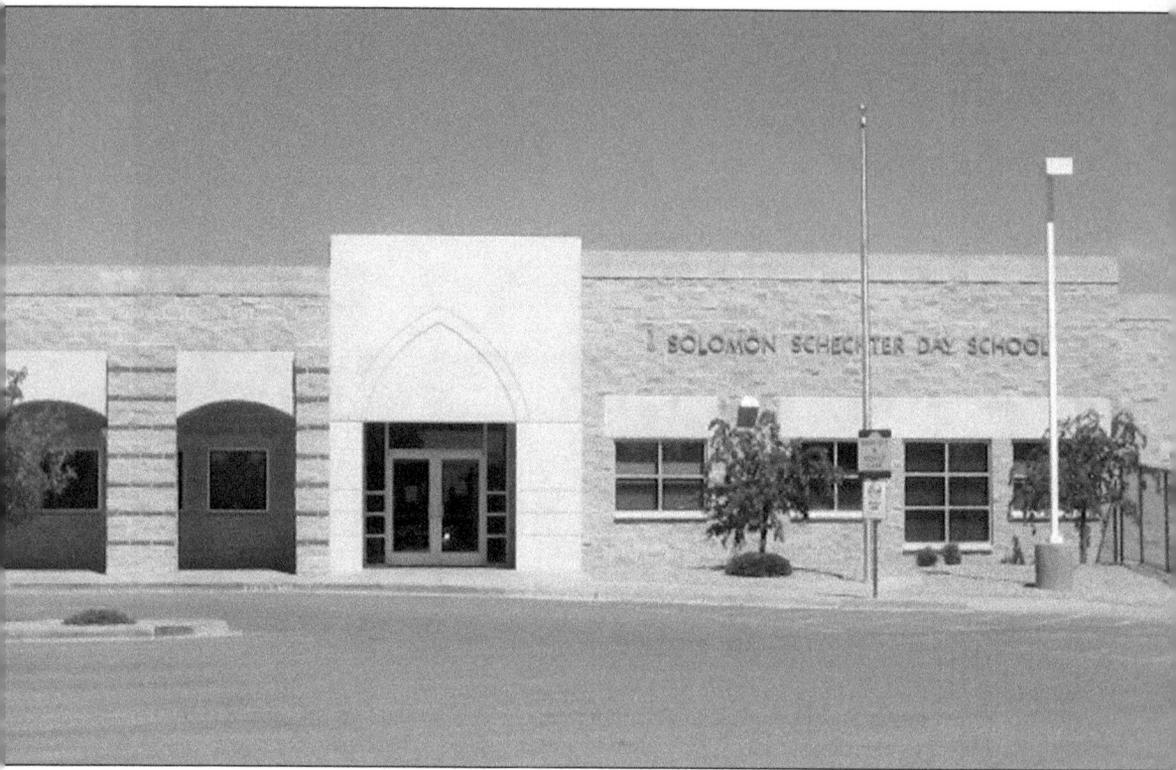

Solomon Schechter Day School was founded in 1996. In 2000, the school moved to a 12,000-square-foot facility adjacent to the Jewish Community Center. It is an affiliate of the Solomon Schechter Day School Association. (Author's Collection.)

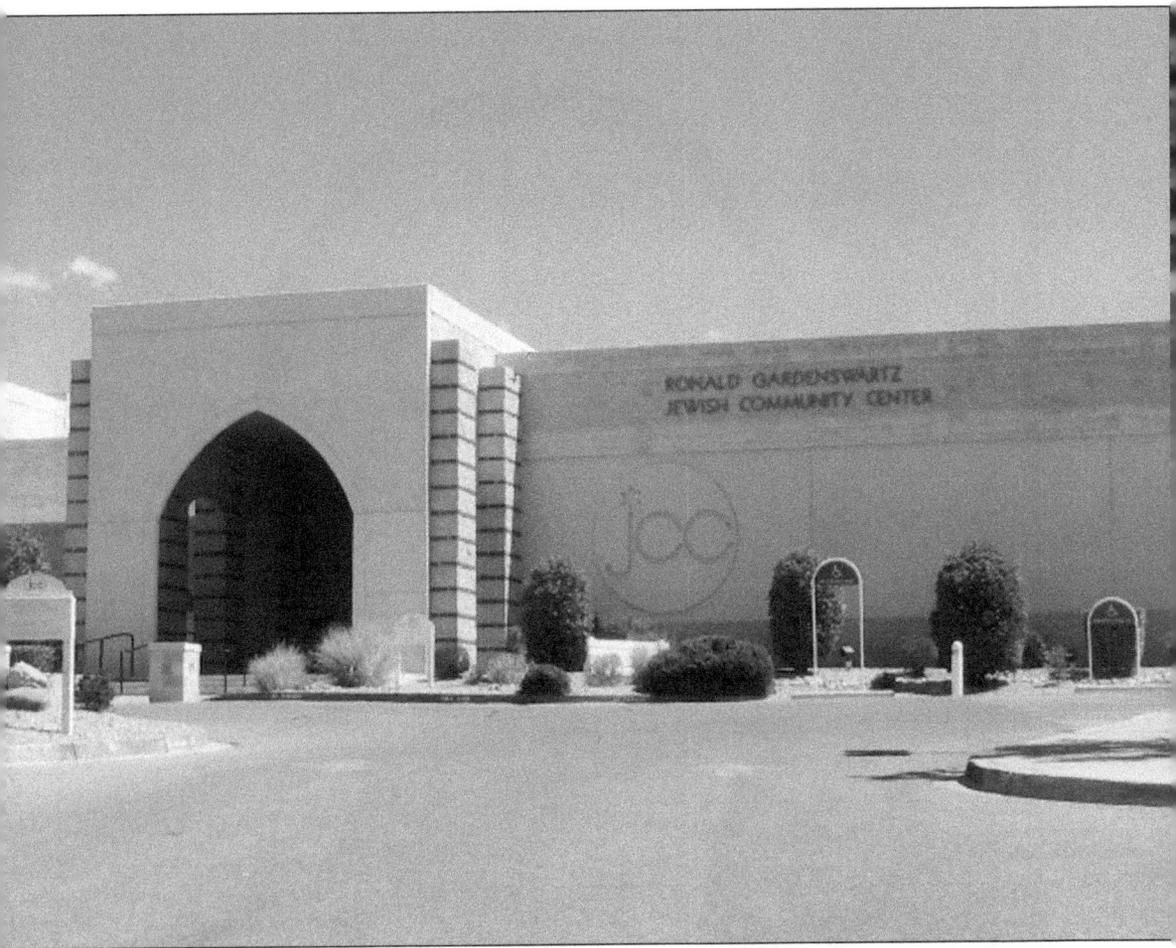

Above is the Ronald Gardenswartz Jewish Community Center of Albuquerque in 2000. The Gardenswartz family was a major donor, as were Abe and Sophia Cohen. The center houses a fitness facility and pools, community meeting rooms, a youth lounge, a day care center, a delicatessen, and the offices of numerous Jewish organizations. (Author's Collection.)

Steve Schiff (1947–1998) attended the University of New Mexico School of Law and served as a U.S. representative for the First District of New Mexico, which includes Albuquerque. During his fifth term in office, Schiff died of skin cancer. The Bernalillo County District Attorney Building and a post office were named for the former congressman after his death in 1998. Schiff is buried at the Congregation Albert cemetery. (Courtesy of the University of New Mexico Center for Southwest Research.)

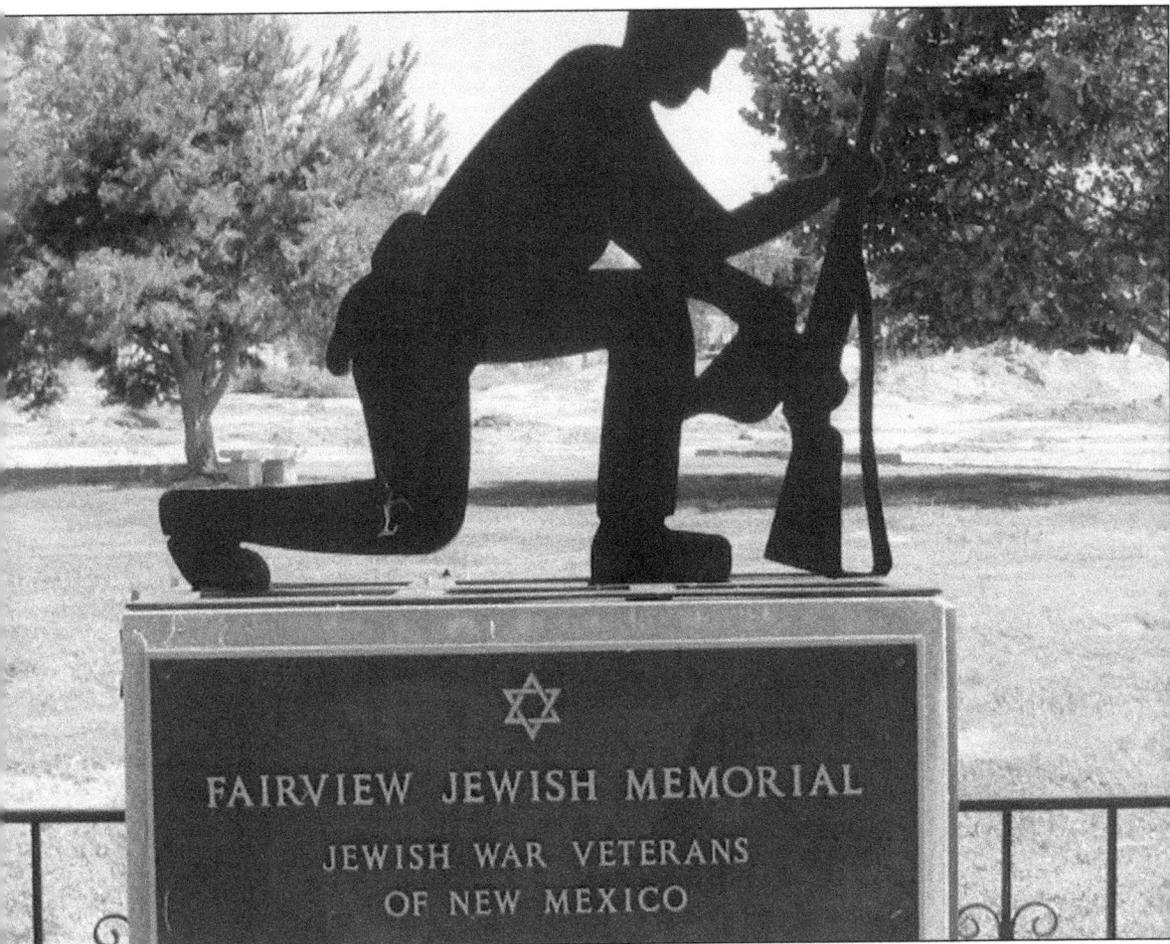

The Congregation Albert, B'nai Israel, and Chavurah Hamidbar cemeteries remain at Fairview Memorial Park. In addition, a Chevra Kadisha, or Jewish burial society, serves the community. In 1978, a Jewish War Veterans memorial was erected at Fairview Memorial Park. There are active Jewish War Veterans chapters in Albuquerque and neighboring Rio Rancho. (Author's Collection.)

In 2008, the Sandoval County Historical Society dedicated a memorial garden to honor three Jewish merchant pioneer families—the Bibos, the Blocks, and the Seligmans. These families established and operated the Bernalillo Mercantile Company, employing hundreds of local residents. (Author's Collection.)

BIBLIOGRAPHY

Ball, Durwood. *Jewish Pioneers of New Mexico: The Ravel Family*. Albuquerque: New Mexico Jewish Historical Society, 2005.

Chaves, Thomas. *New Mexico Past and Future*. Albuquerque: University of New Mexico Press, 2006.

Fierman, Floyd S. *Roots and Boots*. Hoboken, NJ: Ktav Publishing House, 1987.

Fitzpatrick, George and Harvey Caplin. *Albuquerque: 100 Years in Pictures*. Albuquerque: Modern Press, 1976.

Howard, Kathleen. *Inventing the Southwest: The Fred Harvey Company and Native American Art*. Flagstaff, AZ: Northland Publishing, 1996.

Hughes, Debra. *Albuquerque in Our Time: 30 Voices, 300 Years*. Santa Fe: Museum of New Mexico Press, 2006.

Jaehn, Tomas. *Jewish Pioneers of New Mexico*. Santa Fe: Museum of New Mexico Press, 2003.

Oppenheimer, Alan J. *The Historical Background of Albuquerque, New Mexico*. Albuquerque: City of Albuquerque Planning Department, 1962.

Palmer, Mo. *Albuquerque Then and Now*. San Diego: Thunder Bay Press, 2006.

Parish, William J. "The German Jew and the Commercial Revolution in Territorial New Mexico, 1850–1900." *New Mexico Historical Review* 35, no. 1 (January 1960).

Pugach, Noel. *Jewish Pioneers of New Mexico: The Spiegelberg Family*. Albuquerque: New Mexico Jewish Historical Society, 2005.

Rochlin, Harriet and Fred. *Pioneer Jews: A New Life in the Far West*. New York: Houghton Mifflin, 1984.

Rothenberg, Gunther. *Congregation Albert 1897–1972*. Albuquerque: Congregation Albert, 1972.

Tobias, Henry. *A History of the Jews in New Mexico*. Albuquerque: University of New Mexico Press, 1990.

———. *Jews in New Mexico since World War II*. Albuquerque: University of New Mexico Press, 2008.

A Tribute to Our 50-Year Members. Albuquerque: Congregation B'nai Israel, 1994.

INDEX

Adler, Rena, 88
Albuquerque Country Club, 85, 105, 109
Albuquerque Jewish Welfare Fund, 59, 88
Alvarado Hotel, 74, 95, 97, 105, 112
Bergman, Rabbi Moise, 10, 50, 73
Bernalillo Mercantile Company, 30–32, 124
Bibo family, 29, 30, 95, 96, 124
Blaugrund family, 64, 81
B'nai B'rith, 9, 11, 46, 81, 117
Chabad of New Mexico, 117
Chapman, Rabbi Edward, 50
Commercial Club, 9, 19, 105–108
Congregation Albert, 9, 10, 14, 20, 25, 30, 41–65, 71–73, 76, 81, 83, 89–91, 98, 99, 105, 106, 110–112, 116–118, 122, 123
Congregation B'nai Israel, 10, 41, 65–70, 79, 82, 84, 88, 114, 116–118, 123
Congregation Montefiore, 40
Congregation Nahalat Shalom, 117
Elks Club, 9, 76, 108
Feinstein, Stan and Rosalia Myers, 62, 116
First American Pageant, 99, 100
Freemasons, 9, 110
Gardenswartz family, 92, 121
Goldstein, Joseph, 39
Goldstein, Rabbi Raphael, 51
Goodman, Manny, 95, 103
Greenburg, Rabbi William H., 41, 48
Grunsfeld family, 18–21, 37, 41–43, 74, 76, 105–107
Hadassah, 78, 88, 92
Hillel, 117, 119

Hoffman, Samuel, 93
Horwitz family, 57, 87
Ilfeld family, 8–11, 23–25, 38, 76, 86, 111
Jaffa family, 9, 11, 14, 15, 37, 42, 47, 76, 99, 107
Jewish Community Center, 117, 120, 121
Kaplan, Rabbi Jacob, 10, 49
Katz family, 65, 79
Krohn, Rabbi Abraham Lincoln, 55
Lewinson family, 74–78
Maisel family, 53, 57, 95, 101
Mandell family, 9, 11, 16, 34–38, 40, 83
Meyer family, 38, 65, 73, 74, 82
Moise family, 10, 14, 89
Myer family, 110, 111
National Council of Jewish Women, 72
Nordhaus family, 23, 95, 104
Ravel family, 67, 68, 84, 125
Rosenwald family, 10, 20, 26–28, 37, 38, 76
Rosenstein, Simon, 11, 12
Sandia Peak Tramway, 95, 104
Schiff, Steven, 122
Schweizer, Herman, 95, 98
Seligman family, 30–33, 64, 73, 87, 90, 91, 95, 98, 124
Shor, Rabbi David, 41, 61, 62, 72
Shinedling, Rabbi Abraham and Helen, 71
Solomon Schechter Day School, 120
Spiegelberg family, 7, 11, 18, 19, 29, 95, 98, 125
Staab family, 37, 50, 104
Sutin, Lewis, 57, 72, 89
Weiller family, 38, 64, 83
Weinman family, 16, 39, 74–78, 108

ABOUT THE AUTHOR

Naomi Sandweiss, an Albuquerque native, enjoys learning about New Mexico history. As a volunteer for the New Mexico Jewish Historical Society (NMJHS), Naomi participated in the Jewish Pioneers project, interviewing descendants of New Mexico Jewish pioneer families, and authored a booklet on the Gusdorf family of Taos. She is editor of the *Legacy*, the society's publication, for which she writes a regular column. In 2010, Sandweiss received the society's Dr. Alan P. and Leona Hurst Award for outstanding service to the society and New Mexico Jewish history. She is also a member of the NMJHS Board of Directors. Naomi brought an exhibit, speakers, and a play about the Kindertransport to Albuquerque in conjunction with the New Mexico Holocaust and Intolerance Museum. Naomi received a B.A. in American Studies from Dickinson College in Carlisle, Pennsylvania, and an M.A. in Education from Bowling Green State University in Ohio. She lives in her hometown with her husband, daughter, son, and two rescue cats.

Visit us at
arcadiapublishing.com